Jonathan Brown

Collecting Ar

KINGS & CONNOISSEURS

n Seventeenth-Century Europe

Yale University Press : New Haven & London

To the memory of my mother,
Jean Brown, a great collector of the twentieth century

This is the forty-third volume of the A. W. Mellon Lectures in the Fine
Arts, which are delivered annually at the National Gallery of Art,
Washington. The volumes of lectures constitute Number XXXV in
Bollingen Series, sponsored by Bollingen Foundation.

Designed by Derek Birdsall
Set in Monophoto Poliphilus with Blado Italic by Servis Filmsetting Ltd.
Manchester

Printed in Italy by Amilcare Pizzi Spa., Milan
10 9 8 7 6 5 4 3 2 1

Library of Congress Cataloging in Publication Data

Brown, Jonathan, 1939–
 Kings & connoisseurs : collecting art in seventeenth-century
Europe / Jonathan Brown.
 p. cm.
 Includes bibliographical references and index.
 ISBN 0-300-06437-3 (h/b)
 1. Royal houses–Art collections. 2. Painting–Private
collections–Europe. 3. Art patronage–Europe–History–17th
century. I. Title.
N5240.B76 1995b
759.94′074′4–dc20 95-15646
 CIP

A catalogue record for this book is available from the British Library

EC (BRO)

Contents

When, in the spring of 1990, I received the invitation to deliver the Andrew W. Mellon Lectures in the Fine Arts at the National Gallery of Art, Washington, my reaction veered between panic and pleasure. While the experience of delight needs no explanation, a shiver of fear may not be quite so understandable a reaction. A series of public lectures is a delicate exercise in erudition and entertainment. Any seasoned scholar is bound to be loaded with information. However, learning and amusement are not natural companions, and the members of a public audience have an effective way to demonstrate their boredom—they stop attending the lectures.

The most dramatic example of this phenomenon that I know was told to me by an Oxford don just before I was scheduled to begin a series of extracurricular lectures at that venerable university. It appears that, some years earlier, a distinguished foreign scholar had been invited to give several public lectures at Oxford. His subject, while important, was obscure and, unfortunately, he spoke English with a heavy accent. After the first lecture, the attendance dropped off dramatically and, by the third, only a single person appeared. With commendable professionalism, the lecturer decided to proceed. As soon as he began to speak, his audience of one, an undergraduate, rose to his feet and excused himself, saying, "Sorry to have to leave, but I am writing an essay."

It was with this image in mind that I decided to lecture on art collecting in the seventeenth century. For reasons which are probably as much pecuniary as cultural, collecting is one of the few aspects of art history with a wide appeal. Furthermore, in recent years the study of art collecting has been integrated into the wider world of cultural history, and to good effect. Collecting, then, would be my topic.

This topic, I hasten to add, was not new to me. Over the years I had done some work on collecting at the court of Philip IV of Spain (reigned 1621–65). Indeed, as I followed the trail of acquisitions for this royal collection, I found myself arriving in Paris, London, Brussels and Antwerp, where rivals competed for works, and dealers and agents plied their trade. It soon became apparent that Philip IV had not collected in a vacuum. His passionate interest in acquiring pictures was shared by monarchs and aristocrats in other courts, and the impact and implications of their activities could be seen as transforming the way in which the art of painting was viewed within the context of European culture. Indeed, it seemed that only by a comparative study of collecting at the courts of Spain, France, England and Flanders, the major centers of large-scale picture collecting in the seventeenth century, could the full dimensions of the phenomenon be perceived. The problem with this expansive approach was its vast scale; dozens of collectors and hundreds of pictures were involved.

How to organize this material thus became a crucial problem, which was solved by the requirements of the Mellon Lectures. Brevity is not only the soul of wit, it is the salvation of public lectures. I estimate that a fuller treatment of art collecting in seventeenth-century Europe would require at least thirty hours of lectures or several hundred pages of text. By that time, even the die-hards in the audience would surely have died, and readers of the resultant book would soon be following them into a common grave. Fortunately for all concerned, the Mellon Lectures number but six, which compelled a synthetic approach.

As it happened, one of the richest hauls of pictures to arrive at the court of Philip IV came from the collection of Charles I of England, who was put to death by his subjects in 1649. The

history of the dispersal of the English royal collection proved the solution to my problems. Here was an event rich in dramatic possibilities; the English Civil War is probably the most compelling (and consequently well studied) event in the history of seventeenth-century Europe. Furthermore, the reputation of Charles I as an art collector is without equal, although I do apply a few corrective touches to that image in this book. But perhaps more important is that the dispersal of the collection, or at least the cream of the collection, opens a vista on the rise of large-scale picture collecting at the monarchical courts of Europe, with all that it entails: the expansion of art dealing, the increased interest in questions of authenticity, the publication of illustrated books of collecting and, most important, the repositioning of the art of painting within the context of European high culture.

In some respects, the story unfolds like a realist novel of the nineteenth century. As a Hollywood press agent might say, it is a story of passion, beauty and greed played against a background of international politics and intrigue, with a cast of hundreds, including princes, painters and plotters. As in the fiction of Dickens, Pérez Galdós and Balzac, the characters keep popping up at different times and in different contexts. I have not resisted the novelesque possibilities of this material and have tried to infuse a period flavor into the tale by abundant quotations from the writings of participants and observers. However, in the interests of keeping the story-line clear, I have reduced the number of players and pieces to manageable proportions by concentrating on the most important collectors and the most famous pictures. Another way to reduce the clutter has been to make a firm distinction between collected works and commissioned works, the latter of which belong to the history of patronage. A collector buys existing pictures while a patron orders them made to specification (although a commissioned work, on the death of the patron, would become part of the collection of an heir or successor).

The decision to fashion the book in the form of what is, I hope, an entertaining narrative carries certain consequences with it. By choosing a high vantage-point from which to survey the action, there is an inevitable loss of detail on the ground. To some extent this also reflects the nature of the sources and the studies of individual courts. The Spanish sources, for example, are rich in inventories of collections but poor in personal accounts, be they first-hand descriptions of collections and collectors or original correspondence. France and England, on the other hand, are rich in eye-witness testimony but under-supplied with published inventories. English historiography has provided another inestimable advantage, the abundance of biographical studies of all the major and many of the secondary characters involved in collecting at the Caroline court. The Flemish situation is well provided with source material of every kind; however, the bibliography on collecting is still rather sparse, with the exception of the activities of Peter Paul Rubens. While I have tried to smooth out the differences, it has not always been possible to compensate for the uneven distribution of the existing bibliography. (I confess that my archival research was limited to Spain.)

I have saved the question of monetary values for last, more out of caution than a sense of propriety. All art collectors profess a love of beauty and I have no doubt that they are sincere. But beauty is abstract, ineffable and therefore difficult to evaluate in material terms. The monetary value of a work of art is thus called upon to validate a collector's judgment and acquisitive power. In Western societies, art has become, among other things, a commodity, despite the best efforts to keep it pure from commerce, and price and worth are now inseparably linked when pictures are talked about. As a matter of fact, a major step in this direction was taken in the seventeenth century, as is discussed in this book.

It would therefore be desirable if the prices of pictures in the seventeenth century could be translated into the currencies of today. Unfortunately, as I am informed by economic historians, such values are impossible to calculate with any degree of accuracy, and the only way to grasp them is somewhat complicated and unsatisfactory. This involves placing pictures in relation to the cost of other goods and representative levels of income. In the main, as I demonstrate below, fine pictures were inexpensive compared to other items of luxury consumption such as jewelry or silver plate. Even such an apparently mundane item as fancy clothing cost much more than the finest picture. For instance, in 1613 Princess Elizabeth, daughter of James I and Anne of Denmark, wore a gown adorned with gold and silver lace. The lace alone was valued at £1700, which would have made it more valuable than all but a few paintings in the famous collection of her brother, Charles I.

Among the pictorial arts paintings were overshadowed by tapestries. To take an example from Spain, in 1633 the crown acquired a set of eight tapestries depicting the story of Diana for the price of 4400 ducats. In the following year, eight landscape paintings were bought for 840 ducats. The quality of these pictures must have been fairly high, because 100 ducats was a lot to pay for a single canvas, although a top-drawer price for an important painting was in the range of 1500 ducats. These prices acquire further significance when compared to the levels of income enjoyed by the rich and well-to-do. While a grandee with extensive landholdings might receive as much as 100,000 ducats per annum, an untitled gentleman would have 1000–2000 ducats at his disposal. The best pictures, therefore, were available only to the "best" people. However, to a manual laborer, who might earn around one hundred ducats a year, even a cheap picture was far too expensive. (It also needs to be remembered that the value of the currency suffered severe fluctuations over the course of the century.)

Much the same comparisons could be made in the other monarchies discussed here. In England, for example, a laboring family might live on £10 per year, while the lower nobility could count on an average income of about £5000. Paintings by Titian from the collection of Charles I were sold in a range of £150–£600, although two portraits by Albrecht Dürer brought only £75 apiece. From these and other numbers, it would appear that fine old pictures were an easily affordable luxury for the top echelon of society and were certainly not as expensive as they are today.

The story of how these pictures finally achieved their present social and financial status lies outside the scope of this book, although I offer hints about this development in a brief postscript. Here the focus is on what might be considered an intermediate stage in the process. This conforms in general to the transitional position of seventeenth-century Europe in the formation of what we call the modern world. For example, the scientific revolution which began at this time and is associated with such names as Galileo, Newton and Descartes would not mature until the eighteenth century. Similarly, the political process known as "state building" achieved only a partial completion in the 1600s. So it is with collecting. Therefore I have not tried to force a conclusion, however much this compromises the entertainment value of the story. At the end of the day, I am forced to concede that this book is an exercise in historical writing, despite my efforts to appropriate certain strategies of imaginative fiction.

Over the years devoted to this study, I profited from the advice and assistance of what by now must be half its potential readership. I gave lectures on parts of the material at scholarly communities and conferences (The Johns Hopkins University, the University of

Massachusetts, Princeton University, the University of Amsterdam, the Kunsthistorisches Museum), where colleagues offered much-needed criticism and information. And members of the audience at the National Gallery of Art (yes, some did stick it out) came forward after each lecture with questions and reactions which were invaluable as I revised the text for publication.

The contributions of several people were so vital as to merit special attention. Sandra Brown, John H. Elliott, Richard L. Kagan and John Nicoll read drafts of the manuscript and helped me improve the balance, clarity and accuracy. Jean-Claude Boyer and Orest Ranum took chapter five in hand and provided advice on the situation at the French court. (I regret that the second volume of the book on French collecting by Antoine Schnapper, with whom I also talked, is appearing too late for me to consult.) I enjoyed many conversations with Thomas DaC. Kaufmann on collecting in general and on the Austrian Habsburgs in particular, while Fernando Checa was equally helpful with the Spanish branch of the dynasty. S.A.C. Dudok van Heel devoted an afternoon of his time to discussing collecting in Amsterdam, although I suspect that he will regard those hours as mis-spent once he sees that I continue to regard Dutch collecting of early Italian painting as falling short of what occurred in the princely courts. A special debt of gratitude is owed to R. Malcolm Smuts for helping with the English section and for directing my attention to some of the wider implications of collecting at the courts of Europe in this period. A number of my students contributed to the research and gathering of illustrative material for the lectures and the book – Luisa Elena Alcalá, Carina Fryklund, Lisa Pilosi, Lisa Rotmil, William Russell, Ann Trautman and Isabel von Samson. Sheila Lee in London efficiently helped in the cumbersome process of ordering photographs and ektachromes. Henry A. Millon, Dean of the Center for Advanced Study of the Visual Arts at the National Gallery of Art, showed that his reputation as the most gracious, attentive of hosts is richly deserved. Finally, I offer thanks to Lynda Emery, who transformed my manuscript into a typescript; to John Trevitt, who edited it and, again, to John Nicoll, who supported and encouraged me at every stage of the publication process.

The text, except for the Postscript, substantially corresponds to the lectures delivered at the National Gallery of Art from 10 April–15 May 1994. I have furnished limited annotations, chiefly to cite the source of quotations and to acknowledge the principal bibliography upon which I relied. Given my synthetic approach, it did not seem appropriate to provide an exhaustive bibliography, and preference is given to recent books and articles. I hope that these citations will open the door to anyone wishing to enter the fascinating realm of courtly collecting in seventeenth-century Europe.

This book is dedicated to the memory of my mother, Jean Brown (20 December 1911–1 May 1994), a renowned and pioneering collector of objects and documentation of avant-garde movements of the twentieth century. The Jean Brown Archive, as her collection came to be known, now resides at the J. Paul Getty Center for the History of Art and Humanities. Although it took me a surprisingly long time to realize that my interest in the history of collecting was simply an extension of my mother's activities as a collector (the mental distance from the Chateau de Versailles to the Cabaret Voltaire in Zurich, where Dada was born, is enormous), I now see that all I have done in this field has been inspired and informed by her brilliant example.

Princeton, October 1994

I. *Charles I and the Whitehall Group*

The events that unfolded in London on those frosty days of 1649 are among the most dramatic in the history of modern Europe. On 19 January Charles I, King of England since 1625, had been brought from Windsor to stand trial for conspiring to "overthrow the rights and liberties of the people" and taking away "the right and power of successive Parliaments," for which purpose he had "traitorously and maliciously levied war against the present Parliament and the people therein represented." Since 1642, the armies of the king and Parliament had been engaged in civil war, a war that had virtually ended with the defeat of the Royalist army at Naseby in June 1645. Over the next eighteen months, Charles sought to obtain through negotiation what he had failed to win on the battlefield, the unconditional recognition of his authority. This effort did not succeed, and in June 1647 he was taken prisoner by Parliamentary forces.

His trial, which began on 20 January 1649, had a foregone conclusion. Charles had steadfastly refused to compromise on the crucial issues of religion and governance, forcing Parliament to a decision which many of its members feared to contemplate and refused to join. On 27 January, having listened to the king's eloquent defense of his rule, the court pronounced its sentence: that he should "be put to death by the severing of his head from his body." Three days later this awful punishment was carried out.

A scaffolding was erected at the Banqueting House of Whitehall Palace, the ceiling of which, in better days, had been decorated with a series of paintings by Rubens exalting the glory of the Stuart monarchy. At 2 p.m. the king was called from St James' Palace to meet his fate, which he did with remarkable serenity and dignity (plate 1). With a swift stroke of the axe, his troubled reign came to an end.

Once Parliament had disposed of the king, it decided to dispose of his property.[1] The idea was to raise money urgently needed for other purposes and also to eradicate the trappings of majesty with which the king had surrounded himself, including his famous collection of art. The Puritan faction was especially emphatic about the art collection, which it viewed as epitomizing the worst of Caroline rule—its devotion to pagan antiquity, its indulgence in privilege and ostentation, its dangerous and ill-concealed tolerance of the religion of Rome. As early as 30 March 1643 a committee of the House of Commons had impounded the contents of the Queen's Chapel in Somerset House (the queen, Henrietta Maria of France, was a Catholic) and thrown an altarpiece by Rubens into the Thames.

After the execution of the king, the government determined to proceed more systematically. On 4 July 1649 the Commons voted to liquidate the art collection, except for objects reserved by the Council of State, the governing body which now replaced the monarchy. Commissioners were to be appointed to inventory, appraise and then sell the goods. By late summer the trustees, as these officers are known, were ready to begin what is often regarded as the greatest art sale of all time.

In order to appreciate the true dimensions of what was occurring, we need to consider that the collection of Charles I was only one of a number of English collections to be dispersed at this time. Around the king had clustered other collectors of almost equal magnitude, noblemen who participated in the renascence of art for which the Caroline court is justly famous. The most important of these aristocratic collections were owned by Thomas Howard, Earl of Arundel, James Hamilton, Earl of Hamilton, and the heirs of George Villiers, Duke of Buckingham. Their lives were shattered by the Civil War and substantial parts of their collections, like those of their master, were virtually dumped on the market all at once. As a consequence hundreds of works of art, and especially paintings, became available to collectors on the continent, who profited from the misfortunes of their English counterparts.

The story of the dispersal of the English collections is inherently fascinating; it was an unprecedented event, equalled later only by the massive movement of art works during the Napoleonic period. There is more to this story, however, than just a treasure trove of collecting lore. The sale of the English collections in the middle years of the seventeenth century accelerated the development of practices and attitudes about art collecting which had started to take shape in the sixteenth century and would culminate in the eighteenth. Many of these attitudes still prevail and color the views of our own society about the role of collectors and collections.

1. Anonymous, *Execution of Charles I*
Earl of Rosebery

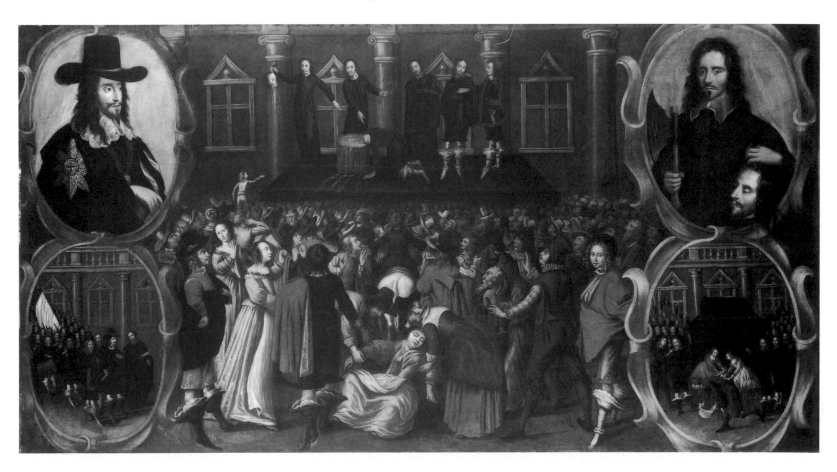

2. Peter Paul Rubens,
Ceiling of Banqueting House
Whitehall, London

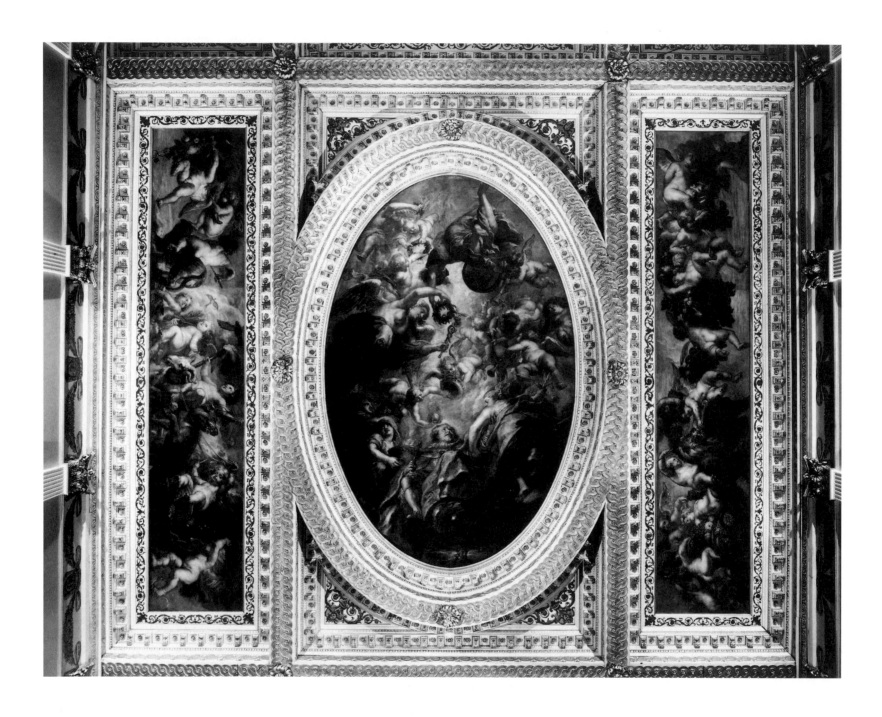

By custom and logic, every story should begin at the beginning. This one, however, is best told by starting at the middle, since the English elite were not the first in Europe to make large-scale collections of art. The precedents, as we shall later see, are found in certain Italian princely courts and then in the courts ruled by members of the Habsburg dynasty. These collections were formed during the sixteenth century, and particularly during its second half, when English nobles seldom traveled on the continent. We automatically identify the Elizabethan age as one of cultural achievement, but this is true only of the literary arts, not the visual arts. The renascence of the visual arts in England occurred during the reign of our protagonist, Charles I.

Charles was born in Scotland on 19 November 1600, the second son and third surviving child of James VI of Scotland (soon to become James I of England) and Anne of Denmark.[2] The early years of the prince were lived in the shadow of his brother Henry, a young man of great promise who died an untimely death aged eighteen in November 1612. Charles was created Prince of Wales in 1616 and ascended the throne nine years later on the death of his father. Over the next thirteen years, until the outbreak of conflict with his Scottish subjects, he proved to be a more successful patron of the arts than politician.

The troubled reign of Charles I is one of the most magnetic periods in the history of England. Even today a steady stream of books and articles seeks to arrive at an understanding of this conflictive, ultimately cataclysmic epoch.[3] The allure of the ill-fated monarch is only intensified by his notable activities as a patron of art. The princes and princesses of Europe had long employed skillful artisans to create an aura of majesty around their sometimes lackluster persons. Few, however, were more inspired in this pursuit than Charles. As a consequence, it is easy to confuse the achievements of Charles the patron with those of Charles the collector, the latter of which constitute a separate endeavor.

The artistic patronage of the king was focused on two of the greatest image-makers of the seventeenth century, Peter Paul Rubens and Anthony van Dyck. Rubens' ceiling paintings for the Banqueting House of Whitehall Palace (plate 2), completed in 1635, are the culmination of the king's long-standing interest in this prodigious painter and the grandiloquent climax of the pictorial glorification of the Stuart dynasty.[4] The portraits of the royal family by van Dyck, created after his appointment as painter royal in 1632, imbue the king with an ineffable sense of grace, refinement and understated grandeur (plate 3).[5] Charles was small of stature, somewhat diffident in manner, and spoke with a stammer (plate 4). In the legendary world of van Dyck's portraiture, however, he became the perfect prince.

The rose-colored vision of the reign proffered in the commissioned works has inevitably tinged the opinion of Charles as an art collector. Claims of his pre-eminence among the princely collectors of his age began as early as 1625, when no less an authority than Rubens called him the "greatest amateur of paintings among the princes of the world."[6] It goes without saying that he was a major collector and that he possessed an exceptionally keen eye, although his tastes followed the fashions of the day. However, on the European stage he was only one of the major collectors of the seventeenth century, and not necessarily the greatest. His collection was rivaled and, in a few instances, surpassed by others who will be discussed in this book. Perhaps a truer measure of his attainments is to be found by situating him within the small circle of aristocratic collectors at the English court, called the Whitehall Group, which started to coalesce around 1615.

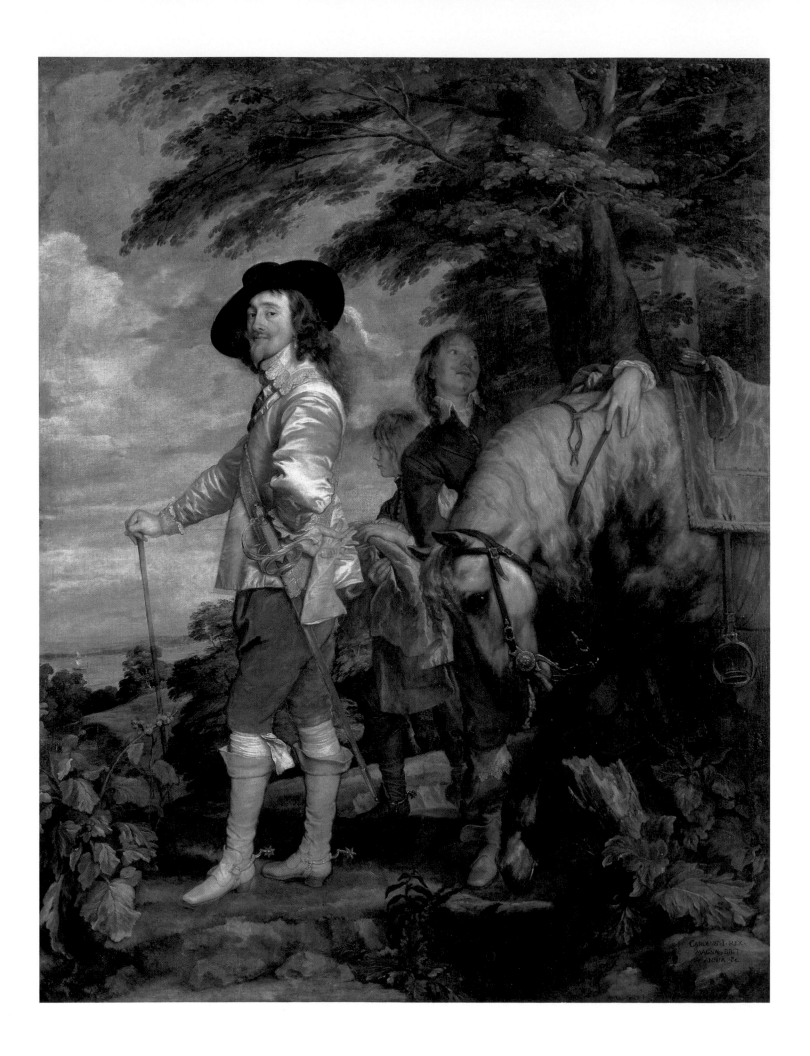

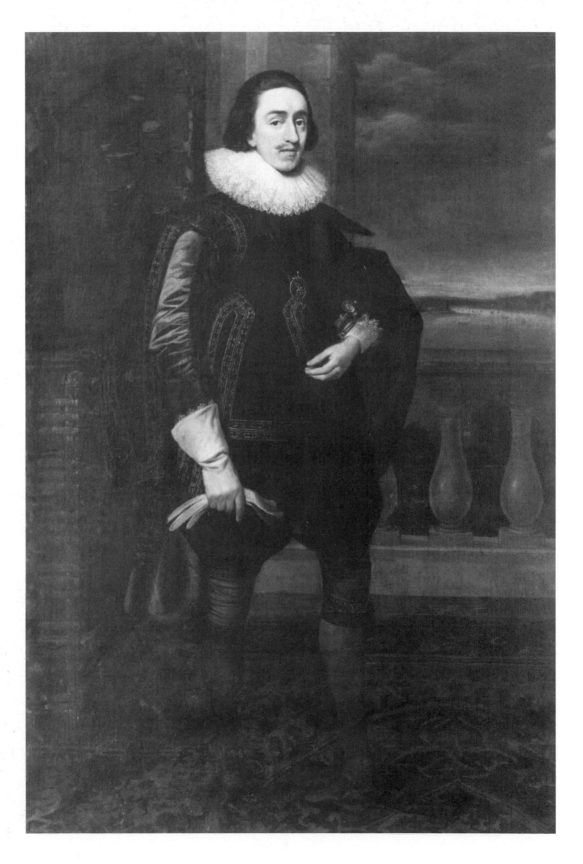

4. Daniel Mytens, *Charles, Prince of Wales*
London, Royal Collection

3. Anthony van Dyck,
Hunting Portrait of Charles I
Paris, Musée du Louvre

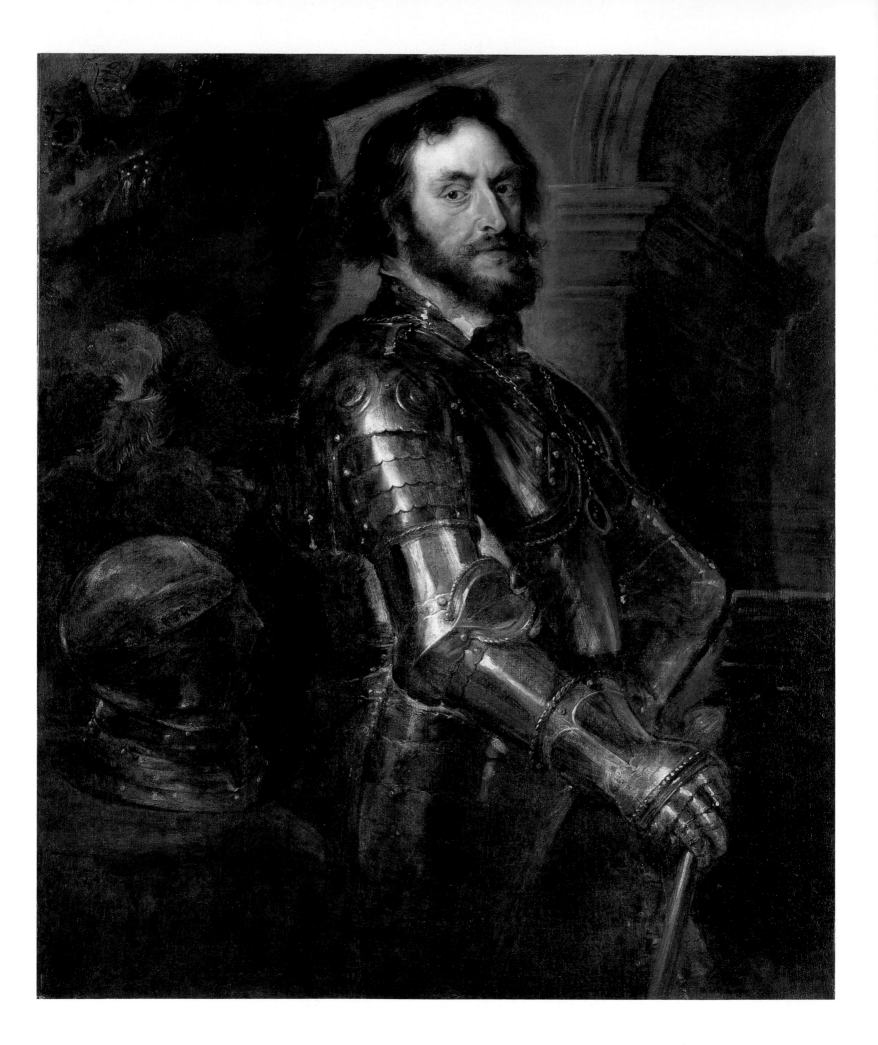

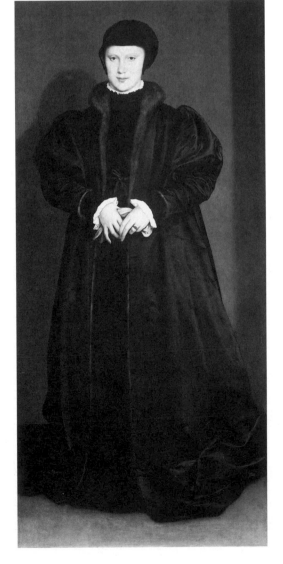

During the Elizabethan age (1558–1603) the English had not formed important collections of painting and sculpture, in part because travel on the continent was made difficult by the Wars of Religion, in which England was aligned against Spain. Rome, the most important destination for the seeker of artistic beauty, was virtually proscribed to the Protestant English, who ran the risk of arrest and persecution by the Inquisition. While it is known that art collecting on a small scale took place during the reign of Elizabeth I, it was not until 1604 that the two enemies made peace and that the English genie for collecting was released from the bottle.[7]

Over the next dozen years the English began to learn the ways of continental collecting. Leading figures at court, such as Prince Henry, Robert Carr, Earl of Somerset, who was briefly the favorite of James I, and Robert Cecil, Earl of Salisbury and Lord Treasurer,[8] were among the first to make forays into the market for Italian pictures of the sixteenth century, which would later be exploited with greater intensity by the Whitehall Group. However, as has always been recognized, the founder of modern collecting in England was Thomas Howard, Earl of Arundel (plate 5).

Arundel, born in 1585, had endured a miserable childhood. Although his family was among the most ancient of the English aristocracy, his father Philip, a Catholic, had run foul of Queen Elizabeth and been sentenced to life imprisonment in the Tower of London.[9] Deprived of a father and raised in a household of modest means, Arundel developed into a man who, as one observer noted, "lived always within himself and of himself." These inner resources were very considerable and after some years Arundel was able to recoup the lost reputation and position of his family.

Arundel's interests in arts and letters were awakened by his mother, Anne Dacre, and a relative, John, Lord Lumley, a famous bibliophile and collector of the later Elizabethan—early Jacobean period. (Arundel was to inherit some of the Lumley collection in 1617, including portraits by Holbein such as *Christina of Denmark* (plate 6), which sparked a passionate interest in this great painter.) However, Arundel lacked the wherewithal to become a collector himself until 1606, when he married Aletheia Talbot, daughter of Gilbert, 7th Earl of Shrewsbury, a wealthy aristocrat who had been to Italy as a young man and become fascinated with its culture. This interest was inherited by his daughter, a formidable patron and collector in her own right. With the Shrewsbury fortune behind him, Arundel began to repair his standing at court and widen his knowledge of the world of art.

It was not until 1612 that he first ventured abroad, undertaking a trip to Spa for reasons of health. En route to Spa (near Liège in Belgium), Arundel stopped at Brussels and Antwerp, where he saw the artistic sights and made the acquaintance of Peter Paul Rubens, whose involvement with the court of St James' stems from this encounter. After taking the waters, Arundel decided to make a dash for Italy, which may have been his plan all along. No sooner had he reached Padua than he heard news of the death of Prince Henry and hastened back to London.

The pleasures of Italy were not postponed for long. In the following year Lord and Lady Arundel accompanied Princess Elizabeth, the sister of Prince Charles, to Heidelberg to marry Frederick, the elector Palatine. Among their party was the architect Inigo Jones, who continued the journey with the Arundels to Italy, where they spent all of 1614. Their itinerary was later recorded by Jones: it included stops at every major art center. By Christmas 1614 the travelers were once more in England and Arundel was ready to collect in a serious way. However, another year passed before he could make his ambitions a reality. In 1616 his father-in-law died, leaving his fortune to Lady Arundel and her two sisters. The Arundels wasted no time in improving their standard of living and enriching their collections. Alterations were made to Arundel House on the Strand (plate 7) and to their country house in Highgate, which was an English version of an Italian villa. Works of painting and sculpture were acquired to grace these mansions. The first important purchases date from this year and are enmeshed in a complicated transaction. Despite its twists and turns, this deal is worth following for the insights it affords into how international commerce in art was conducted in the seventeenth century.

Strange as it may seem today, many of the most important purchases were made sight unseen by the eventual owners, particularly if they were rulers or important courtiers. Shopping trips to view works on offer were simply out of the question. Travel abroad was slow and dangerous; also, a prolonged absence provided enemies a chance to do their work in courts rife with rivalry and intrigue. Therefore, agents in the field were an unavoidable necessity, and the quality of purchases depended on their knowledge and acuity, not to mention the sharpness of their commercial instincts.

In the main, two options were available to home-bound collectors. They could turn to ambassadors or to personal advisors, who were sometimes under-employed artists. A representative figure drawn from the ambassadorial ranks is Sir Dudley Carleton (plate 8), who was at the center of Arundel's purchases of 1615. Carleton was born in Brightwell, Oxfordshire, in 1573.[10] After leaving Oxford he became secretary to Henry, Earl of Northumberland, who was later to be implicated in the Catholic attempt to blow up the

7. Wenceslaus Hollar, *Arundel House* Windsor, Royal Library

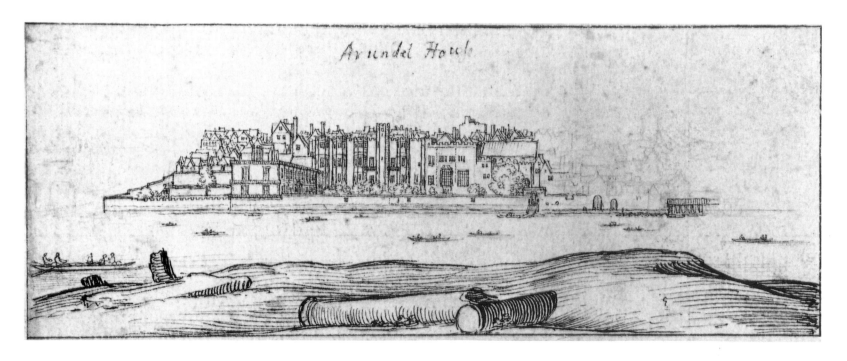

Houses of Parliament (the Gunpowder Plot). Carleton was cleared of charges in this affair, but his way to preferment at court was blocked and he was forced to look abroad for opportunities. In 1605 he accompanied Lord Nottingham on a mission to Spain, where he would have seen the great collection of paintings amassed by Philip II.

From 1610 to 1615 Carleton was ambassador in Venice, a city then beginning to experience a sustained economic decline which, to the profit of the English, would compel many collectors to divest themselves of works of art. Carleton soon found his way through the treacherous byways of the local art market. He seems to have been acting strictly for his masters in London, hoping to gain their favor and a place at court, but for reasons beyond his control, he became a dealer as well.

In 1615 Carleton, still in Venice, obtained a lot of fifteen Venetian pictures and a sizable collection of antique sculptures.[11] The purveyor was Daniel Nys, a cunning Flemish art dealer, resident in the city, whom we shall soon meet again. The ambassador was acting on behalf of Robert Carr, Earl of Somerset, then riding high as the favorite of James I. Carleton advanced the money with the expectation of being reimbursed once the goods had reached London. Unfortunately, the arrival of the shipment coincided with the precipitous fall of Carr from favor. The pictures were hanging in Somerset's house, still unpaid for, when he was arrested on 17 October 1615. In the meantime Carleton had been recalled. He arrived in London later that same month and was able to retrieve most of the objects. However, he was now the unwilling owner of an art collection which had cost him almost £900, a considerable sum of money.

His apparent salvation arrived in the person of Lord Arundel. But just as it looked as if the ambassador would be relieved of the merchandise, he was struck by another cruel blow of fate. Out of the blue, Arundel was presented with a large collection of antique sculpture by a nobleman who, as Carleton learned, was "desirous to buy friends." Consequently, Arundel lost interest in the sculpture and bought only the pictures for the sum of £200. Carleton, by now posted to The Hague, had to keep the sculpture, which he asked to have sent to him in the hopes of selling it in the Netherlands. Some time would pass before he could recoup his investment.

At any rate, Carleton had at least made a valuable contact and Arundel wasted no time in putting him to work. By 1617 Arundel and Lord Pembroke were dividing a shipment of Venetian paintings which Carleton had obtained from a dealer in Venice. Two years later Arundel wrote to Carleton acknowledging, among other things, his gratitude for the ambassador's offer to search for works by Holbein, which he especially cherished. As Arundel wrote to the agent-ambassador, "I hear likewise, by many ways, how careful your Lordship is to satisfy my foolish curiosity in inquiring for the pieces of Holbein."[12]

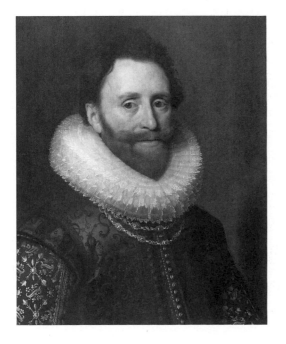

8. Michiel Mierevelt, *Sir Dudley Carleton*
London, National Portrait Gallery

Unfortunately, Arundel was still not interested in purchasing the almost ninety pieces of sculpture reluctantly owned by Carleton. However, in 1618 he finally found a customer, Peter Paul Rubens (plate 9), who played a shrewd hand in the buying and selling of art.[13] After extended negotiations Carleton traded his antiquities for several pictures by Rubens, which he apparently thought would be more marketable. Among the pictures he received was *Daniel in the Lions' Den* (plate 10). Carleton wasted no time in offering them for sale to Christian IV of Denmark, who refused to buy. Ultimately he seems to have disposed of them piecemeal, with *Daniel in the Lions' Den* entering the collection of Charles I, perhaps as a gift from the ambassador.

Carleton's practice of trading on his own account reveals a flaw in the employment of ambassadors as agents; they often served more than one master as well as their own interests. Arundel finally concluded that he had to put his own man in the field, and the person he chose was trained for the purpose. This was the Rev. William Petty, who had been educated at Cambridge and entered the Arundel household as the tutor in 1613.[14] There he became a pupil himself, receiving training in the appreciation of the fine arts from Arundel and members of his circle, including Inigo Jones. After the requisite trip to Italy in 1618, Petty was ready to go to work, although he did not undertake his first mission until 1624. In that year he was sent to Constantinople in search of antiquities, and spent three eventful, not to mention hazardous, years acquiring all manner of antiquities for the earl.

9. Peter Paul Rubens, *Self Portrait*
London, Royal Collection

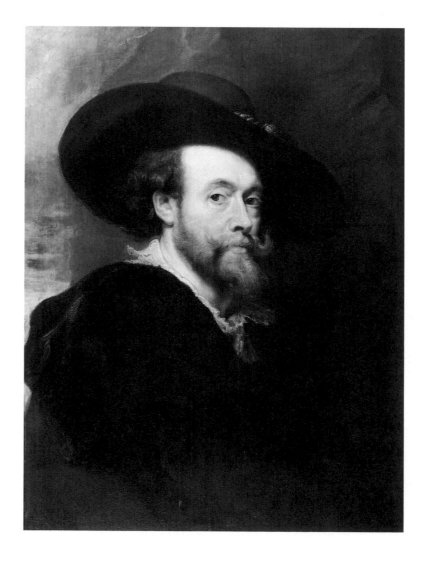

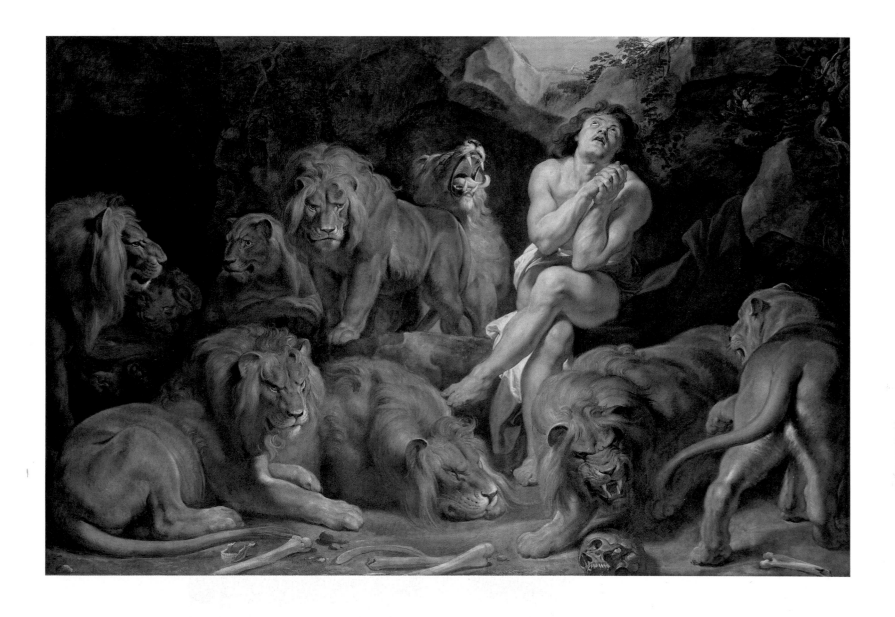

The extent of the Arundel collection in these years is difficult to gauge. Around 1618 Daniel Mytens painted matching portraits of Lord and Lady Arundel seated in a somewhat fanciful view of the galleries of Arundel House (plates 11 and 12). If of little documentary value concerning the works in the collection, these ostentatious portraits are important for revealing the connection between nobility of status and spirit and art collecting which was now being made at the English court.

There is surely no doubt that the formation of the Arundel collection was observed with interest by Prince Charles. In the effort to rehabilitate the reputation of his line, Arundel was frequently in attendance on the king and the prince of Wales. His attentions were rewarded in 1621 by his appointment as Earl Marshal, which placed him at the head of the nobility and gave him control over a structure of court patronage. However, it is unlikely that Charles found this imposing man to be a kindred spirit. Arundel, older by a generation, was a remote, introspective person, and his collecting interests reflected a high, almost somber seriousness of purpose. Through temperament and training, he was devoted to learning and letters, much

11. Daniel Mytens, *Lord Arundel in the Sculpture Gallery of Arundel House* London, National Portrait Gallery, on loan to Arundel Castle

12. Daniel Mytens, *Lord Arundel in the Picture Gallery of Arundel House* London, National Portrait Gallery, on loan to Arundel Castle

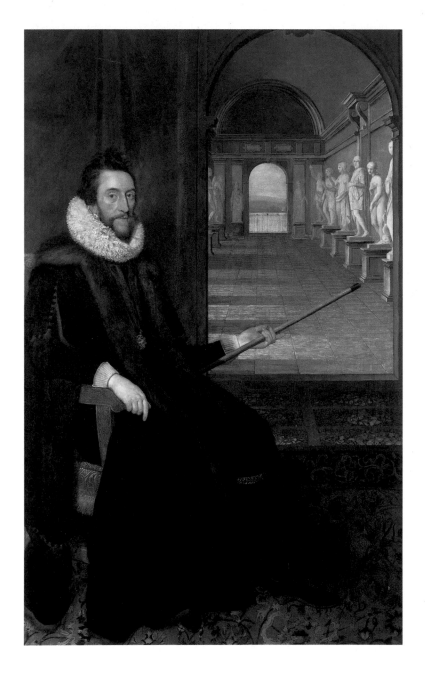

like the humanists he knew in Italy, and was more at home with the erudite men he patronized, such as the scholar Sir Robert Cotton and Dr William Harvey, who first understood the circulation of blood. Arundel was a devoted collector of books and manuscripts and a profound admirer of classical antiquity. His pictures were certainly fine, but they represented only one facet of a multifaceted collection, which included also a sizable group of drawings. Arundel, in short, was admirable but not accessible. Much more to Charles' liking was the earl marshal's hated rival, George Villiers, Duke of Buckingham, the most flamboyant member of the Whitehall Group.

Villiers, who was born in 1592, was the second son of a small Lancashire landowner and came to London in 1614 with little in the way of money or status.[15] His principal assets were his physical beauty and attractive manner. As a contemporary described him, "he was one of the handsomest men in the whole world. From the nails of the fingers—nay from the sole of his foot to the crown of his head—there was no blemish in him" (plate 13).[16] Villiers quickly made the most of his flawless features and captured the attention of James I, whose sexual appetites in later life were aroused by handsome young men. (The physical relationship soon subsided, but the emotional bond endured.) Once the incumbent favorite, Robert Carr, had been maneuvered out of the way, Villiers began a rapid rise through the ranks of the nobility. In the first eight months of 1616 he was successively appointed Master of the Horse, Knight of the Garter, Viscount Villiers and Baron Whaddon. On 5 January 1617 he was created Earl of Buckingham; he was finally elevated to a dukedom in 1623.

13. Peter Paul Rubens,
George Villiers, Duke of Buckingham
Vienna, Graphische Sammlung Albertina

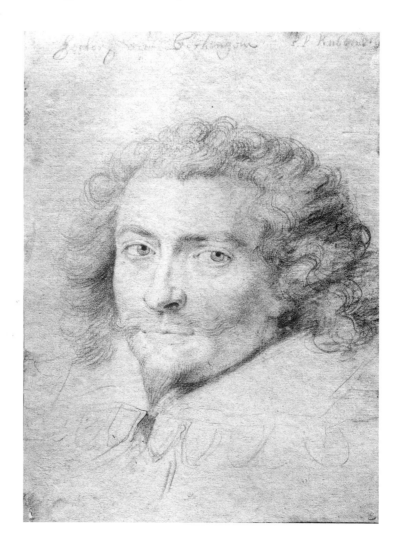

Villiers and Arundel were contrary personalities in every way, and it was inevitable that they would clash and that the high-spirited Buckingham would win. In 1623 Arundel was undone by the unsanctioned marriage of his oldest son to a distant relation of the king; he was heavily fined and, after a brief spell in the Tower, banished to his country estates. The way was now clear for the upstart noble, who had already ingratiated himself with Prince Charles and thus retained his position as favorite after the death of James I in 1625.

Buckingham was more renowned for his impetuosity and bravura than for his judgment and intellect, and his disastrous political maneuvers soon antagonized the nobles and public opinion alike. Charles, however, grew dependent on the duke, who seemed to possess all the qualities he lacked. Thus, when it came to forming the royal collection, it was the model of Buckingham and not of the disgraced Arundel that he followed.

In assembling his collection, Buckingham emphasized speed of acquisition and brilliance of effect. Unlike Arundel, who was steeped in knowledge and imbued with the love of art, Buckingham seems, at least initially, to have regarded collecting as one among other attributes of noble status. Thus, around 1619, when he decided to make a collection he sought an advisor who understood his intentions. His choice fell on a clever, somewhat unsavory character named Balthasar Gerbier (1591–1667) (plate 14), who perfectly interpreted his master's taste.

Gerbier was born in 1591 in Middelburg, Zeeland, the son of Huguenots who had fled France, and came to England in 1616 in the retinue of the Dutch ambassador.[17] Although he had received training as a painter, his true forte was as a connoisseur of pictures. In 1619, he entered Buckingham's household and, as the duke put it, "began to have the keeping of my pictures and other rarities. . . ." Gerbier immediately packed his bags to travel in search of worthy objects and, for the next several years, seems to have lived out of a suitcase.

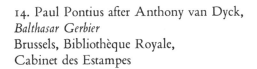

14. Paul Pontius after Anthony van Dyck, *Balthasar Gerbier* Brussels, Bibliothèque Royale, Cabinet des Estampes

By July 1619 he was in Hainaut, in the Spanish Netherlands, inspecting the property of the deceased nobleman Charles de Croy, 4th Duke of Arschot. He was not wanting for competition. Rubens was trying to obtain a copy of the inventory on behalf of Wolfgang William, Duke of Neuburg, and the agents of Arundel and Somerset were also on the scene. Gerbier acted with dispatch and purchased nine paintings by the workshop of Paolo Veronese.[18]

In 1621 Buckingham sent his keeper to Italy on a buying expedition, which proved very fruitful.[19] During his stay in Rome he acquired the *Four Seasons* by Guido Reni (plate 15) and two paintings by Caravaggio's follower Bartolomeo Manfredi. Presumably he also took time to fill in the gaps in his artistic education, although he would have been the last to admit that any existed.

15. Guido Reni, *Four Seasons*
Vienna, Kunsthistorisches Museum

16. Titian, *Ecce Homo*
Vienna, Kunsthistorisches Museum

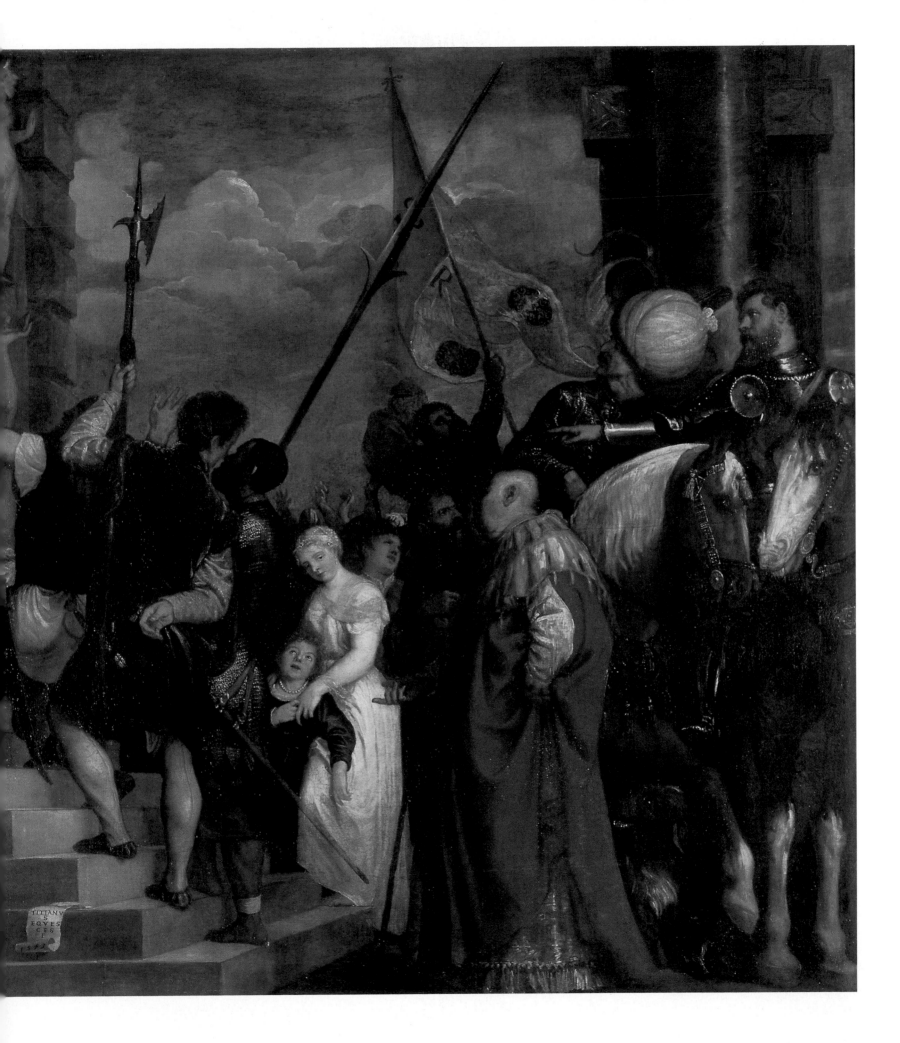

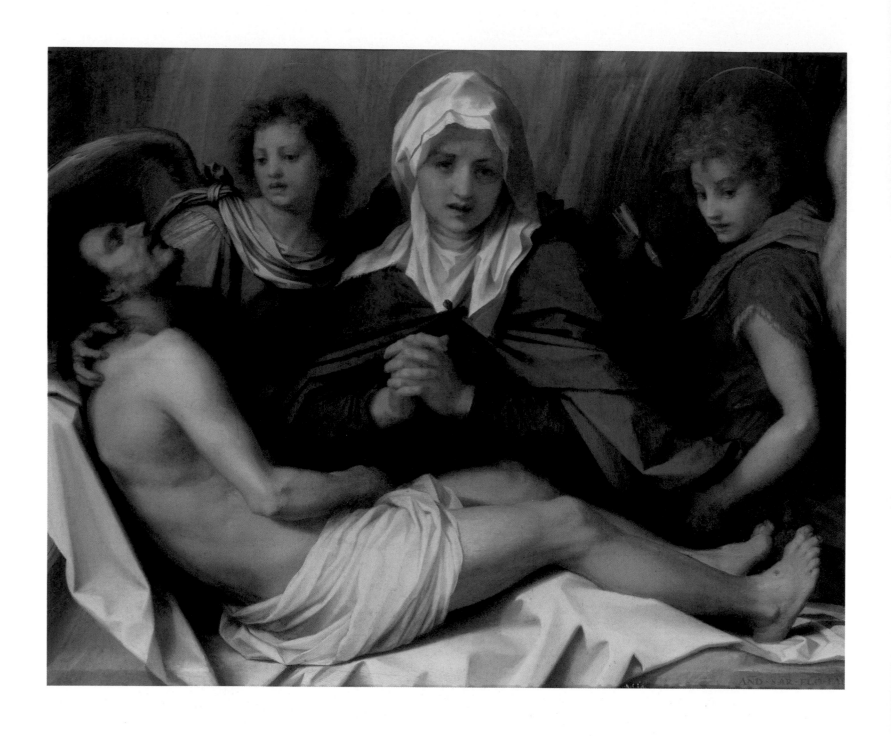

17. Andrea del Sarto, *Pietà*
Vienna, Kunsthistorisches Museum

Venice was another rewarding stop. With the assistance of the ambassador Sir Henry Wotton and the dealer Daniel Nys, he purchased eleven pictures, including one of the jewels of the collection, Titian's *Ecce Homo* (plate 16), which cost the princely sum of £275. Another acquisition was Tintoretto's *Christ and the Woman Taken in Adultery* (Dresden), a relative bargain at £50.

During 1623 Gerbier was a member of the party which accompanied Prince Charles and Buckingham to Madrid, a trip to be discussed shortly. The next year found the enterprising agent in France, where he obtained superb results.[20] His success was abetted by the imminent marriage of Prince Charles and Princess Henrietta Maria, sister of Louis XIII of France, which induced some French collectors to part with important works in order to curry favor at the English court. In a letter dated 17 November 1624 Gerbier provided his employer with a description, written in his typically vivid style, of some of the paintings he had seen: "a picture of our Lady by Raphael, which is repainted by some devil who I trust was hanged"; "the most beautiful piece of Tintoretto, of a Danaë, a naked figure the most beautiful, that flint as cold as ice might fall in love with it"; "a picture by Michael Angelo Buonarotti, but that should be seen kneeling, for it is a Crucifixion with the Virgin and St. John—the most divine thing in the world. I have been such an idolater as to kiss it three times...."[21] The best of the identifiable pictures bought on this occasion were a *Pietà* by Andrea del Sarto (plate 17) and Titian's *Georges d'Armagnac with Guillaume Philandrier* (plate 18).[22]

18. Titian, *Georges d'Armagnac with Guillaume Philandrier*
Alnwick Castle,
Duke of Northumberland

19. Peter Paul Rubens,
Equestrian Portrait of the Duke of Buckingham
Fort Worth, Kimbell Museum of Art

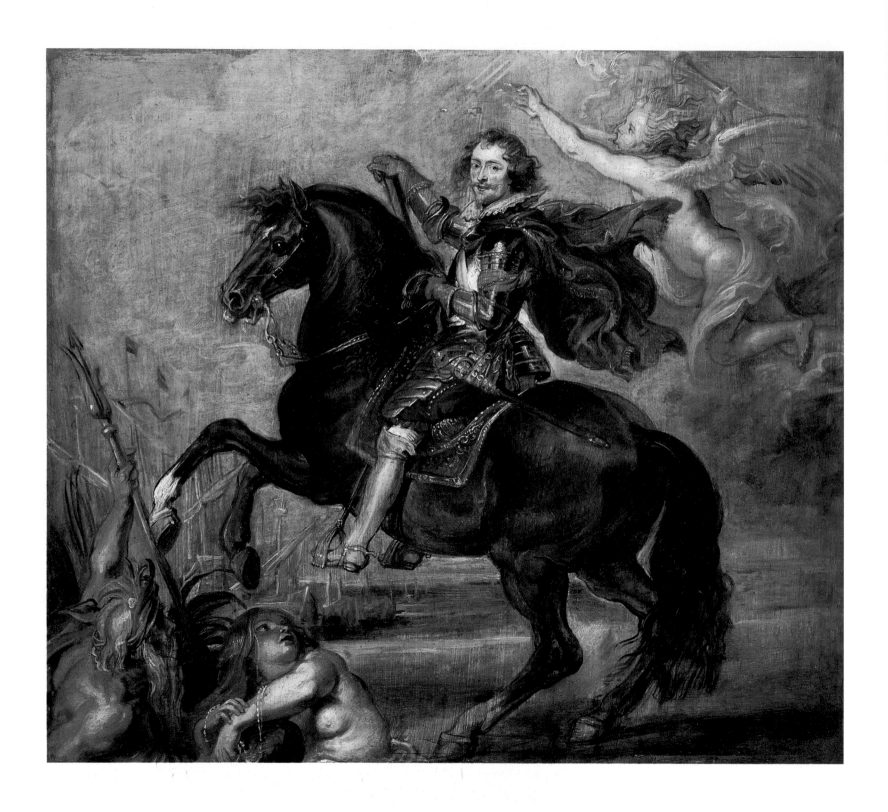

The royal marriage was performed by proxy in Paris on 1 May 1625, and shortly thereafter Buckingham himself arrived to escort the bride to London. By one of the coincidences which are still common in the incestuous world of art collecting, Rubens was then in town, overseeing the installation of the monumental allegories he had painted for Marie de' Medici's residence, the Luxembourg Palace. The duke and the painter made a tour of Fontainebleau; Buckingham was in a foul mood because his request for the *Mona Lisa* (plate 182) had just been refused, but Rubens was able to calm him down. They certainly talked of other things, for Buckingham was to commission two works from the painter—an *Equestrian Portrait* (plate 19) and the *Glorification of the Duke of Buckingham* (plate 20).

20. Peter Paul Rubens,
Glorification of the Duke of Buckingham
London, National Gallery

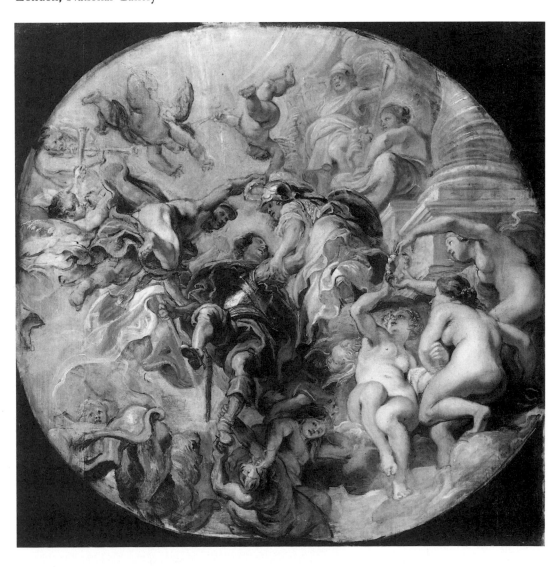

Another subject arose as well, a possible sale of paintings and antiquities by Rubens to Buckingham. The duke's interest in ancient sculpture, unlike that of Arundel, was strictly aesthetic, not antiquarian. As he wrote to an agent in 1626, "Neither am I so fond of antiquity (as you rightly conjecture) to court it in a deformed or misshapen stone, but where you shall meet beauty with antiquity in a statue, I shall not stand upon any cost your judgment shall value it."[23] This preference was no secret to Sir Dudley Carleton, who made a timely gift of a beautiful ancient statue to Buckingham in 1624, just as a position as vice-chamberlain was becoming vacant.[24] As a result, Carleton at last came out of the cold of foreign service to the warmth of a royal appointment. In 1628 he was elevated to the title of Lord Dorchester, and in the few remaining years of his life (he died in 1632) he became an influential advisor to the king on foreign affairs.

It was only after the death of Rubens' first wife, Isabella Brant, in June 1626 that the painter decided to heed Buckingham's offer to buy part of his collection. By the end of the year, the deal had been concluded: Rubens sold the majority of his antiquities and around two dozen of his own paintings in exchange for 84,000 florins. (He invested the proceeds in Antwerp real estate.) The parcel of ancient sculpture included many of the pieces acquired from Sir Dudley Carleton in 1617, which finally found an English home in Buckingham's villa in suburban Chelsea.[25]

The speed with which Buckingham's collection was amassed is impressive; it appears that in five or six years nearly four hundred pictures were brought to York House, the duke's London residence (plate 21), and about a hundred pieces of statuary to Chelsea House. Gerbier, for one, was not above gloating, and in a flowery letter written to his patron in 1625, he extolled the magnitude of their artistic and financial achievement.

Sometimes when I am contemplating the treasure of rarities which Your Excellency has in so short a time amassed, I cannot but feel astonished in the midst of my joy. For out of all the amateurs and princes and kings, there is not one who has collected in forty years as many pictures as Your Excellency has in five. Let enemies and people ignorant of painting say what they will, they cannot deny that pictures are noble ornaments, a delightful amusement and histories that one may read without fatigue. Our pictures, if they were to be sold a century after our death, would sell for good cash, and

21. Wenceslaus Hollar, *York House*
Cambridge, Pepysian Library

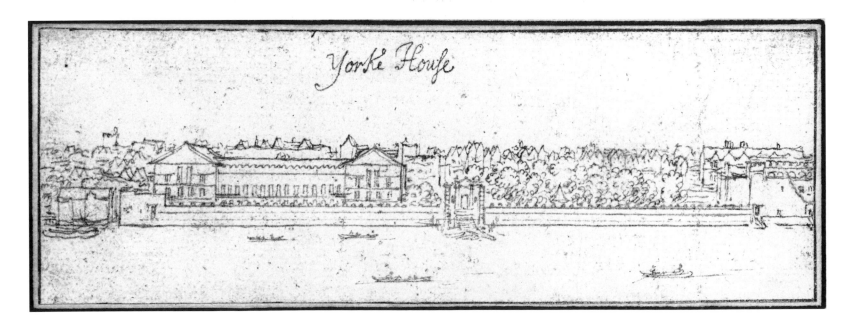

for three times more than they cost. I wish I could live a century, if they were sold, to be able to laugh at these facetious folk who say it is money cast away for baubles and shadows.[26]

Gerbier's pride, unfortunately, preceded Buckingham's fall. On 23 August 1628 the favorite's life was abruptly terminated by a disgruntled lieutenant, who attacked him with a knife while he was in Portsmouth and killed him with a single blow. Thus Buckingham became the first of the early Stuart collectors to meet an untimely and violent end.

The activities of Arundel, who returned to court after Villiers' death, and of Buckingham, not only raised English collecting above its provincial level; they also ignited the passion for collecting in Prince Charles who, with the resources of the crown at his command, would form the most impressive collection of all.[27] To judge from later events, Charles was more inspired by the showy style of Buckingham than by the patient, methodical procedures of Arundel. Like Buckingham, he favored pictures and antique sculpture, although he collected work in other media. However, as early as 1622, Charles' taste for Italian painting was apparent to the sharp-eyed Venetian ambassador who, in his dispatch of 21 September, reported of the prince that "he loves old paintings, especially those of our province and city."[28] This observation is confirmed in a later inventory of the royal collection, which reveals that pictures were given pride of place in St James' and Whitehall.

The history of Charles' collection begins in 1623 or 1624, the year when a list was drafted of "all such pictures as Your Highness hath at present, done by several famous masters' own hands."[29] While the name of owner is not specified (it could be either James I or the prince of Wales), there is ample reason to believe that the reference is to Charles.[30] The striking thing about the list is its brevity; only twenty-one pictures are included, a far cry indeed from the over 1500 owned by the king at his death. More remarkable still, the collection achieved its apogee by 1638 when the king, beset by grave financial and political difficulties, withdrew from the market.

Collections of this size were unprecedented in England; indeed, they were hardly to be found in the 1620s anywhere in Europe. However, just about the time when the first inventory was being drafted, Charles had the opportunity to see what was and would continue to be the greatest picture collection of all, the one belonging to the king of Spain, Philip IV. As every student of Charles has recognized, the prince's visit to Madrid in 1623 was the culminating experience in his education as a collector.

The trip to the Spanish court undertaken by Prince Charles and the duke of Buckingham was regarded from the start as quixotic. Behind it lay the ill-founded notion that a marriage between Charles and the infanta María, sister of Philip IV, would cement an alliance between Protestant England and Catholic Spain and induce Spain to restore the Palatinate, a German territory, to its Protestant ruler, the elector Frederick, the son-in-law of James I. After years of fruitless negotiations, the prince and the favorite decided to break the deadlock by undertaking an incognito dash to Madrid, through which true love would overcome the endless wrangling of diplomats. As they were soon to discover, love conquered all but Spanish obduracy.

22. Anonymous,
Entry of Prince Charles into Madrid
Madrid, Museo Municipal

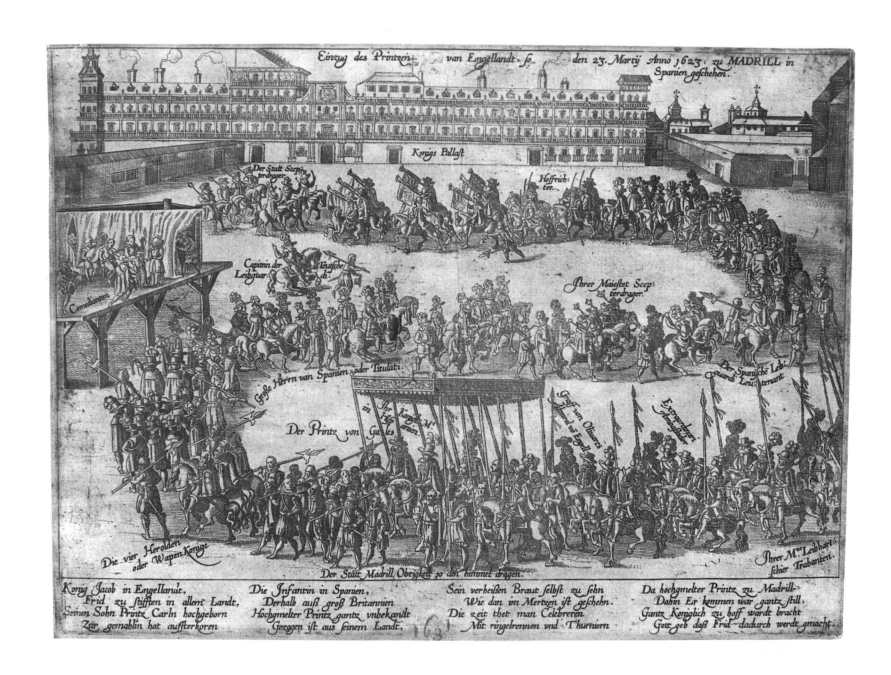

Off they set on 17 February 1623, arriving in Madrid a mere seventeen days later. After waiting over a week for the Spaniards to recover from the surprise of the unexpected royal visitation, they made their ceremonial entrance into town (plate 22), which proved the high point of the trip. The proposed match foundered for obvious reasons—the Spaniards could not compromise on religious questions or contemplate the restoration of the Palatinate.

The political failure was compensated to some extent by the artistic experience. Thanks to earlier visits to Madrid by several members of the court, Charles and Buckingham were aware of the richness of Spanish collections and had arranged for a team of experts to join them. Needless to say, Balthasar Gerbier was among its number. So was Endymion Porter (1587–1649), a future collector and artistic advisor to the king (plate 23).[31] Porter's maternal grandmother was Spanish and, as a youth, he had been a member of the household of Gaspar de Guzmán, the count (later count-duke) of Olivares, now risen to power as the favorite of Philip IV. Also in the party was Toby Mathew, the son of the archbishop of York who, to his father's acute dismay, had converted to Catholicism. Mathew was a seasoned veteran of the international art world; he had made an earlier visit to Madrid in 1609, spent several years in Italy, and worked with Carleton in the Netherlands, where he had bargained long and hard with Rubens.[32] If the motives of the trip were primarily political, artistic concerns came a close second.

Confronted with this formidable team of advisors, the Spaniards organized a junta of dignitaries from the Council of State to guide the Englishmen through the local collections.[33] Charles made purchases as he went, including Titian's *Woman in a Fur Wrap* (plate 24).

23. Anthony van Dyck,
Endymion Porter and Anthony van Dyck
Madrid, Museo del Prado

24. Titian, *Woman in Fur Wrap*
Vienna, Kunsthistorisches Museum

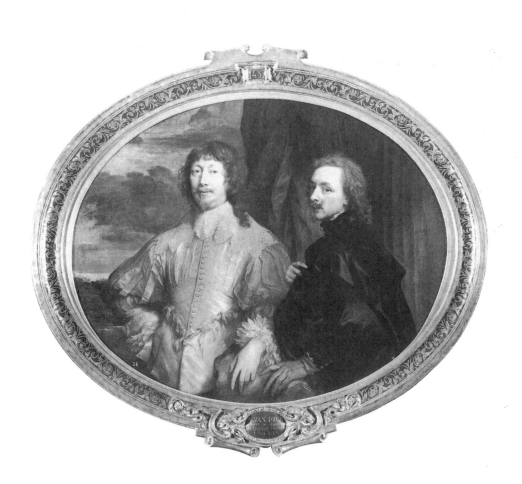

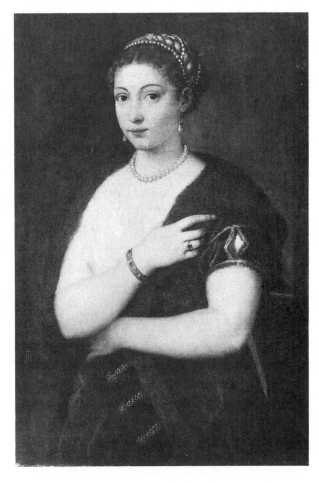

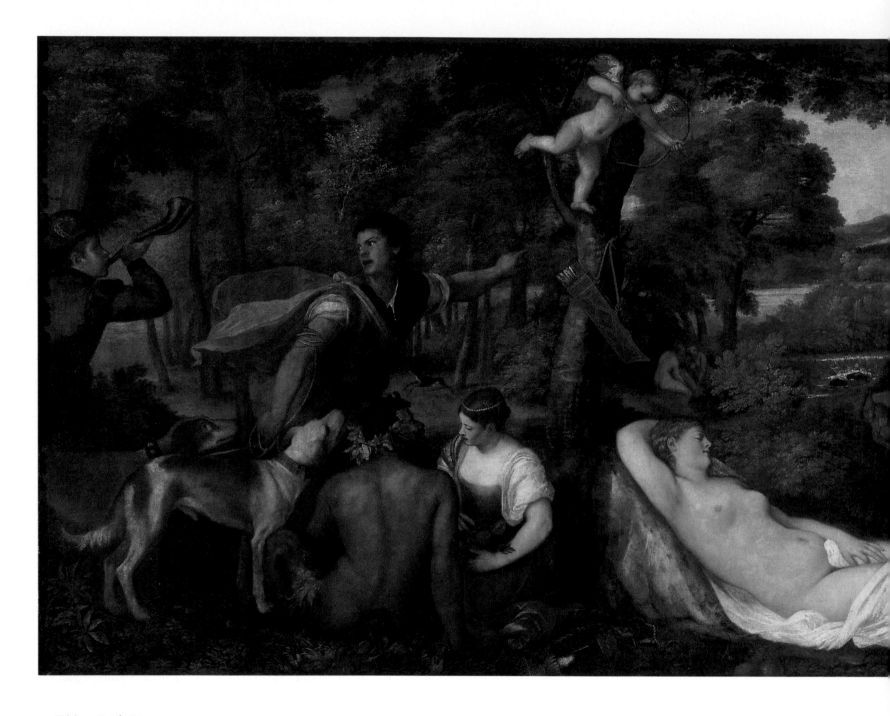

25. Titian, *Pardo Venus*
Paris, Musée du Louvre

26. Titian, *Charles I with a Hound*
Madrid, Museo del Prado

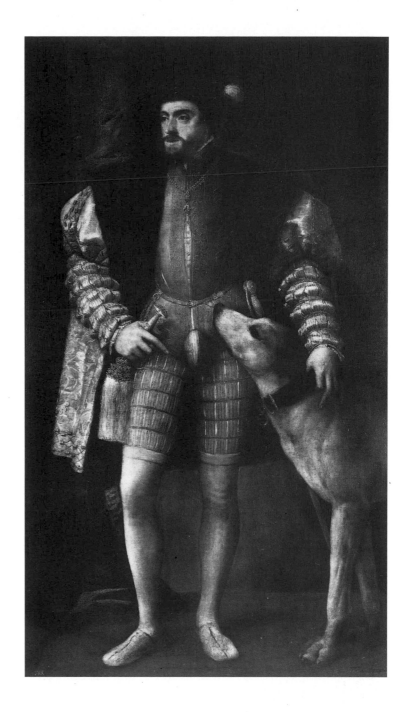

However, his best acquisitions were gifts from the king—Titian's *Pardo Venus* (plate 25) and *Charles V with a Hound* (plate 26). These are important pictures, but Philip could spare them. He had inherited the largest group of works by Titian ever owned by a single individual which, however, were only part of a collection then numbering over two thousand pictures. On the return trip, the royal party stopped in Valladolid, and Charles was given another important picture, Veronese's *Mars and Venus* (plate 27), and a great work of sculpture, Giambologna's *Samson Slaying the Philistine* (plate 28), which had formerly belonged to the duke of Lerma.

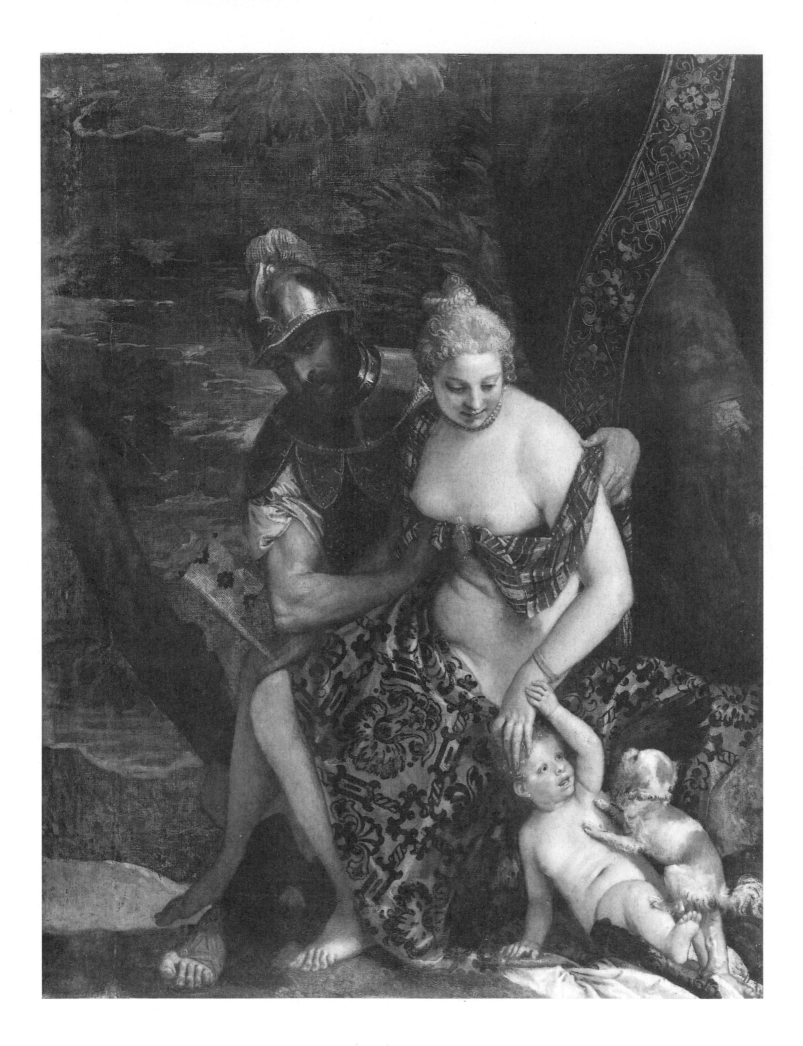

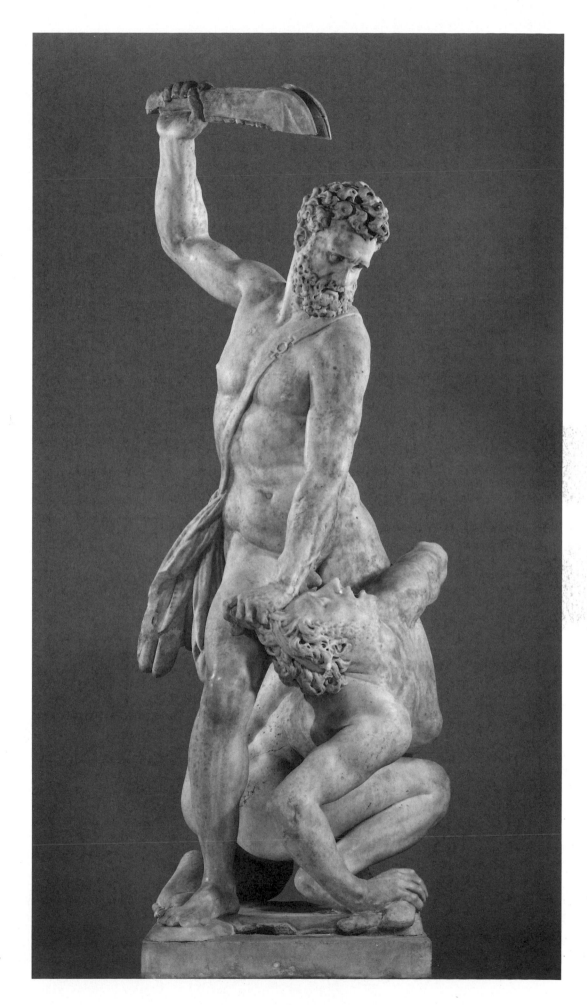

27. Paolo Veronese, *Mars and Venus*
Edinburgh, National Gallery of Scotland

28. Giambologna, *Samson Slaying the Philistine*
London, Victoria and Albert Museum

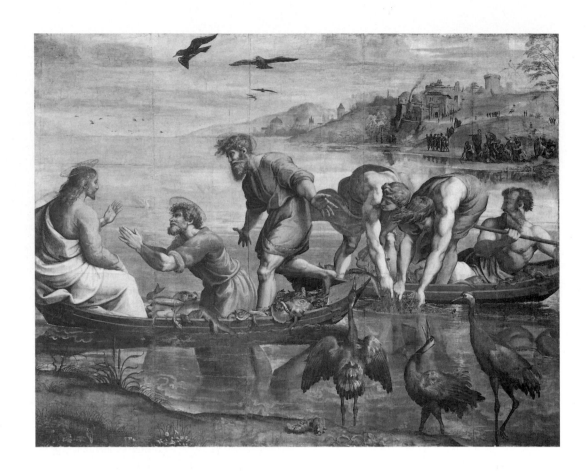

29. Raphael, *The Miraculous Draught of Fishes*
London, Victoria and Albert Museum

During the reign of Philip IV the Spanish royal collection would more than double in size. Even in 1623 it was an inspiration and a challenge to Prince Charles, and he made a valiant effort to equal it. His first major acquisition, and one of his best, was initiated even before he went to Spain. This was the series of ten cartoons made by Raphael for the tapestries depicting the Acts of the Apostles destined for the Sistine Chapel (plate 29).[34] On 28 March 1623 Charles, writing from Madrid, ordered that about £700 be sent to Genoa, where seven of the cartoons had come to rest.

Charles' next fishing expedition in Italian waters provided the greatest catch of all. In 1623 Lady Arundel had visited Mantua where, over the course of the sixteenth century, the ruling family, the Gonzaga, had built up one of the best collections of paintings and antiquities in Italy. (Rubens had been keeper of the collection from 1600 to 1608.) During her visit she was apparently told that some of the collection might be offered for sale to relieve the financial difficulties of Duke Ferdinando Gonzaga.[35] This was an opportunity almost too good to be true. The Gonzaga had been patrons of Andrea Mantegna, Giulio Romano, Correggio and Titian. With a single stroke, Charles could overtake Arundel and Buckingham and possess some of the finest pictures in England.

In 1625, the year he succeeded to the throne, Charles sent an agent to Italy to negotiate the purchase in the person of Nicholas Lanier, the royal master of music and an amateur painter (plate 30). Lanier went to Venice and engaged the services of Daniel Nys, the purveyor of pictures and antiquities to Sir Dudley Carleton. As the sale unfolded, Nys did little to enhance the reputation of his trade.

30. Anthony van Dyck, *Nicholas Lanier*
Vienna, Kunsthistorisches Museum

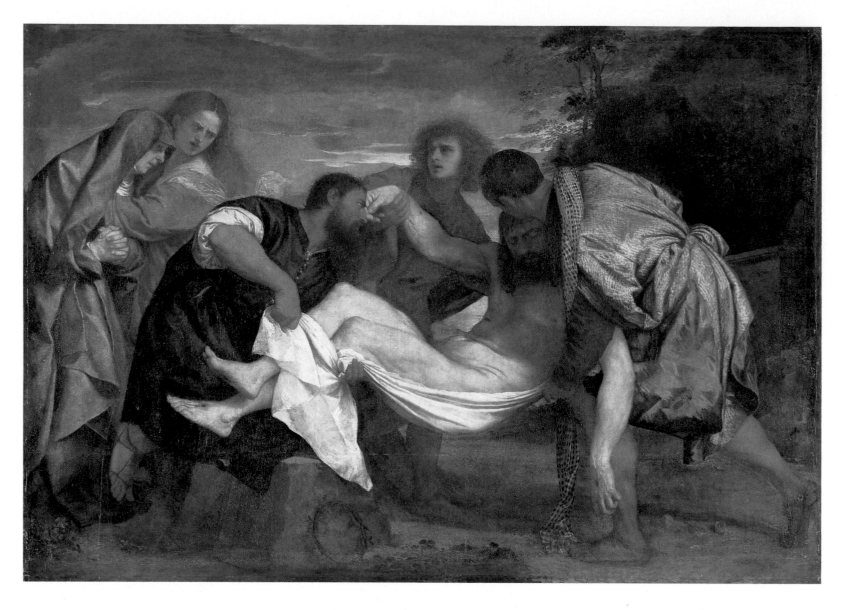

31. Titian, *Entombment*
Paris, Musée du Louvre

Lanier traveled to Mantua to view the collection and, by the spring of 1626, was back in London with his report. Obviously it was favorable, but just at this moment Duke Ferdinando died. Fortunately for the English, he was succeeded by Vincenzo Gonzaga, who was fonder of parrots and dwarves than of works of art. Lanier returned to Italy, and in April 1627 Nys went to Mantua and closed the deal. By September the pictures and sculpture were in the dealer's house on the island of Murano. For the price of roughly £16,000, Charles had acquired such magnificent paintings as these: Titian's *Entombment* (plate 31), Raphael's *Holy Family, La Perla* ("The Pearl") (plate 58), Correggio's *Venus with Satyr and Cupid* (plate 59) and *Education of Cupid* (plate 72), Mantegna's *Death of the Virgin* (plate 32), Guido Reni's *Four Labors of Hercules* (plates 63–6) and Caravaggio's *Death of the Virgin* (plate 67).

32. Andrea Mantegna, *Death of the Virgin*
Madrid, Museo del Prado

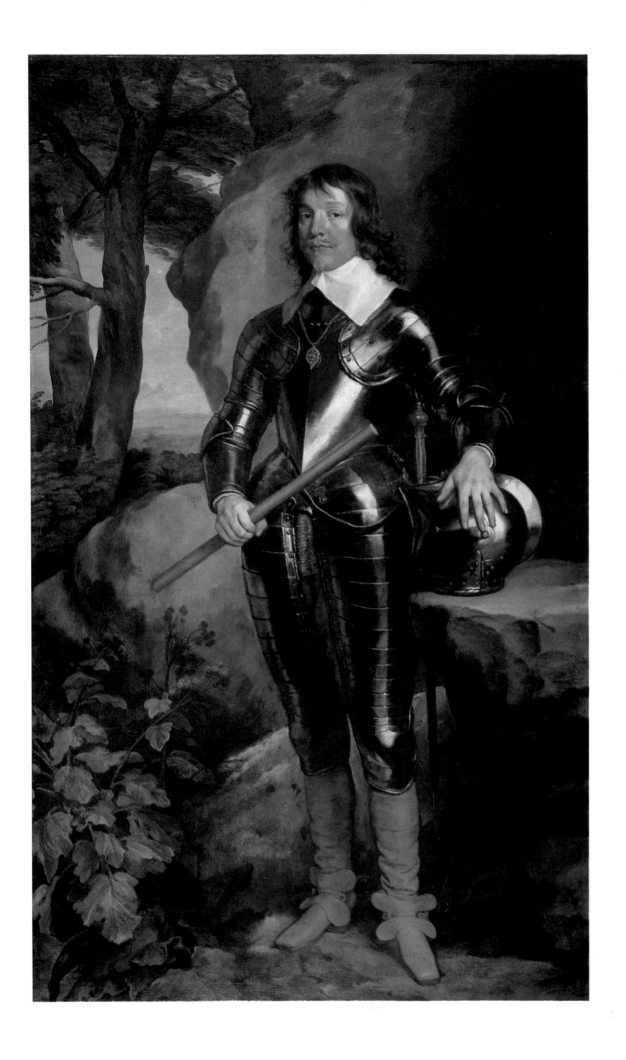

If Charles I added little to his collection in the 1630s, Lord Arundel's rate of acquisition was unabated. His Italian agent, the redoubtable William Petty, was dispatched to Italy in 1633, and during the succeeding five years cut a wide swath through the collections, snapping up paintings, antiquities and drawings with unerring taste. According to a rival, Petty cornered the market by using unscrupulous tactics.

So if he [Arundel] likes any of them [pictures], he gives directions to Petty to make great and large offers to raise their price, by which means the buyers are forced to leave them and the pictures remain with their owners, he well knowing that no Englishman stayeth long in Italy. So consequents the pictures must fall into his hands at his own price; Petty being always upon the place and provided with monies for that end. . . .[40]

For all his wily ways, however, Petty was not invincible and, despite extraordinary efforts, lost out in the competition for a collection scarcely less important than that of the Gonzaga. In July 1634 Charles I instructed Petty to go to Venice to purchase "an excellent collection of paintings" belonging to Bartolomeo della Nave, a merchant.[41] The king proposed to enter into a syndicate with three unnamed collectors, who would make their choices in a rotation to be determined initially by a throw of the dice.

For some reason this cooperative approach disintegrated and, later in the following year, Petty, acting for Arundel, entered into a three-way competition with the Spanish ambassador and Basil, Viscount Feilding, who was bidding for his brother-in-law, James, Marquis (and, from 1643, Duke) of Hamilton (plate 37). Hamilton (1609–49) belonged to the leading family of Scottish nobility, the head of which stood in direct line of succession to the throne of Scotland.[42] His father, James, the second marquis of Hamilton, had gone to London in 1617, and become a member of the Privy Council. When he died prematurely in 1625, the younger James assumed the title.

The third marquis was then and always an uneasy member of the inner circle of the court. In 1622 he had entered into an arranged marriage with Buckingham's niece, Mary Feilding, then only nine years old, whom he disliked almost as much as he did her uncle. By 1626 the rivalry with Buckingham had become intolerable, and Hamilton withdrew to his Scottish estates, returning to London only after the duke's assassination two years later.

With Buckingham out of the way, Hamilton began his rise at court, commencing in 1628 with his appointment as Master of the Horse (an appointment reputedly made on condition that he consummate his marriage). In 1631 he left for the continent, and for fifteen months fought with the armies of Gustavus Adolphus, although without great distinction. Once back in London, the marquis acquired more offices and cemented his relationship with the king. Inevitably, his position involved him in picture collecting.

Prior to 1636, Hamilton is not known to have been a collector, although his father had gathered a respectable group of Venetian pictures.[43] As a matter of fact, Hamilton himself had participated in that formative "seminar" held in the Spanish royal collection in 1623. None of these precedents, however, suggests that Hamilton would become the owner of a formidable group of paintings.

37. Anthony van Dyck,
James, Duke of Hamilton
Vaduz, Liechtenstein Collection

Hamilton's sudden dedication to pictures is explained partly by his political maneuvers. The marquis' relationship with the king was founded on personal ties and on Charles' conviction that he could be useful in dealing with the Scots, whose religious quarrel with the government was growing ever hotter. However, Hamilton also yearned for political power, as opposed to personal influence, and like other courtiers and government officials, hoped to advance his position with the king by showing an interest in pictures.

Beginning in early 1636, Hamilton commenced a correspondence with Feilding, which extended until 22 September 1638. At issue was the acquisition of the della Nave collection and two others, the first belonging to the Procurator Michiel Priuli, the second to the Flemish painter and dealer Nicolas Regnier (c. 1590–1667), who had settled in Venice and was speculating in pictures. This exchange of letters comprises one of the most detailed records of an art transaction in the seventeenth century yet discovered.[44]

Hamilton, it must be said, was an ambivalent collector, perhaps because, at least at first, he was motivated by a desire to please the king, who wanted the pictures brought to London. At other times, however, he writes with the enthusiasm of a dedicated collector. But on one point he never wavers, and this is his desire to beat Arundel and Petty.

All started smoothly for the partnership of Hamilton and Feilding. Eighteen pictures from the stock of Regnier were acquired in April 1637 and sent to London.[45] In May, Feilding noted that della Nave's collection was now on offer for 20,000 ducats. He soon sent a list of the contents which, while exciting the interest of the king, left Hamilton largely indifferent—"not that I care so much for the pictures," he wrote on 4 August 1637, "but His Majesty has seen the note and made a bargain with me for them, and I obliged myself to bring them here for which he has advanced me some part of that money."[46]

By then the Spanish ambassador had made an offer of 14,000 ducats and William Petty had arrived on the scene, although Feilding pugnaciously assured Hamilton that "Mr Petty shall not take them out of my hands for my Lord of Arundel." Feilding and Petty went to view the collection on 7 September, and Petty allowed that it might indeed be worth the 14,000 ducats offered by Spain, which seemed to imply that he, too, would be willing to pay that amount.[47] "Beware Master Petty," Hamilton had cautioned from London, and these were wise words. Feilding bought the della Nave collection for 15,000 ducats (about £2500) and then in December discovered that Petty, up to his old tricks, had contrived to bid up the price in return for a payoff consisting of two bronze statuettes and a portrait attributed to both Correggio and Leonardo.[48]

As if this were not competition enough, the two agents were simultaneously bidding for the important collection of Procurator Michiel Priuli. Feilding triumphed again and reveled in Petty's obvious disappointment when he heard the news. "I was no less pleased this morning at the disorder he was in at my telling him of my agreeing likewise with Procurator Priuli for his pictures. . . ."[49] However, Petty was not always thwarted; Titian's *Flaying of Marsyas* (plate 38) was one of the trophies he captured and sent to London.

38. Titian, *Slaying of Marsyas*
Kroměřiž, Statnzamek

39. Giorgione or Follower,
Adoration of the Shepherds
Vienna, Kunsthistorisches Museum

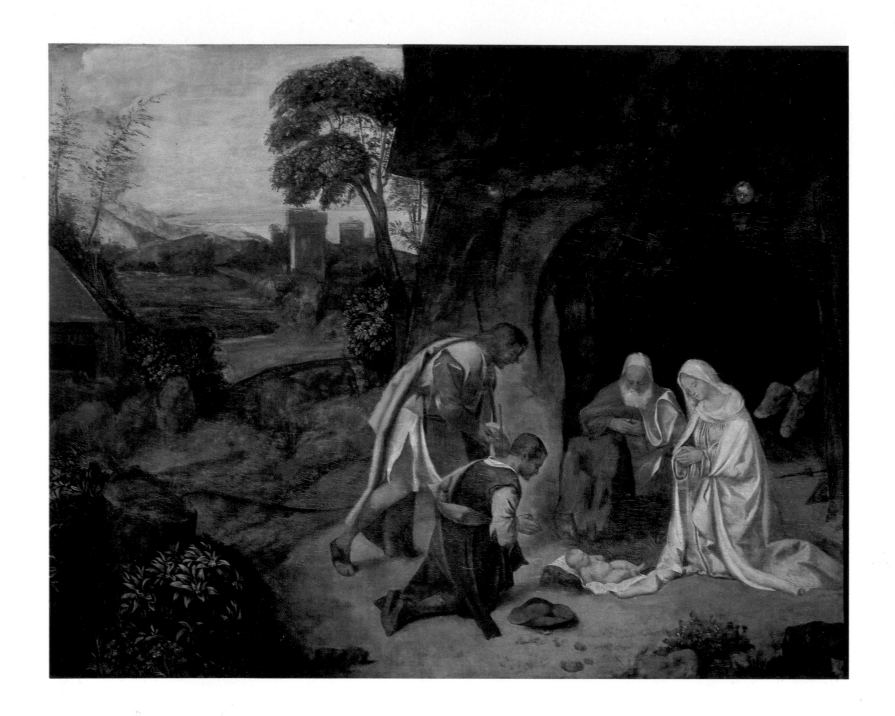

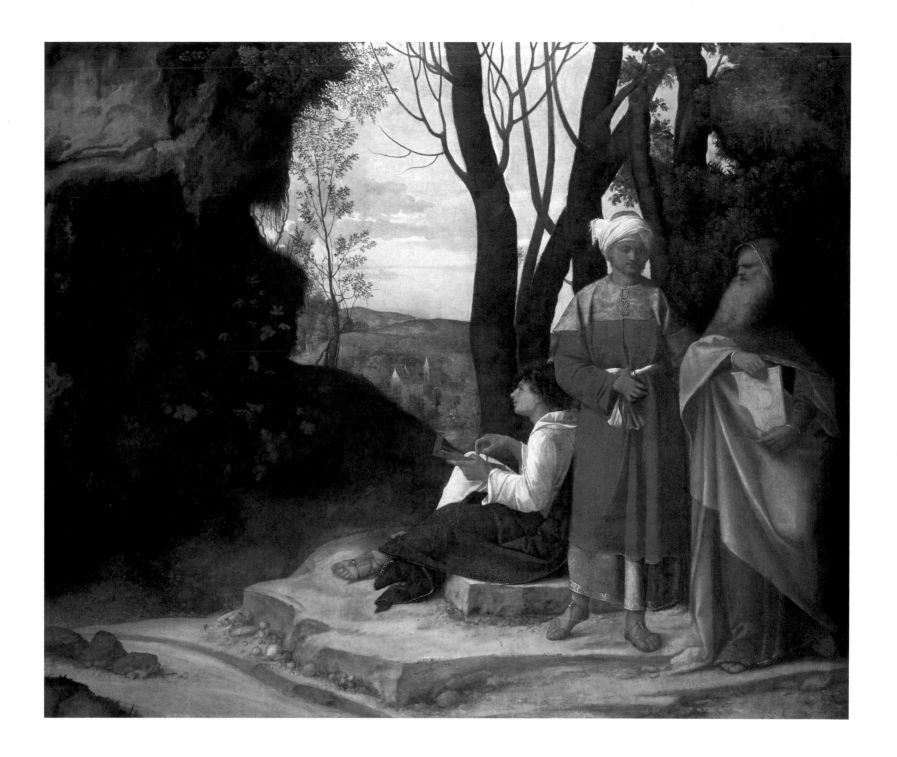

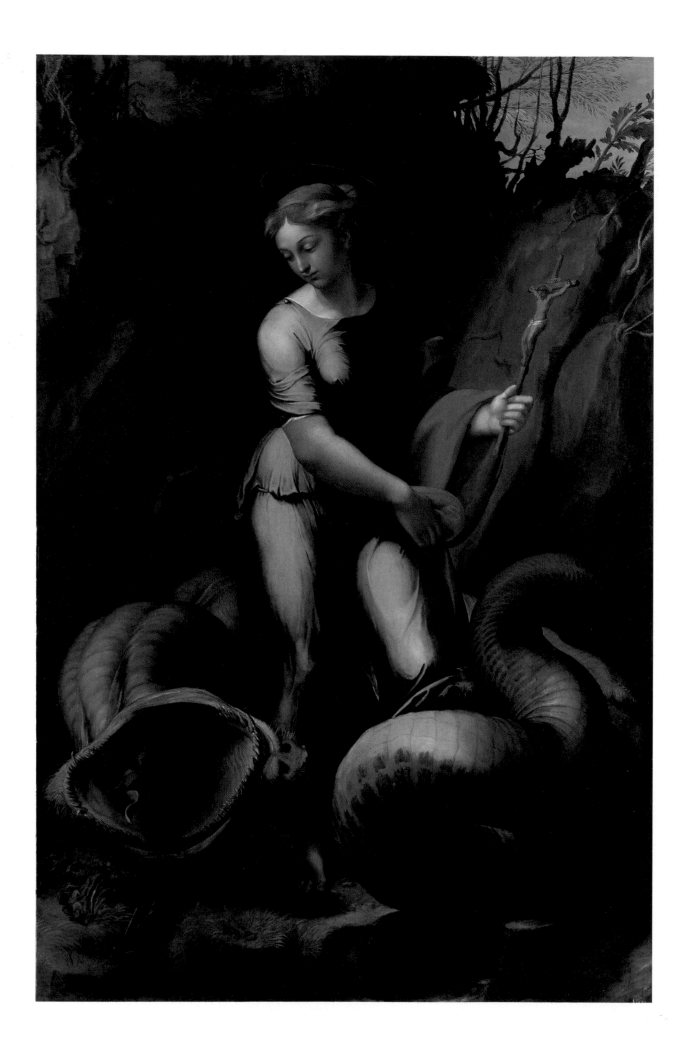

The collection bought from Nicolas Regnier was considerably smaller, comprising some thirty-two works, many of which were by contemporaries such as Guido Reni, Giovanni Lanfranco, Guercino and Poussin.[51] As for the twelve or so paintings from Procurator Priuli, the jewel was a *St Margaret* (plate 44), then attributed to Raphael but now thought to involve the collaboration of his assistant Giulio Romano. This picture was ardently desired by Arundel, but was captured by Feilding early in 1638, and just in time. On 9 February 1638 he reported to Hamilton that "the good old Procurator Priuli, who lately sold your lordship the *St Margaret* by Raphael, entangling his foot in his gown, fell down a pair of stairs, and is since dead; which has moved the *broglio* [scheming crowd] at St. Mark's to say that it was impossible he should live, after he parted with his saint. . . ."[52]

The spectacular growth of Hamilton's collection—by early 1643 it numbered six hundred items[53]—serves to demonstrate how picture collecting had come to be regarded as an essential activity by those who wished to maintain the favor of the monarch. As a matter of fact, most of Hamilton's collection had been made between 1636 and 1638, when he left London to treat with the restive Scottish Covenanters. In the following year he participated in the military action against the Scots that was the harbinger of civil war and that may be taken as the moment when the short, great period of early Stuart collecting came to a close. Hundreds of fine pictures and statues had been accumulated by the Whitehall Group in little more than two decades. With the start of war in 1642 the owners fled from London, some of them fighting for the crown, others seeking refuge on the continent. The art collections which had once graced the royal palaces and the noble houses on the Strand were about to be dispersed in just a fraction of the time it had taken to assemble them.

44. Raphael, *St Margaret*
Vienna, Kunsthistorisches Museum

While the French ambassador dithered over the Arundel collection, his great rival in the English art market, Alonso de Cárdenas, ambassador of Spain, went to work. On 19 January 1654 he had provided his patron, Luis de Haro, principal minister of Philip IV, with a list of the collection, and in June was looking for a qualified painter to send to Holland to inspect it.[15] This unnamed individual went to Amsterdam and, in three months, acquired twenty-six works, almost all by Venetian painters.[16] Although many are attributed to Titian (four), Veronese (eight) and Palma il Vecchio (three), very few can now be identified. Veronese's *Christ and the Centurion* (plate 48) is the most important of these.

48. Paolo Veronese, *Christ and the Centurion*
Madrid, Museo del Prado

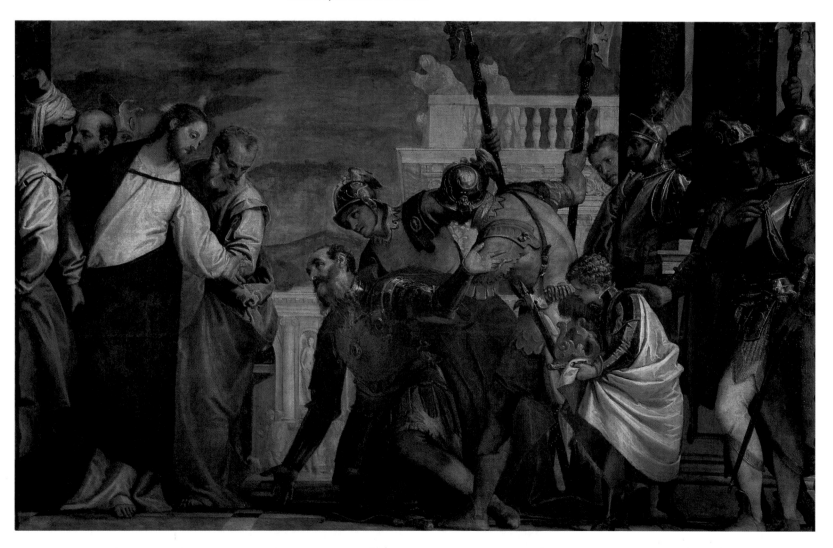

Another beneficiary of the Arundel's plight was Everhard Jabach, who was now coming into his own as a collector. Jabach had almost certainly met Lord Arundel in 1636 during the earl's diplomatic mission to Germany and must have visited Arundel House in 1637 during a stay in London, where the family bank had a branch. In the following year he settled permanently in Paris, where he prospered and became one of the most prolific collectors of the seventeenth century.

His acquisitions from the Arundel collection were made in Utrecht in 1662, in one of the several rump sales by which the collection was depleted. Connoisseur that he was, Jabach focused on the most famous group of pictures accumulated by Lord Arundel, the portraits by Holbein the Younger.[17] The Louvre now possesses four Holbein portraits which were owned successively by Arundel and Jabach, who sold them to Louis XIV in 1671. They include *William Warham, Archbishop of Canterbury*; *Nicholas Kratzer*; *Anne of Cleves* and *Sir Henry Wyatt* (plates 49–52). In addition to the portraits, Jabach bought another of the Arundel masterpieces, Titian's *Concert Champêtre* (plate 53).

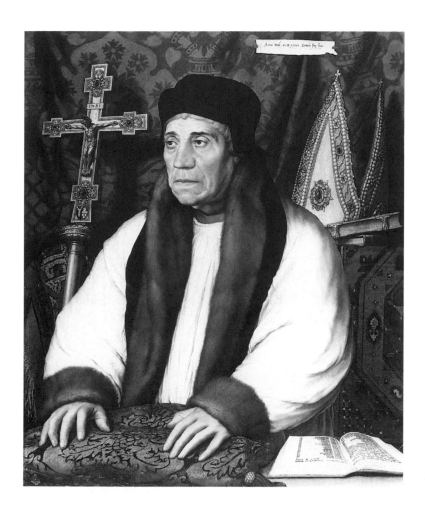

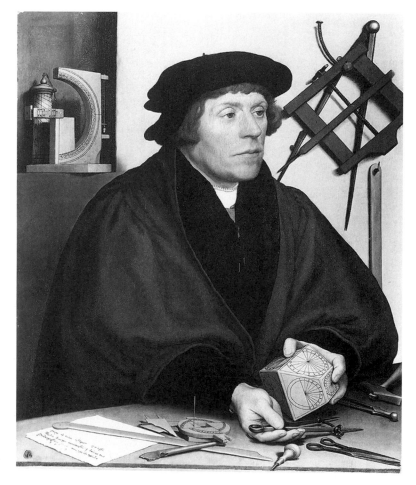

49. Hans Holbein the Younger,
William Warham, Archbishop of Canterbury
Paris, Musée du Louvre

50. Hans Holbein the Younger,
Nicholas Kratzer
Paris, Musée de Louvre

51. Hans Holbein the Younger,
Anne of Cleves
Paris, Musée du Louvre

52. Hans Holbein the Younger,
Sir Henry Wyatt
Paris, Musée du Louvre

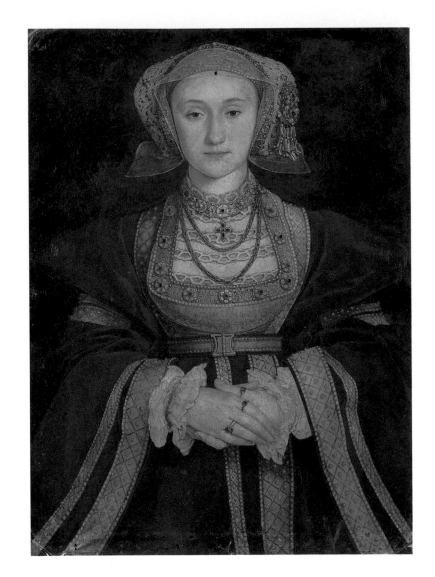

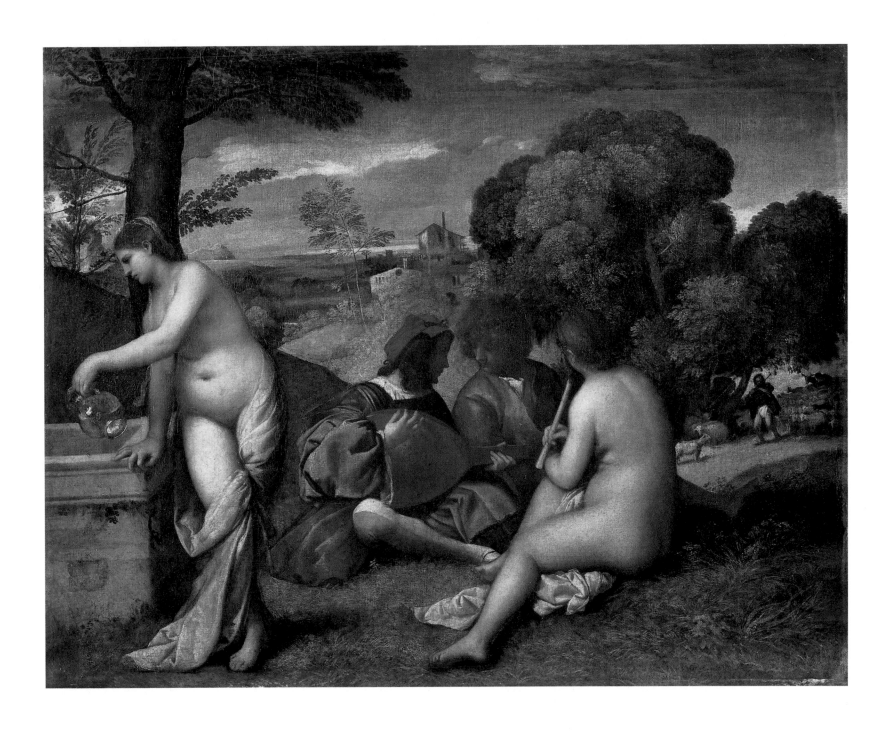

The final documented purchase of note was made by two speculators, the brothers Frans and Bernhard von Imstenraedt, nephews of Jabach.[18] Perhaps inspired, if not advised, by their uncle, the brothers bought several pictures from Viscount Stafford. Among these were two important works by Holbein, the *Triumph of Wealth* and the *Triumph of Poverty* (both destroyed), which had belonged to Prince Henry, four works by Titian and a *St Sebastian* (Dresden) by Antonello da Messina.

In 1667 the brothers decided to cash in and offered the pictures to Emperor Leopold I in Vienna, accompanied by a sales brochure written in limping Latin and extolling the virtues of owning pictures, particularly these pictures. The emperor was not persuaded; he found the prices too high in relation to the promised glory. Thereupon the brothers decided to follow an unusual course of action, which was to offer the paintings in a lottery. Again they failed; apparently the smart money had other bets to make and did not buy the tickets. Finally in 1670 Franz and Bernhard found a buyer, although at a greatly reduced price, Carl von Liechtenstein, bishop of Olmütz, who divided the works between his residences in Olmütz and Kremsier in Moravia. All but a few have disappeared; among the survivors are Antonello da Messina's *St Sebastian* and Titian's *Flaying of Marsyas* (plate 38), now recognized as a masterpiece of the painter's last years. The brothers von Imstenraedt had set out to make a killing in the art market, but in the end they too were skinned alive.

Over the ensuing decades, the remains of the Arundel collection trickled away. Auctions of works took place in Amsterdam in 1684, 1686 and 1687, and more were sold in London in 1686 and again in the 1720s. In these circumstances, it seems fair to say that we shall always be denied full knowledge of the fate of this distinguished collection.

Such is not the case for the collection of Charles I. As an official act of the government, the sale generated a trail of bureaucratic paper which has been known, if imperfectly, since the eighteenth century and which has been more thoroughly published in recent years.[19] Information about the after-market could usefully be augmented, but enough is available to permit us to follow the course of the sale of the century in some detail.

The wheels were set into motion by a resolution of Parliament on 23 March 1649, that the personal estates of the late king, the queen and the prince of Wales (future Charles II) be sold, with the proceeds to be used by the Commonwealth for the payment of debts to the former royal servants. From the Parliamentarians' point of view there was an undeniable logic to this solution; the possessions of the hated monarchy would be liquidated to satisfy its obligations, without incurring public expense. From our vantage-point it was an act of incomparable folly. In any case, this resolution was enacted on 4 July, and provided for the appointment of nine trustees to compile an inventory of goods in the several royal houses, to value them and to place them on sale. Properties up to the amount of £10,000 were reserved for the Council of State, but otherwise all was to be on offer. The sale was to take place in Somerset House (plate 54), a palace on the Strand used by the queen, and was to be conducted by a group of six men, known as the contractors, who were responsible for its orderly conduct. During the summer and early autumn, the trustees worked feverishly to compile the inventories, and in October they opened for business.

As it transpired, business was not at all brisk. Times were bad, money was short and people were uneasy about acquiring the property of the late king, who in certain quarters was already being elevated to the status of a martyr. Also the Parliamentarians had either executed or driven into exile many of the avid collectors. Foreign buyers were invited to participate, but this was not always practical. Neither was it acceptable for other rulers to endorse in public the murder by his subjects of a brother monarch, especially when it meant making payments to those who had done the dirty deed. Most of those who stepped up to buy were supporters of Parliament and speculators, all hoping to turn a quick profit.

54. John Thorpe, *Somerset House*
London, Soane Museum

The most prominent of the Parliamentarians was Colonel John Hutchinson, who had been a member of the tribunal which pronounced sentence on the king. He spent £1349 to acquire, among other works, Titian's *Pardo Venus* (plate 25), which cost £600, and *Venus with Organ Player* (plate 55), which cost £165. Colonel William Webb was another Parliamentary officer who decided to play the market. Rather perversely, he bought a number of van Dyck's portraits of the royal family (plate 56) as well as paintings by Italian masters including *Tarquin and Lucretia*, then ascribed to Titian (plate 57).

Active as always in the dealings were painters, who habitually sought to parlay their expertise into a little extra cash. Remigius van Leemput (1607–1675), an assistant of van Dyck, nibbled at the lower end of the market, making numerous purchases in the sub-£40 range. A colleague, Jan Baptist Gaspars (or Jaspers, *c.* 1620–91), a Flemish painter who had settled in London, seems to have had more cash at his disposal; he paid £1073 for fifty-five pictures.

The risks assumed by these buyers, who mostly paid the evaluated price, were considerable, because there were not many true collectors, or agents of true collectors, in sight. However, lurking just off stage, discreetly hidden from view for the moment, were some well-heeled customers from abroad. The most important of these was the Spanish ambassador, Alonso de Cárdenas.

55. Titian, *Venus with Organ Player*
Madrid, Museo del Prado

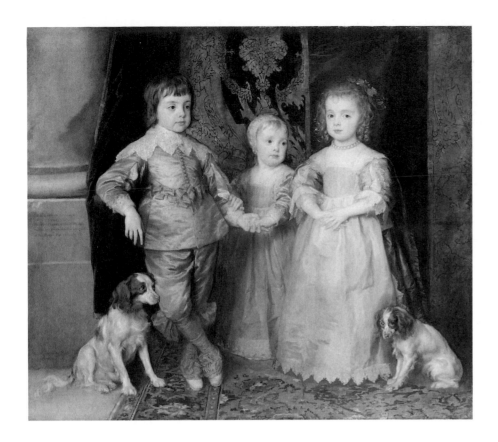

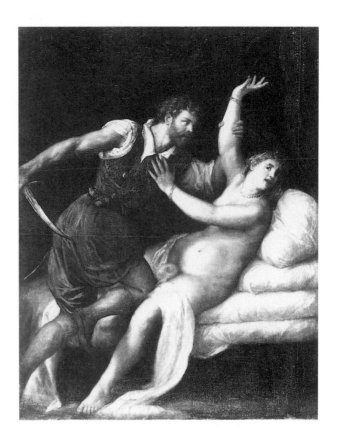

56. Anthony van Dyck, *Children of Charles I*
Windsor, Royal Collection

57. Workshop of Titian, *Tarquin and Lucretia*
Bordeaux, Musée des Beaux-Arts

Cárdenas had come to London in 1635 as resident agent and been promoted to the rank of ambassador in July 1640. In the opinion of Charles I, never the keenest judge of people, he was a "silly, ignorant, odd fellow."[20] This apparently hapless gentleman proved to be the most aggressive, successful purchaser of Charles' prize possessions. As early as 1645 Cárdenas had informed Philip IV that the Parliamentarians were preparing to sell paintings from the collection of Buckingham and advised that "the same would be done with those of the king." Philip immediately ordered the ambassador to find paintings "which might be originals by Titian, Veronese or other old paintings of distinction."[21] Cárdenas was told to accomplish these acquisitions without revealing the name of the purchaser. This requirement was unrealistic in the extreme, but it does explain why the ambassador almost never bought anything directly from Somerset House and dealt mostly on the secondary market.

Contrary to what was believed at the time, Cárdenas was bankrolled not by the king, who put up only a small amount of money, but by the royal minister, Luis de Haro. While it is true that Haro presented many of the best pictures to his monarch, he kept the majority for himself. Soon after the start of the sale, the ambassador went to Somerset House to inspect the wares (which were displayed in great disorder) and, with the consultation of some painters, compiled a list of the most desirable works. This memorandum, probably drafted in December 1649, was annotated by Cárdenas and sent to Madrid for Haro to make his choices.[22] It is a document certain to bring tears to the eyes of every English citizen who loves the art of painting.

The memorandum lists sixty works then on view at Somerset House, Hampton Court and St James'. The entries give the dimensions, the subject and the price, and in the margin is a brief evaluation of quality and, where called for, condition. A few examples will indicate how an art agent advised his patron and also something of the prevailing canons and vocabulary of taste.

The most valuable painting was Raphael's *Holy Family (La Perla)* (plate 58), so-called because it was considered the pearl of the royal collection. It had been valued originally at £3000, but was now marked down to £2500. In the ambassador's opinion, the price was still too high. "The painting is well done, but so expensive that no one talks [of buying] it." Correggio's *Venus with Satyr and Cupid* (plate 59), valued at £1000, was admired but somewhat troubling to Spanish eyes because of the subject. "This painting is well done and, although it is very profane, is much esteemed."

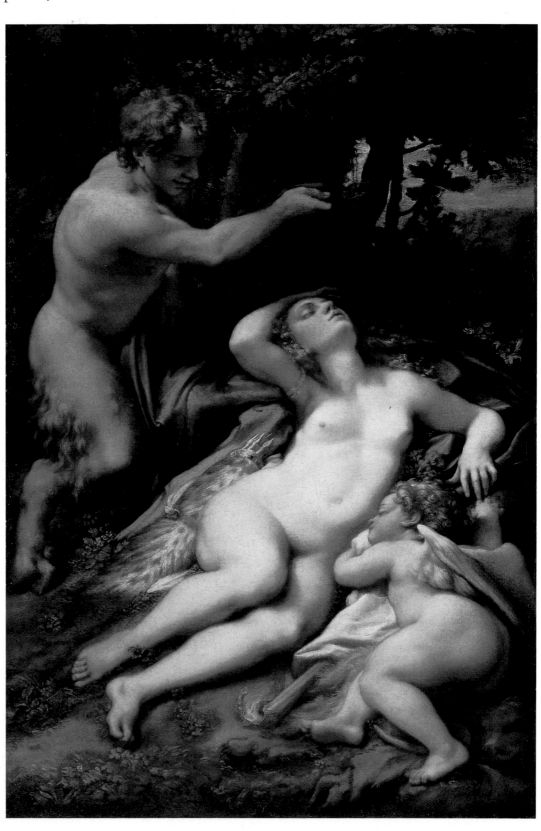

58. Raphael, *Holy Family, "La Perla"*
Madrid, Museo del Prado

59. Correggio, *Venus with Satyr and Cupid*
Paris, Musée du Louvre

Paintings by Titian, who had been generously patronized by Charles V and Philip II and was regarded in Spain as the greatest of all painters, were much desired by Cárdenas, although he was by no means uncritical. The *Adlocution of the Marquis del Vasto* (plate 60), valued at £400, was observed to be damaged. "They say that the painting would be worth £1000 if it were not worn in many parts." *St Peter Enthroned with Alexander VI and Jacopo Pesaro* (plate 61), estimated at £250, presented aesthetic problems. "This painting is melancholy and dark and not a painting of taste." This judgment may seem unduly harsh, but the ambassador was making some useful distinctions, as seen by his remarks on two paintings by Titian, *Christ at Emmaus* (plate 62) and the *Entombment* (plate 31), valued at £600 apiece, which he rightly considered to be better. "This painting and the one that follows are pieces of great esteem and well done."

60. Titian, *Adlocution of the Marquis del Vasto*
Madrid, Museo del Prado

61. Titian, *St Peter Enthroned with Alexander VI
and Jacopo Pesaro*
Antwerp, Koninklijk Museum voor
Schone Kunsten

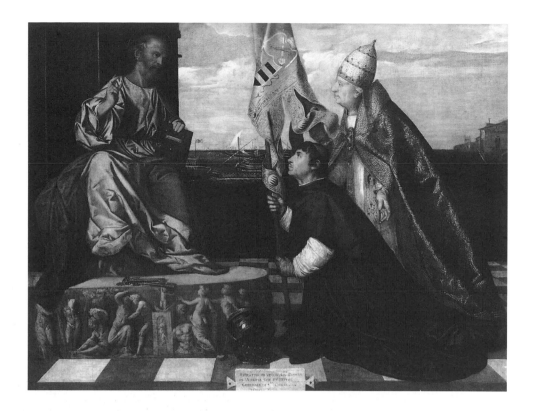

62. Titian, *Christ at Emmaus*
Paris, Musée du Louvre

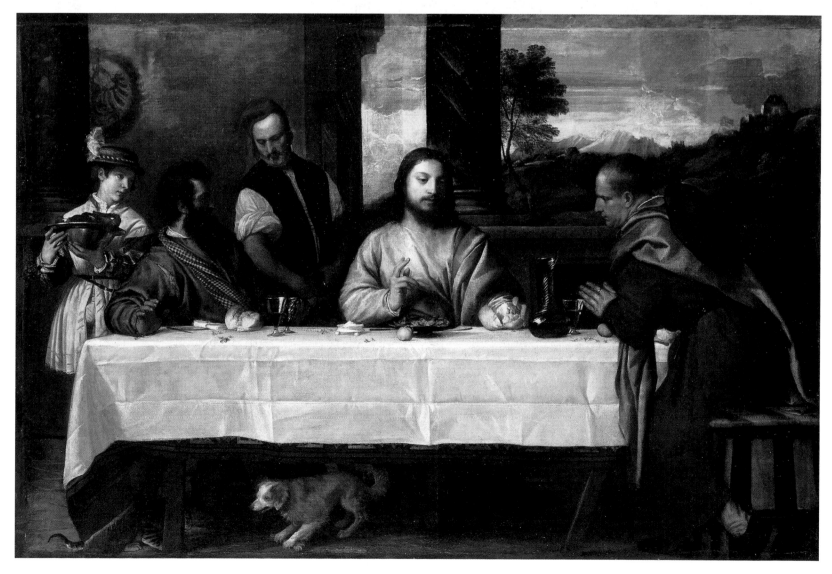

Clearly Wetton was no art lover; soon after, he sold the much-admired work to Cárdenas for £350, along with another picture listed on the memorandum, Andrea del Sarto's *Mystical Subject* (plate 68), described by the ambassador as "very well done and held in great esteem as being a very excellent piece." Wetton bought it for £230 and sold it for £300. Cárdenas was forced to pay the mark-up in order to keep his purchases quiet. For reasons of discretion he could not buy directly from the contractors although on at least on one occasion he hired an English agent to arrange a purchase, the most expensive he was to make. This was the series of nine tapestries of the Acts of the Apostles designed by Raphael, woven in gold and silk, which cost £3559. His accounts reveal a payment of £75 to a certain William Akins, who masterminded the scheme and sent Robert Houghton to make the purchase.[23] This cover-up might be used in exceptional cases, but it was too risky to become standard practice. So Cárdenas had to wait and carefully watch the portals of Somerset House.

It soon became obvious that the results of the sale were not meeting expectations, as the supply totally overwhelmed the demand. By May 1650 only 375 pictures, roughly a quarter of the total, had been sold for £7700. The trustees had begun to despair and the creditors were becoming impatient. In fact, on 14 March 1650, the Commons had empaneled a special committee to expedite the claims of the neediest among the former royal servants. This first list of creditors was approved on 10 April and they were paid partly in cash and partly in goods from the collection. As a consequence, there was an increase in the availability of works to buy, although the quantity is difficult to gauge precisely.

One of the most "necessitous servants and creditors to the late king" was Balthasar Gerbier, formerly keeper of the Buckingham collection. In the twenty-two years which had transpired since the duke's death, Gerbier had lived a novelesque life.[24] In 1631 he was appointed the English resident agent at Brussels, and during the rest of the decade he was engaged in high-level diplomatic intrigues, which were marked by self-serving and occasionally treacherous schemes and misguided initiatives. Although he was knighted in 1638, he lost all credibility with friends and enemies alike.

During the war Gerbier was in France, returning to London shortly after the execution of the king. He tried to make ends meet by opening an academy for young gentlemen at his house in Bethnal Green. It soon failed, but by then Gerbier had weaseled his way into the confidence of the Council of State. To prove his allegiance to the cause, he wrote an infamous pamphlet, *The None-such Charles*, which viciously attacked the deceased monarch. In one of the high-water marks in the history of hypocrisy, the erstwhile art agent reviled Charles and his court for the "great sums . . . squandered away on braveries and vanities; on old, rotten pictures, on broken-nosed marbles."[25]

This was the man who on 21 June 1650 acquired for the value of £150 Titian's *Charles V with Hound* (plate 26), which had been presented to Charles by Philip IV in 1623. Gerbier apparently received the picture in satisfaction of unpaid expenses incurred in the Netherlands. He soon sold it to Cárdenas for an unknown sum, and Titian's portrait was sent back whence it had come.

68. Andrea del Sarto, *Mystical Subject*
Madrid, Museo del Prado

Most of the works purchased by Cárdenas in 1650 came from two vendors.[26] Sargeant Major Robert Gravener sold a gem of a picture, Veronese's *Finding of Moses* (plate 69), along with a painting attributed to Caravaggio and two bronzes by Francesco Fanelli, which cost only £7 7s. 10d. apiece. As many as twenty pictures were sold to Cárdenas by the painter Remigius van Leemput, only a few of which can be traced. Correggio's *Agony in the Garden* (plate 70) was bought for £30 and sold for £44. Several bronze statuettes by Giambologna changed hands for trifling sums; a *Hercules* bought for £4 10s. was sold for £7 7s.; a *Kneeling Woman* bought for £3 10s. passed to Cárdenas for the same amount. The most expensive acquisition of the year was the set of Raphael tapestries, bought on 11 October 1650, which arrived in Madrid in May 1651. As a footnote to this transaction, it should be mentioned that Cárdenas spent an additional £395 above and beyond the cost of the tapestries, which included payments to the agent who arranged the purchase, to carpenters for crates, to teamsters for carriage to Dover, as well as fees and bribes to customs agents, premiums for insurance and shipping charges to the captain who transported the precious cargo to Vigo on Spain's north-western coast.

During the first several months of 1651 more paintings trickled on to the secondary market, and Cárdenas wrote a monthly dispatch to Madrid, describing the latest offerings and his efforts to secure them. By now these efforts and advancing age were taking a toll on the ambassador. In a letter of 10 July 1651 he complained that his health was failing and requested permission to return to Madrid.[27] Perhaps with this in mind, on 8 August he sent to Haro an accounting of purchases in the amount of some £6000. But just as he was preparing to close his books and retire after thirteen years of meritorious service, a dramatic turn in the sale was taking place, which compelled him to remain at his post.

69. Paolo Veronese, *Finding of Moses*
Madrid, Museo del Prado

70. Correggio, *Agony in the Garden*
London, Wellington Museum

71. Tintoretto,
Christ Washing the Feet of the Apostles
Madrid, Museo del Prado

On 22 July Parliament approved payment to a second list of creditors, who received 684 pictures in lieu of back wages. Long before art for the masses was to become a societal goal, these humble folk were possessors of some fairly impressive paintings. Dividing the booty in an equitable fashion proved no easy feat. On 20 October, Cárdenas reported that the distribution had again been suspended because of squabbles among the creditors over the partition of pictures. However, the problems were quickly solved, and on 23 October the paintings began to leave Somerset House by the cartload.

As was only to be expected, the proprietors were unable to afford the luxury of retaining ownership. They needed to turn the pictures into cash as soon as possible and for this purpose banded together into syndicates, known as dividends.[28] In all, fourteen dividends were formed, holding about £5000 worth of art apiece. Each dividend appointed a leader, who in effect was the sales representative. For example, the eighth dividend comprised eighteen members and was headed by Thomas Bagley, chief glazier of the king's houses, while the seventh was led by Ralph Grynder, upholsterer, and had nine other members. Edward Harrison, the royal embroiderer, was in charge of the works of the eleventh dividend, which had seventeen members in all. A leader would gather the works belonging to the dividend and open an impromptu gallery either in his house or in premises leased for the occasion.

Cárdenas must have thought himself to be in that art collectors' heaven which we may suppose really exists. It was not simply that the supply was abundant; the competition was scarce. One of his potentially greatest rivals, the ambassador of France, who acted for Cardinal Jules Mazarin, was nowhere to be seen. He had been expelled in December 1651 and his replacement would not arrive until late in 1652. Leopold William, another great collector, was still digesting the hundreds of works he had swallowed from the Buckingham and Hamilton collections. Another possible threat would have been Queen Christina of Sweden. However, her collecting instincts had been satisfied by the looting of the castle at Prague in 1648, during which the Swedish soldiery made off with part of the famous collection of Rudolph II. For Cárdenas this situation was too good to be true, but true it was, at least for the moment.

The lack of competition and the urgent needs of the sellers put Cárdenas squarely in the driver's seat where prices were concerned. Only rarely did he pay even the full valuation price. One exception was Tintoretto's *Christ Washing the Feet of the Apostles* (plate 71), valued at £300 and acquired for £325.[29] At the other extreme were the portraits of the twelve Roman emperors by Titian (destroyed), one of which had been lost and replaced by van Dyck. These were delivered to Captain Robert Stone, head of the sixth dividend, for an assessed value of £1200; Cárdenas paid him only £625. Correggio's *Education of Cupid* (plate 72) suffered a similar reduction; it was taken by the dividend for £800 and bought by Cárdenas for only £400. Edward Harrison was better able to hold his ground in a sale of eight pictures in the spring of 1652. Two paintings by Palma Giovane, *David with Goliath's Head* and the *Conversion of St Paul* (both Prado), were bought for £137 against an evaluation of £200. Cárdenas obtained more or less the same markdown on Rubens' *Peace and War* (plate 73), which went from £100 to £75. Two splendid portraits by Albrecht Dürer (plates 74 and 75), distributed at a value of £100 to the second dividend, headed by the king's tailor, brought an offer of £75 from the cagey Cárdenas.

72. Correggio, *Education of Cupid*
London, National Gallery

73. Peter Paul Rubens,
Allegory of Peace and War
London, National Gallery

The only challenge to Cárdenas' ascendancy during this heady period came in the form of a lightning attack from a Spanish general, Alonso Pérez de Vivero, Count of Fuensaldaña.[30] At the time of the sale, Fuensaldaña was the highest ranking Spanish official at the court of Brussels, second only to the archduke Leopold William. Fuensaldaña arrived in the Spanish Netherlands in March 1648, just prior to the time when the archduke acquired the collections of Hamilton and Buckingham, and caught the fever for owning pictures. A painting by David Teniers (plate 45) represents the count in Leopold William's gallery, soaking up the beauty of the Italian works which the archduke had just purchased.

It was to Teniers that Fuensaldaña turned as his agent in a somewhat murky transaction. In a letter to Haro dated 24 November 1651 Cárdenas mentioned that a painter had been sent to London by Fuensaldaña to do some buying. This painter, known from other sources to have been Teniers, told Cárdenas that he had acquired works from the earl of Pembroke, a famous patron of van Dyck. These were brought to the house of Cárdenas and immediately crated for shipment to Spain. The ambassador claimed not to have seen the pictures, but later came to realize that they were from the royal collection.

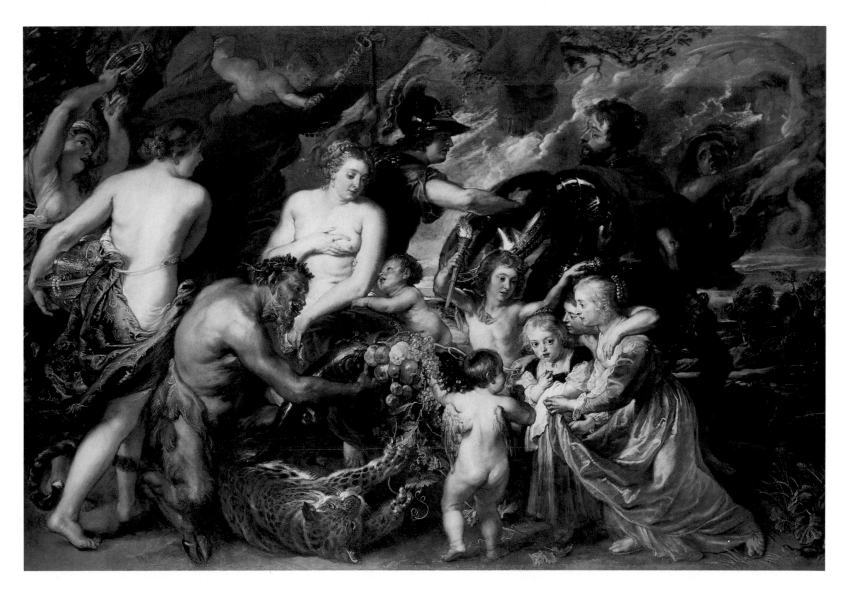

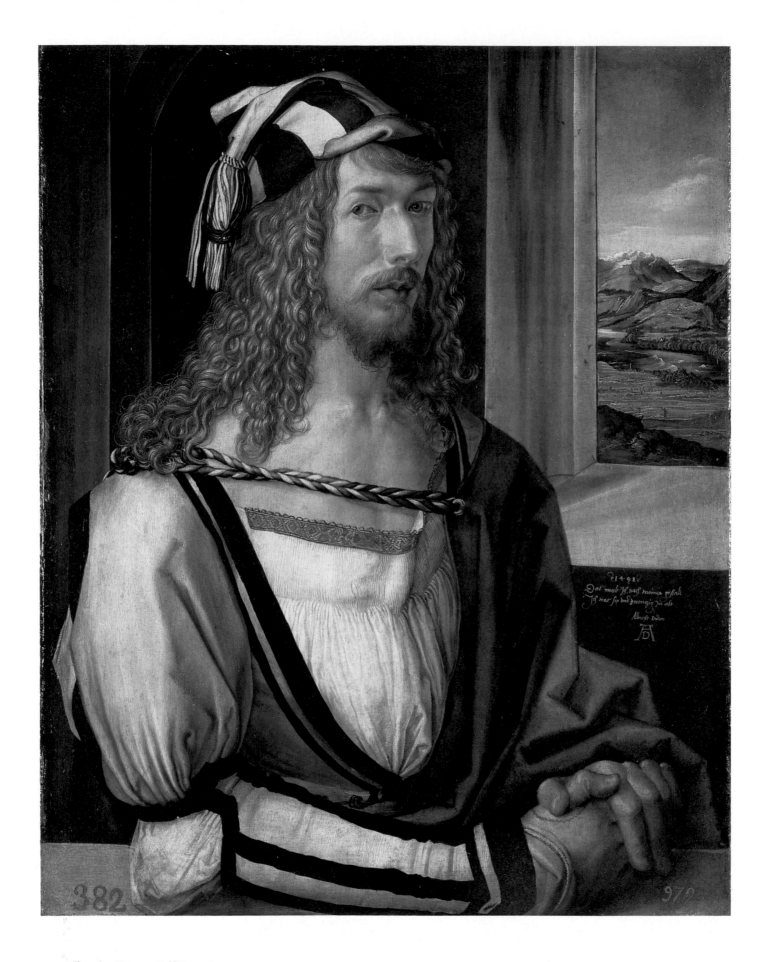

74. Albrecht Dürer, *Self Portrait*
Madrid, Museo del Prado

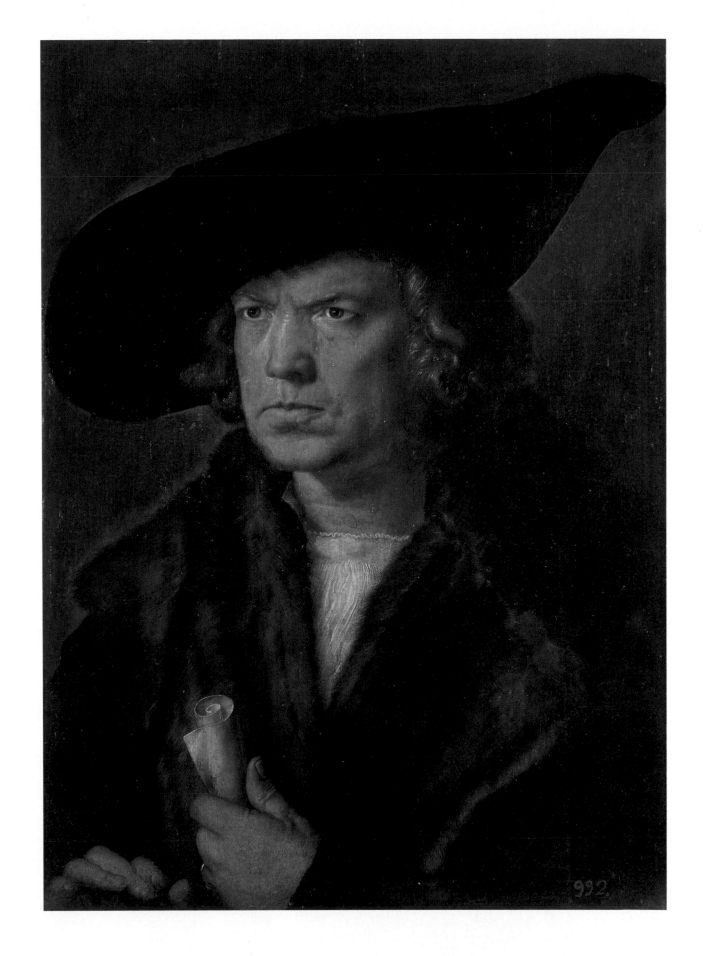

75. Albrecht Dürer, *Portrait of a Man*
Madrid, Museo del Prado

This discovery could have been made in only one way; by prizing open the crates. This was surely done, because Haro was sent a memorandum entitled "The forty-four pictures that the count of Fuensaldaña is sending to Spain in five parcels numbered 1, 2, 3, 4 and 5." Later Haro's son, Gaspar, noted the location of thirty-one of the pictures, which were either in one of his houses or had been given as gifts, mostly to the king. This suggests that Haro, once informed of the contents of the crates, pre-empted the shipment. In this way he came to possess two paintings by Paolo Veronese, *Sacrifice of Abraham* (plate 76), which was given to Philip IV, and *St Mary Magdalene* (plate 77), which he kept. Among the other identified pieces are van Dyck's *Penitent St Francis* (plate 78), one of several by this artist in the shipment, and Titian's *Portrait of Daniele Barbaro* (Prado). The most expensive picture is described as "a very pretty piece that is esteemed as one of the best by Titian, which is a nude woman and a man playing the organ, life-size," and could be the work purchased by Colonel Hutchinson on 8 November 1649 for £165 (plate 55). If so, Hutchinson, who was the sharpest dealer of all, turned a tidy profit, selling it to Teniers for £600.[31]

Cárdenas' virtual domination of the market for the king's pictures came to an end later in 1652, when that passionate collector, Cardinal Mazarin, decided to renew diplomatic relations with the Commonwealth. Although Cárdenas had already purchased many of the desirable paintings, he had by no means exhausted the stock, and with the arrival of the French agent, Antoine de Bordeaux, he at last encountered a worthy competitor.[32]

76. Paolo Veronese, *Sacrifice of Abraham*
Madrid, Museo del Prado

77. Paolo Veronese, *St Mary Magdalene*
Madrid, Museo del Prado

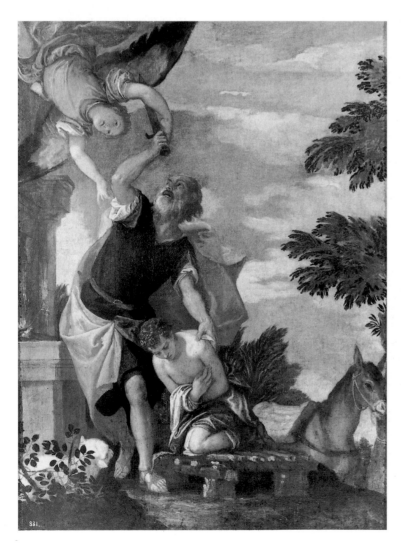

During 1653 the two ambassadors fought tooth and nail over choice pictures, although curiously their rivalry did not always raise the depressed prices to the point where the sellers could profit. By May, Bordeaux had gained a grasp of the picture market. (He had been instructed also to buy tapestries and thoroughbred horses and initially was much occupied in these pursuits.) The two best available pictures, he concluded, were Raphael's *Holy Family* (plate 58) and Correggio's *Venus with Satyr and Cupid* (plate 59). Raphael's painting was being actively sought by the Spanish ambassador. Although Mazarin had decided that the picture was too dear, a compatriot desperately wanted it, as Cárdenas told Haro in a letter of 11 August, in which he jubilantly described his capture of the prize.[33] (Unfortunately, the letter never reached Haro; it was intercepted by the French and surely sharpened the already keen competitive instincts of Cardinal Mazarin.)

I can now tell Your Excellency, much to my pleasure, that, thanks to God, I have also purchased the large painting by Raphael of Our Lady, Her Child, St John and St Anne, life-size, and St Joseph, in small, in a perspective, that was valued at 8000 escudos [£2000], which I have had for 4000 escudos, which is half. I do not wish to talk to Your Excellency about this picture for fear of understatement, but in a word I can tell Your Excellency that nowadays it is esteemed as the best in all Europe, and here it is renowned among the painters as the finest painting in the world.

78. Anthony van Dyck, *Penitent St Francis*
Madrid, Museo del Prado

As Cárdenas went on to explain, the picture was not won without a fight.

Those who sold me the painting [one of the three dividends headed by Edward Bass, which had indeed received it for a value of £2000] had a bit of a legal action with a painter who had come expressly from France to buy it and pretended that he had been the first to make an agreement with them. . . . The French painter so regretted not having it that he has let it be understood through different people that he will give me 600 escudos [£150] more than it cost if I let him have it.

The text of this informative letter goes on to describe the state of play. Four important paintings by Correggio were among the remaining trophies, of which Cárdenas could capture only one, the *Education of Cupid* (plate 72). There were also two small paintings by Andrea Mantegna, the *Death of the Virgin* (plate 32) and the *Virgin and Child with Saints* (plate 79), which were in the hands of a painter who had purchased them before the division among the creditors. The painter in question was Jan Baptist Gaspars, who had paid £34 for the two in March 1650. Cárdenas gave him his profit and bought the pair for £105. Another key picture was Raphael's *Madonna of the Rose* (plate 80), which was owned by a Parliamentarian and was valued at £500. This price was considered to be only a third of its worth, which made it unlikely that he would sell. Nonetheless, Cárdenas was able to acquire it for an as yet unknown price.

79. Andrea Mantegna,
Virgin and Child with Saints
London, National Gallery

80. Raphael, *Madonna of the Rose*
Madrid, Museo del Prado

For all these successes, Cárdenas did not always have the better of his French counterpart. In this same letter of 11 August he admitted that M. de Bordeaux had purchased two large works by Giulio Romano. However, by this time the number of desirable canvases was running low, as Cárdenas wrote at the end of this dispatch: "Only a few paintings of the king remain here, and there are more buyers for them than there used to be." As a result, the competition between France and Spain intensified, especially for the remaining paintings by Correggio, now considered the cream of the crop. (In a letter of 27 October 1653 Bordeaux claimed that he had virtually snatched away a *St Jerome* by Giulio Romano from Cárdenas;[34] however, only a couple of months before, the Spaniard had dismissed the painting as "somewhat melancholy.") These were three in number: *Venus with Satyr and Cupid* (plate 59) and two works executed in tempera, the *Allegory of Virtue* and the *Allegory of Vice* (plates 81 and 82). By 27 October the *Allegory of Virtue* had been purchased for the French collector Jabach and left London. The other tempera, however, was acquired by Bordeaux for an undisclosed price.[35]

The acquisition of *Venus with Satyr and Cupid* occurred in the following month. Bordeaux had received a letter from Mazarin dated 17 November which stressed the importance of buying it: "In no case allow it to go to the Spanish ambassador." On that very day, Bordeaux closed the deal for the staggering sum of £3000.[36] (Cárdenas, it will be recalled, paid only £400 for the pendant, the *Education of Cupid*.) Even so, it had been a near thing because Cárdenas had attempted to bribe the seller to put it back on the market.

The sudden elevation in prices in the final months of 1653 was the consequence of the virtual disappearance of admired pictures. Once the values went into the stratosphere, Cárdenas pulled back. He had had the best of it and did not care to throw vast sums at what remained. Bordeaux was left with no choice but to deal at the inflated prices, and his vendors were merciless, none more so than Colonel Hutchinson. He chose this moment to sell Titian's *Pardo Venus* (plate 25), which he had purchased in 1649 for £600. By 15 December, he had offered it to Bordeaux for approximately £4200. Three days later the conniving colonel raised the price to £4900 and Bordeaux, having been warned not to let it escape, took the plunge.[37]

The preservation of the colorful correspondence between Mazarin and Bordeaux has tended to obscure the fact that the most important French purchaser of works from the royal collection was not the minister of state but the banker Jabach. Unfortunately, next to nothing is known of how Jabach managed his acquisitions. It is unlikely that he came to London; his presence would have been noted by someone, if not by Cárdenas or Bordeaux. In one of his transactions, he was represented by a French merchant called Adamcour, who is otherwise unknown. Whatever the method, Jabach was the only collector to give the Spaniards a run for their money.[38]

81. Correggio, *Allegory of Virtue*
Paris, Musée du Louvre

82. Correggio, *Allegory of Vice*
Paris, Musée du Louvre

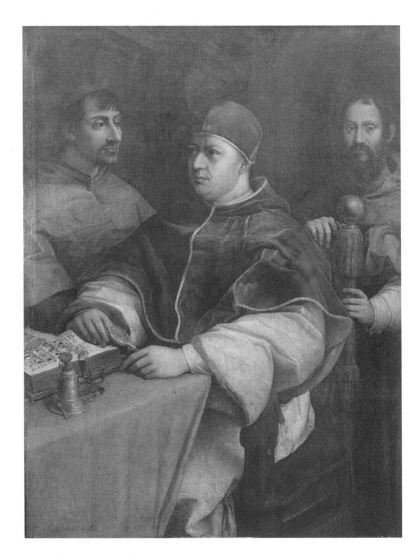

86. Raphael, *Leo X and Two Cardinals*
Florence Uffizi

87. Giulio Bugiardini after Raphael,
Leo X and Two Cardinals
Rome, Galleria Nazionale d'Arte Antica
in Palazzo Barberini

Haro, like many a successful courtier before him, had discovered that the way to the king's heart was through his eyes. Thus, in a subsequent letter, he again praised the pictures and informed the ambassador that "when His Majesty returns from San Lorenzo (El Escorial), I shall have the large painting of Our Lady (plate 57) placed in his private quarters, with which I believe he has to receive great pleasure. Velázquez has seen it already, and to him it seemed a very great thing, as I believe will happen to everyone."[3] Some time later, he could report that all had gone as planned. "I can now add that when His Majesty returned from El Escorial, I had placed in his quarters the large [painting of] Our Lady of Raphael, with which he has received the greatest pleasure, and at the same time I can say that Velázquez has admired it, as have all who have seen it, judging that it must be one of the most outstanding paintings that Raphael did."[4]

The repeated references to the famous painter Diego de Velázquez are no accident. Since the early 1640s, Velázquez had been serving as de facto curator of the royal collection, which meant that Haro felt obliged to pass any proposed offering before his eyes. Velázquez, like Inigo Jones in Whitehall, was nothing if not confident of his powers as a connoisseur. Also like Jones, he could be fallible.

The portrait of *Leo X and Two Cardinals* failed to pass his scrutiny, and with reason. Cárdenas had purchased the painting from the Arundel collection, a problematic provenance in as much as the Raphael original was then in the Medici collection (plate 86) while the Sarto copy was in the Farnese Palace in Rome. Velázquez had seen one or both of these during his recent trip to Italy (1649–50) and recognized that the version sent by Cárdenas was different.[5] (In fact, it appears to have been a copy by Giulio Bugiardini (plate 87), in which the identity of one of the cardinals is changed.)

The other rejected attribution was not so astute. Someone had cast doubt on the authenticity of Correggio's *Education of Cupid* (plate 72), an opinion which was shared by Velázquez. Haro sought to palliate the injury to the ambassador's self-esteem by writing, "but you should moderate this unpleasantness with [the knowledge] that, if they do not find it appropriate for the private quarters of His Majesty, they will hang it in mine with the good faith one ought to have, according to the knowledge of the painters over there" (in London).[6] Given the accurate judgment of the painters in England, it seems only fair that the picture now resides in the National Gallery, London.

Velázquez obviously set high standards for the monarch's collection and with good reason, for Philip IV was unsurpassed, and perhaps unequalled, as a picture collector among the royalty of seventeenth-century Europe.[7] Acceptance of this fact has always encountered resistance, perhaps because the king is best known for presiding over the decline of Spain. History does not glorify losers, nor does making a great picture collection compensate for losing political hegemony.

Philip was slighted by as great an authority as Peter Paul Rubens, small thanks from an artist who enjoyed his lavish patronage. In January 1625, although he had never met Charles, Prince of Wales, Rubens described him, in oft-quoted words, as "the greatest amateur of paintings among the princes of the world." About four years later the painter was in Madrid, where he spent much time in the company of Philip IV, owner of the best picture collection in Europe. Rubens noted the king's interest in painting, but in words of praise that fail to match the enthusiasm bestowed on Charles. "He really takes an extreme delight in painting, and in my opinion this prince is endowed with excellent qualities."[8] Perhaps the timing was wrong; had Rubens lived to see the Spanish royal collection in 1665, the year of Philip's death, he would have been compelled to apply his remark about Charles to the Spanish monarch. In the seventeenth century, Philip IV, not Charles I, was truly "the greatest amateur of paintings among the princes of the world."

In fairness to the English monarch, it must be said that the Spanish ruler enjoyed an incomparable advantage. Philip, who was born in 1605, spent his childhood surrounded by an art collection that had been started a good eighty years earlier and had steadily grown. The founder of the Spanish royal collection was also the founder of the Habsburg dynasty in Spain, the emperor Charles V. Charles was an ambitious sponsor of artistic enterprises, which he recognized as an efficacious way to promote his political ideals. However, he seems to have regarded painting as a private form of art, so it was decidedly a secondary interest. The one exception to this rule was Titian, whom he began to patronize in 1532.[9] In the following year, the Venetian master executed the *Portrait of Charles V with Hound* (plate 26), the very picture given to the prince of Wales in 1623 and later recovered for the Spanish royal collection by Alonso de Cárdenas. From then until the emperor's abdication in 1556, Titian provided him with pictures, mostly family portraits and devotional subjects, including the *Empress Isabella* (Prado) and the *Gloria* (plate 88), which formed the nucleus of the royal collection and established Titian as the favorite painter of the house of Habsburg.

The other founder of the Spanish royal collection was the emperor's sister, Mary of Hungary (1505–58), governor of the Netherlands from 1531 to 1556.[10] Mary succeeded her aunt Margaret of Austria, a major patron and collector in her own right, much of whose collection she inherited. In many respects, Mary created a template for the later members of the dynasty. She avidly acquired the requisite trappings of royal majesty—tapestries, sculpture, objects made of precious metals and gemstones, illuminated manuscripts and painting. Her tastes in pictures, while conventional, were nonetheless influential. She especially coveted Flemish painting of the fifteenth century and owned such exceptional pieces as Jan van Eyck's *Arnolfini Wedding Portrait* (plate 89) and Roger van der Weyden's *Descent from the Cross* (plate 90). In due course, she became an even more devoted admirer of Titian than her brother. Most of the twenty-some pictures she commissioned from Titian were destined for a gallery of portraits of family members and rulers of other states. The most illustrious of this group was *Charles V on Horseback* (plate 91). Another important work was the portrait of her nephew Prince Philip (plate 92), who as Philip II of Spain (1555–98) would expand Habsburg patronage and collecting to a new order of magnitude.

88. Titian, *Gloria*
Madrid, Museo del Prado

89. Jan van Eyck, *Arnolfini Wedding Portrait*
London, National Gallery

90. Roger van der Weyden,
Descent from the Cross
Madrid, Museo del Prado

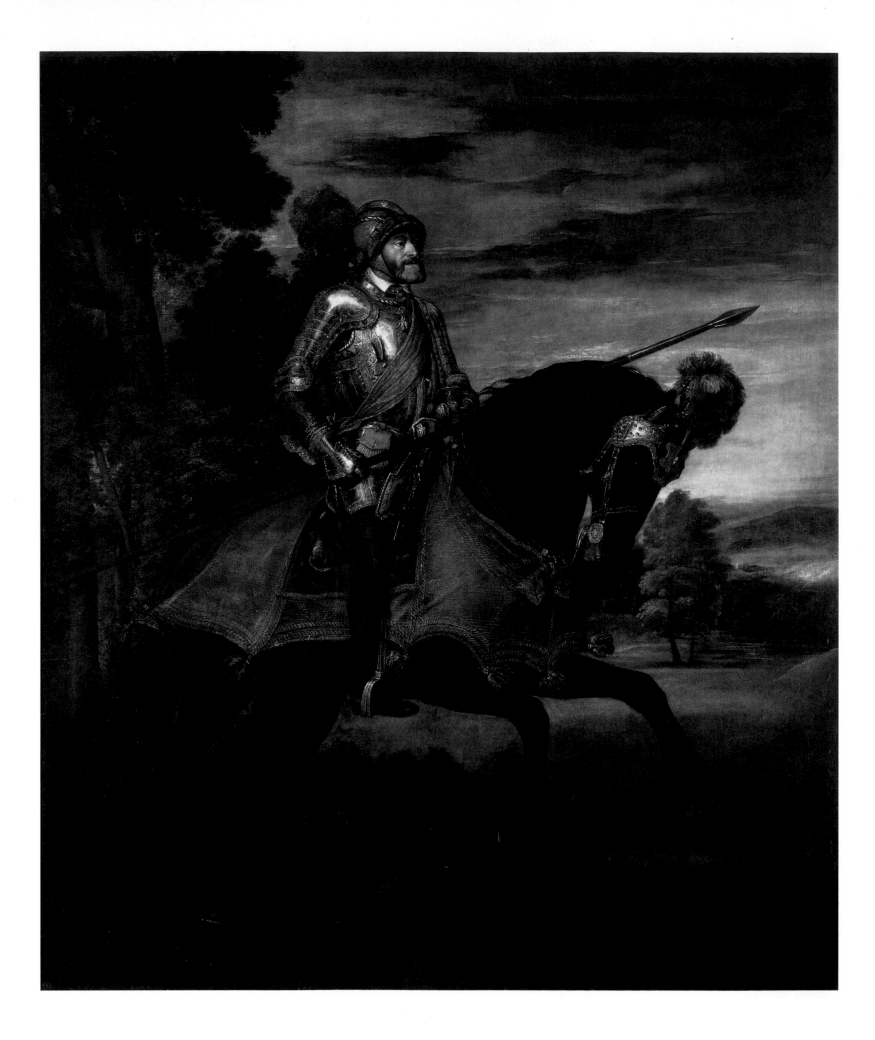

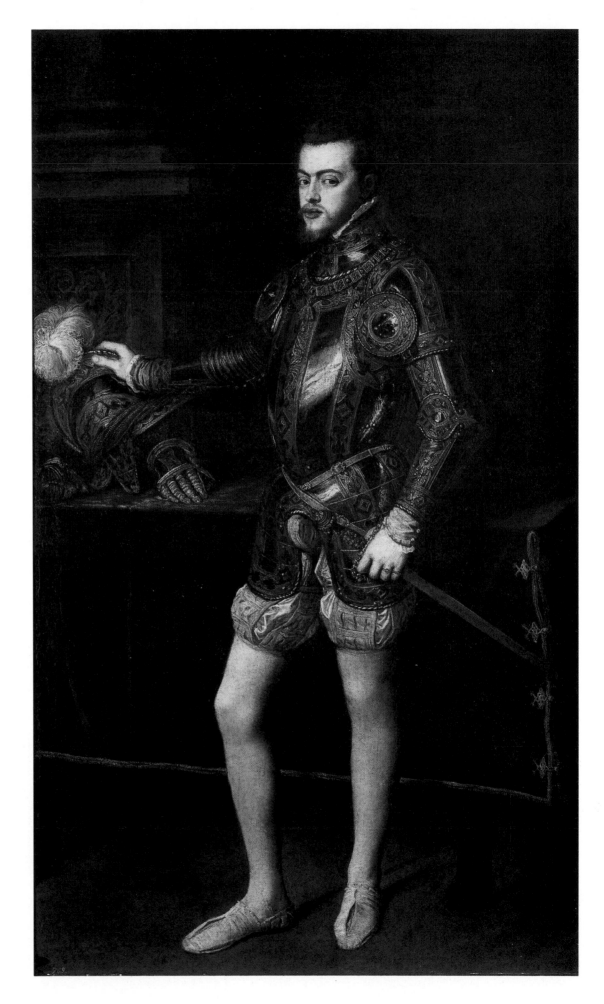

91. Titian, *Charles V on Horseback*
Madrid, Museo del Prado

92. Titian, *Philip II*
Madrid, Museo del Prado

93. Titian, *Rape of Europa*
Boston, Isabella Stewart Gardner Museum

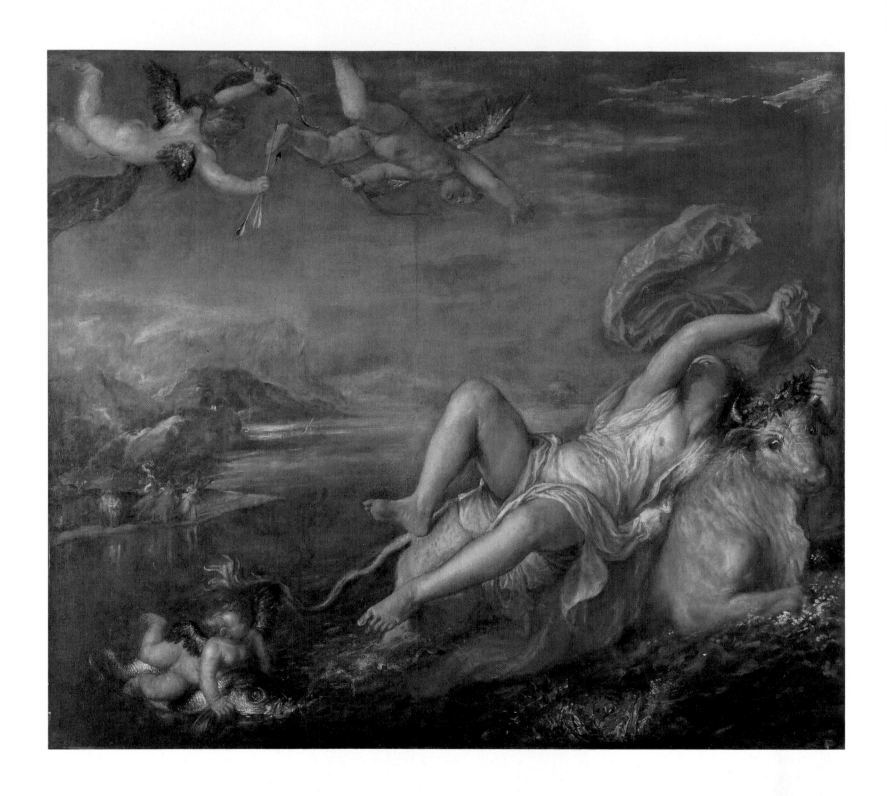

If Charles V and Mary of Hungary laid the foundations of the royal collection, however, it was Philip II who constructed the edifice. Philip was the richest and greatest art patron of the second half of the sixteenth century.[11] His success as a collector cannot be attributed merely to his wealth, which was augmented by regular shipments of silver from the mines of the American colonies. Philip was a man of unusual intellect, learning and taste. His taste, of course, had been molded by his venerated father and beloved aunt, who bequeathed their artistic collections to him. Thus he continued to favor Titian above all others, and from 1550 became his most important patron. Their relationship was singular in that Philip granted Titian a handsome annual stipend (seldom paid on time, it is true) and an unusual degree of freedom; he seldom specified the subject to be painted. By the time the artist died in 1576 he had provided Philip with dozens of pictures, ranging from the sensuous series of mythologies known as the *Poesie* (plate 93) to such important religious works as the *Adoration of the Magi* (plate 94) and *Spain Coming to the Aid of Religion* (Prado).

94. Titian, *Adoration of the Magi*
El Escorial

Once again following in the footsteps of his forebears, Philip was attracted to the art of his northern realms. His collection of fifteenth-century Flemish painting was superb, and included such masterpieces as Robert Campin's *Marriage of the Virgin* (plate 95), van der Weyden's *Christ on the Cross* (El Escorial) and Dirk Bouts' *Triptych of the Virgin* (Prado). Among the masters of the sixteenth century there were works by Jan Gossart (*Christ between Virgin and St John*, Prado), Bernard van Orley (*Virgin of Louvain*, Prado) and Joachim Patinir (plate 96). However, as has long been known, Philip's favorite northern painter was Hieronymus Bosch, whose bizarre, sometimes salacious, works he stalked with a passion entirely at odds with his remote, implacable demeanor. The *Garden of Delights* (plate 97), Bosch's masterpiece, is the most important work of the artist owned by the king, but it was only one of over thirty attributed to him in the royal collection.

95. Robert Campin, *Marriage of the Virgin*
Madrid, Museo del Prado

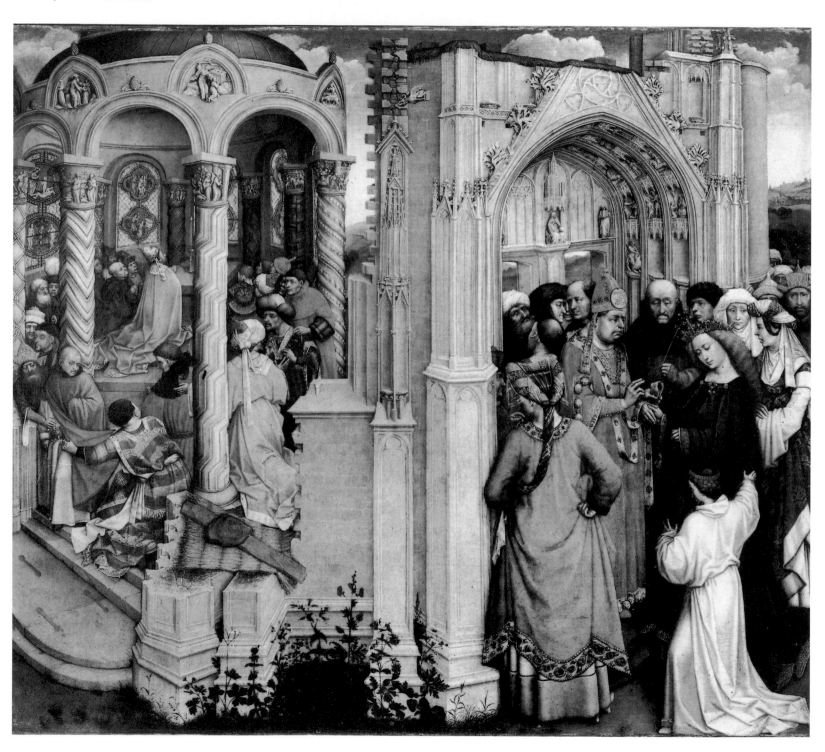

Philip's artistic interests encompassed much more than paintings. His was essentially a universal collection typical of the sixteenth century, although projected on a scale matched only by his Austrian cousin, the emperor Rudolph II (who had resided at Philip's court from 1563 to 1571). The king collected books, manuscripts and prints, tapestries, arms and armor, clocks and mechanical instruments, rare and exotic natural specimens, gold and silver plate, jewelry and, to a lesser extent, sculpture. That said, by the date of his death in 1598, Philip's collection of pictures had grown enormously. There were around 1150 at El Escorial, the principal repository, and some 358 at the Alcázar of Madrid, his primary residence. A lesser quantity was in El Pardo, which housed the series of portraits bequeathed to the king by his aunt and augmented by others he had commissioned. While the grand total exceeded 1500, it is true that only a small percentage could be considered masterpieces. The idea of selectivity that governs collecting in our day, when the supply of important old pictures has virtually dried up, was no more important than sheer numbers. Great collections were also meant to be huge, as a sign of the acquisitive power of the collector. The number of works owned by Philip set a new standard and entitled him to be called the first megacollector, a term which can be applied to those who amassed 1500 or more paintings. (While seemingly arbitrary, this quantity represents approximately the largest total that individual collectors of the sixteenth and seventeenth century acquired.)

96. Joachim Patinir, *Temptation of St Anthony*
Madrid, Museo del Prado

97. (*Overleaf*) Hieronymous Bosch,
Garden of Delights
Madrid, Museo del Prado

98. Correggio, *Leda and the Swan*
Berlin, Staatliche Museum

This deluge of art descended upon a successor who could barely keep his head above water. Philip III (1598–1621) was the first of what Spanish historians have called "los Austrias menores," the lesser Habsburgs. Faced with the challenge of living up to the example of his father and grandfather, the new king rode the ship of state as a passenger. As far as the royal collection is concerned, he might be considered a custodian had he not divested himself of such paintings as Correggio's *Leda and the Swan* and the *Rape of Ganymede* (plates 98–9), which he sold to his relative, the emperor Rudolph II. Undoubtedly the king, who was known above all for his piety, found them a distraction from his devotions, which they certainly would have been.

The vacuum created by the reticent monarch, both as ruler and collector, was filled by an upstart nobleman, Francisco Gómez de Sandoval y Rojas (1552–1625), created duke of Lerma in 1599 (plate 101). Lerma was the head of the house of Sandoval, which had fallen on hard times, and the marquis of Denia (as he was then known) set out to rebuild its political and financial fortunes. This was accomplished by capturing the favor of the future Philip III. Only months after the death of Philip II in 1598, Lerma was in control of the government, and he remained in power until he was overthrown in 1618 by a group of noblemen, including his son. The duke was compensated by a cardinal's hat and lived in dignified retirement in a town built to his specifications which inevitably bears his name.

Once Lerma was installed as favorite, his financial problems were solved by diverting the revenues of the crown into his pocket. As the symbol of his new status, he revamped and furnished several residences, including two in Valladolid, a city near his patrimonial estates which became the seat of the monarchy from 1601 to 1606. One of these was a large apartment contained within the royal palace in Valladolid, the other a suburban villa, La Ribera. During this period, he also acquired a palace in Madrid and a country house known as La Ventosilla.

The simultaneous acquisition of these domiciles posed a formidable challenge of interior decoration, but Lerma was equal to the task. Following the regal standard of Philip II, he emphasized the collecting of paintings.[12] However, whereas Philip II had patiently accumulated pictures over several decades, Lerma made his collection at breakneck speed. In the seven-year period between 1599 and 1606 he acquired 1431 paintings, distributed in ever-changing combinations between his various houses in Madrid, Valladolid, La Ventosilla and Lerma. Building a collection of this magnitude in such a brief period of time was an unprecedented feat and could be done only by taking short cuts. These involved acquiring large series of works, such as 240 portraits of popes and 153 heads of Roman emperors, which were deployed in the ducal quarters of the royal palace in Valladolid.

Another expedient measure was the purchase of copies. Although nowadays this practice would be scorned, in the sixteenth and early seventeenth centuries the copy, while recognized as inferior to the original, was considered a valuable record of an admirable composition or invention. Even so discerning a connoisseur as Charles I sent the copyist Michael Cross to Spain to copy the works by Titian he had so coveted in 1623.[13] The Lerma collection itself contained several copies of the works by Titian in the Gonzaga collection and as many as nineteen copies of famous paintings by Raphael.

99. Correggio, *Rape of Ganymede*
Vienna, Kunsthistorisches Museum

However, not all this vast collection consisted of surrogates and substitutes. Lerma's artistic advisor was the excellent Italian painter Bartolomé Carducho (*c.* 1560–1608), who had been in Spain since 1585 and also served as painter to Philip III. On the side, Carducho was an art dealer, specializing in Italian imports, and some of his merchandise found its way into the ducal collection. Works by the Bassano family must have been a stock item—Lerma owned twenty-nine originals (plate 100) and seventeen copies. Other works by the prestigious Venetians were Titian's *Salome with the Head of the Baptist* (Prado) and Veronese's *Mars and Venus* (plate 27), the picture later claimed by the prince of Wales.

Virtually every Spanish picture collection of the seventeenth century balanced the Italians with the Flemish, reflecting the territorial possessions of the monarchy. Philip II prized works by Bosch, thus Lerma prized them, too. He owned five as yet unidentified panels attributed to the master. The duke was also the first Spanish collector to have works by Rubens, who came to Valladolid in 1603 on a mission from his employer, Vincenzo Gonzaga, Duke of Mantua. Mantua was a client state of Spain, and therefore its ruler was obliged to make a show of fealty to the new monarch, Philip III. A selection of gifts was made for the king, the queen and important courtiers, and Rubens was appointed to accompany them to the Spanish court.

Rubens was impressed by Lerma's interest in pictures, as he wrote to the Mantuan secretary of state on 24 May 1603: "For he is not without knowledge of fine things, through the particular pleasure and practice he has in seeing every day the splendid works by Titian, Raphael and others, which have astonished me by their quality and quantity, in the king's palace, in the Escorial and elsewhere."[14] Lerma seems to have appreciated Rubens' talents and tried to persuade him to remain in Spain. Although the offer was politely refused, Rubens paid homage to his would-be patron by painting the superb *Equestrian Portrait of Lerma* (plate 101), which represents the indolent favorite in the guise of an energetic military commander.

100. Jacopo Bassano, *Supper at Emmaus*
Fort Worth, Kimbell Museum of Art

101. Peter Paul Rubens,
Equestrian Portrait of the Duke of Lerma
Madrid, Museo del Prado

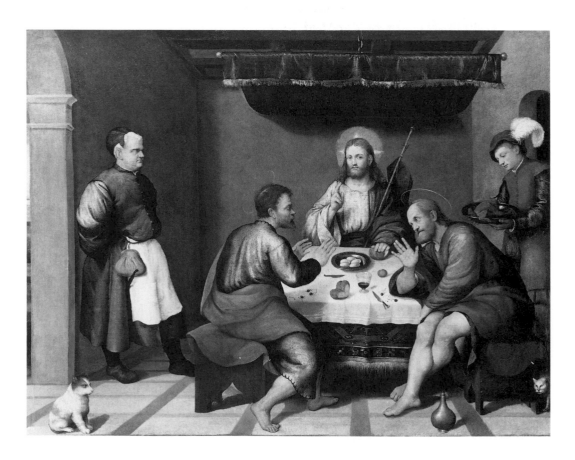

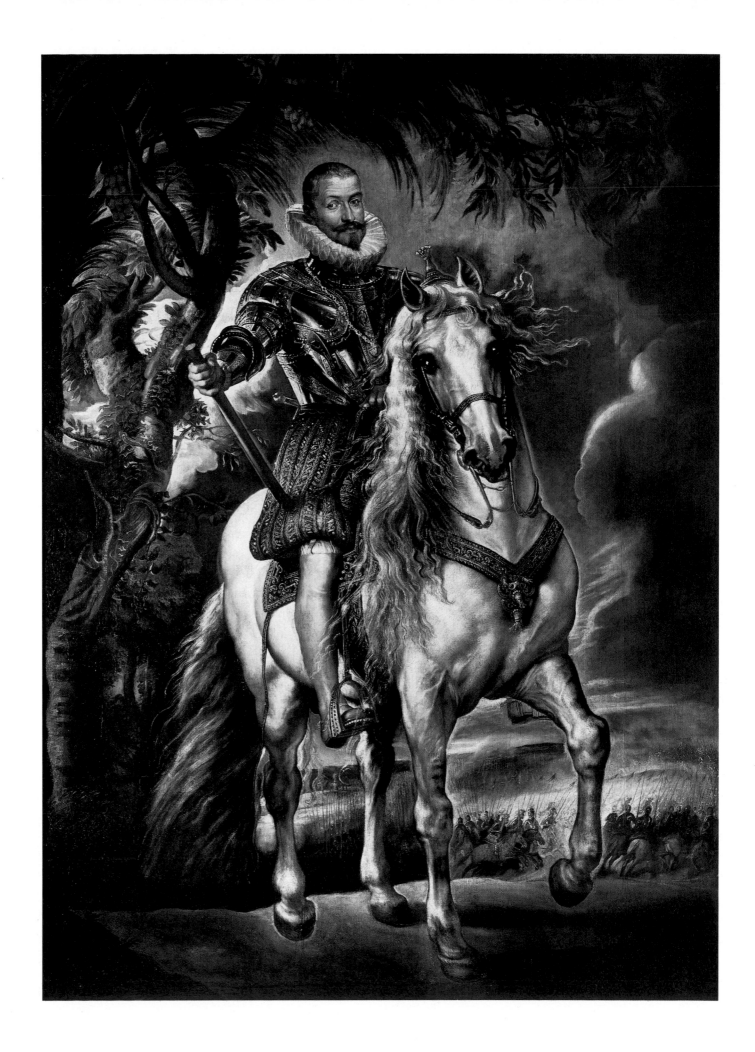

Unfortunately, this promising relationship virtually ended with Rubens' departure. Lerma failed to follow up with further commissions and thereafter acquired only a series of the apostles by Rubens (Prado), which entered the collection around 1612.

As a matter of fact, Lerma did not keep the equestrian portrait for long. In 1607, he made the remarkable decision to sell La Ribera to the king with all its contents, including the *Equestrian Portrait* and six hundred more canvases. His quarters in Valladolid and its contents were also included in the deal. This was the only major addition to the royal collection made during the reign of Philip III, and seems to have been motivated by Lerma's avarice rather than by the king's passion for pictures.

Beginning in 1611, Lerma started to transfer his pictures to religious establishments under his patronage, and by the time he died less than a third of the total remained in his possession. This is a curious collection with a curious history, although not without its importance. Lerma was the first nobleman in Europe to form a megacollection. Perhaps the selectivity left something to be desired, but this may be attributed to timing as much as to taste. The period when the duke made his collection just predates the break-up of the Italian collections which were to enrich the holdings of the Whitehall Group. Nevertheless, it betokens the concentration on pictures that, during the reign of Philip IV, would eclipse every other form of collecting.

On 31 March 1621 Philip III, after a short illness, unexpectedly died. He left an embattled monarchy, poised on the threshold of European wars which would last until 1660, in the hands of an heir no better equipped to rule than he. The new monarch, just sixteen years of age, needed assistance, and before he could cry for help it had already arrived in the person of Gaspar de Guzmán, Count and later Count-Duke, of Olivares (plate 102).[15] From 1621 to 1643, when he lost favor, Olivares sought to restore the power and reputation of the Spanish monarchy, which had clearly declined during the previous reign. As part of his plan, Olivares wanted to polish the image of the king so that it would shine like a beacon to the other courts of Europe. Thus, while he launched new political initiatives, he also intended to bring new life to the arts.

His first move was unquestionably brilliant. In 1623, he appointed a young, still untested artist from Seville to the position of royal painter (plate 103). This of course was Diego de Velázquez, whose name and fame were to be made at the court of Philip IV. However, during the 1620s the monarch needed to further his education in the ways of princely collecting and patronage.

These lessons were provided by three visits, in quick succession, of influential connoisseurs from abroad. The first of these occurred in 1623, when the prince of Wales, the duke of Buckingham and their team of artistic advisors arrived unexpectedly in Madrid.[16] While the English prince was impressed by the venerable royal collection, the Spanish monarch must have been impressed in turn by this youthful royal collector. Guided by the sharp-eyed Balthasar Gerbier, as well as by his own instincts, the prince visited collections and went shopping in Madrid's active art market, which centered around the *almoneda*, or estate sale. From the *almoneda* of the count of Villamediana, as we have seen, he acquired Titian's *Woman with Fur Wrap* (plate 24). And just at this time, the rich collection of the Italian sculptor, long resident in Spain, Pompeo Leoni (d. 1608), appeared on the market, and Charles acquired drawings from the estate.[17] Local collectors, prodded by the count-duke, did their duty and

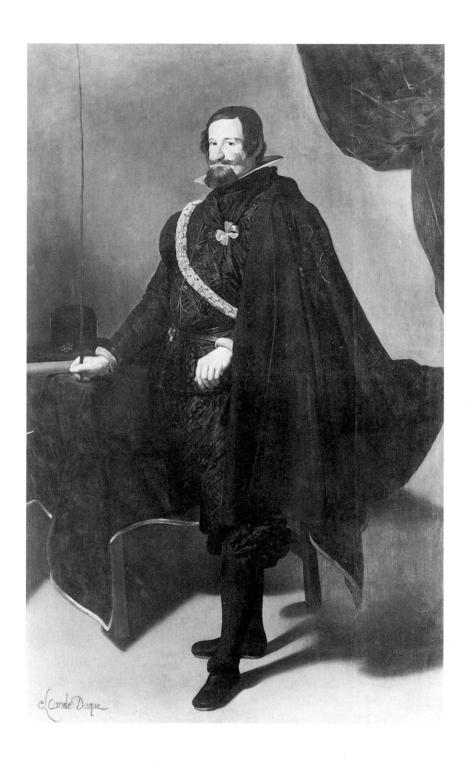

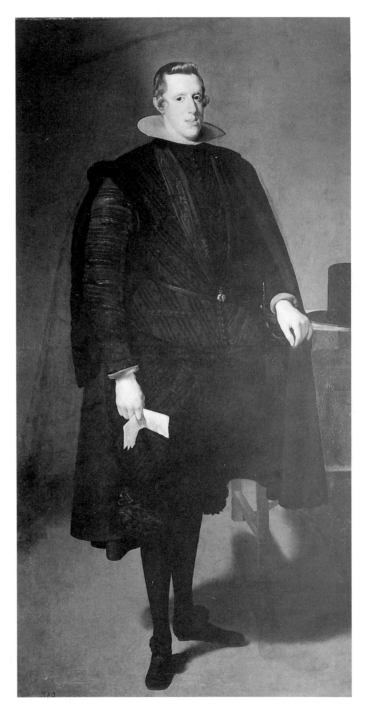

102. Diego de Velázquez,
Count-Duke of Olivares
New York, Hispanic Society of America

103. Diego de Velázquez, *Philip IV*
Madrid, Museo del Prado

offered presents of paintings to the young prince. For instance, Juan Alfonso Enríquez de Cabrera, Admiral of Castile and owner of an important collection, gave six unspecified paintings, while another noted collector, Jerónimo de Funés y Múñoz, presented Charles with two works by Titian. Best of all, of course, was the gift of the king, Titian's *Pardo Venus* (plate 25).

The effect of Charles' passion for painting on the young Spanish monarch can only be intuited. As later events would show, Philip had an innate love of fine painting, and nothing could have brought it to the surface faster than the threatened loss of family treasures to an insatiably acquisitive house-guest. Charles evidently went so far as to ask for the *Poesie* by Titian, and with this he finally overreached himself. According to a contemporary source, they were packed for shipment to London and then returned to the walls of the Alcázar (royal palace) once the Spanish match had failed.

The next foreign delegation arrived from Rome in May 1626 in the person of Cardinal Francesco Barberini, nephew of Pope Urban VIII.[18] His visit was motivated by a desire to forge a peace between France and Spain, which would cause the Spaniards to withdraw their troops from Italian soil. Cardinal Barberini was accompanied by several distinguished prelates and by his secretary, Cassiano dal Pozzo (1583–1657), the humanist, antiquarian and art patron who was to become a central figure in Roman artistic life in the 1630s. Cassiano kept a careful diary of the visit to Madrid, which ended on 11 August 1626, and recorded the impressions of the local scene as viewed by an Italian connoisseur with refined, up-to-date tastes.

The visit to the court was less than triumphant and was marked by endless haggling over matters of protocol. Trouble began even before the retinue reached Madrid. For unexplained reasons, Cardinal Barberini precipitously decided to leave Alcalá de Henares, where his party was supposed to await the signal to enter Madrid. After a single night's stay he bolted to nearby Barajas and went to the palace of the count of Barajas, where he and his party were totally unexpected. There they found neither furniture nor food and were offered nothing to eat but eggs. One of the prelates was allergic to eggs and was served a head of lettuce, which was unforgivably offered without oil and vinegar. This paltry *hors d'oeuvre* seems to have spoiled Cassiano's appetite for Madrid.

During his stay, Cassiano had every opportunity to visit the noble houses of Madrid.[19] For reasons of protocol, Cardinal Barberini devoted his afternoons to paying courtesy calls to the wives of the leading aristocrats, sometimes visiting five or six in a row and not returning to his quarters until after midnight. Cassiano surveyed the houses and their contents, and found little to admire except the occasional work done by one of his compatriots. An exception was made for the royal collection, perhaps explained by the richness of its Italian holdings.

Nor was dal Pozzo to be counted among the early admirers of Velázquez. The Spaniard's portrait of Cardinal Barberini (lost) was rejected because of what Cassiano called its "aria malincolica e severa" and another painter was called in to make a new one. Italian connoisseurs of this period tended to be snobs and chauvinists, and it may well be that Cassiano and other members of the party ventilated their opinions, albeit discreetly, to their hosts. If Cardinal Barberini's mission was a political failure, it may have piqued the artistic pride of the Spaniards while renewing their awareness of the cultural prestige of Italy.

The third influential connoisseur to visit the Spanish court in the 1620s was the ubiquitous painter Peter Paul Rubens, who was in Madrid from mid September 1628 to 29 April 1629.[20] Rubens had been sent to the Spanish court by the king's aunt, the infanta Isabella Clara Eugenia, governor of the Netherlands, to help arrange peace with England. (His visit to London in 1630 was another stage in the process.) However, his diplomatic activities were equalled if not overshadowed by his paintings.

Prior to 1628, Rubens' work was known in Madrid through just a few examples. Now the most industrious painter of the seventeenth century began to fill the royal collection with examples of his artistry. He had arrived with eight paintings in his baggage, which had been ordered by the infanta Isabella (*Reconciliation of Jacob and Esau*, Munich), and during his stay at court he produced still more pictures. On 2 December 1628 he briefly described his output in a letter to a friend: "I have already done an equestrian portrait of the king [copy, Uffizi], to his great pleasure and satisfaction. I have also done portraits of all this royal family, for the particular interest of the Serene Infanta, my patroness."[21]

Besides the commissioned works, Rubens painted a few pictures for his own pleasure, notably a series of copies after masterpieces by Titian in the royal collection (plate 104), which may have been created right in front of the king. "I know him [Philip IV] by personal contact," Rubens wrote, "for since I have rooms in the palace, he comes to see me almost every day."[22]

104. Peter Paul Rubens (after Titian),
Rape of Europa
Madrid, Museo del Prado

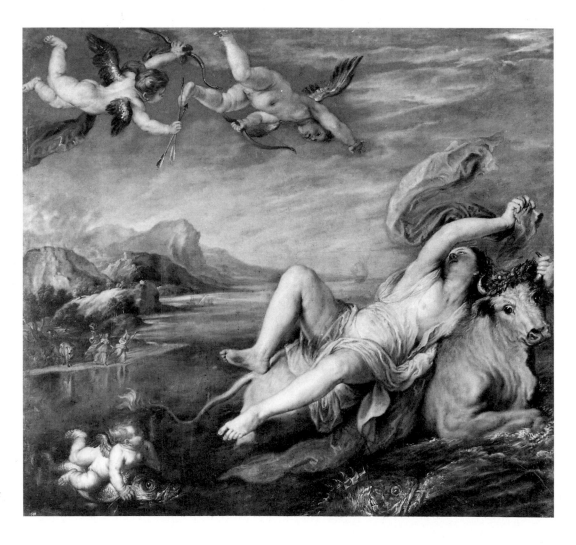

We can only speculate on how the king was affected by the chance to see the art of Titian through the eyes of Rubens, although subsequent events do provide a clue. In June 1629 Philip granted Velázquez permission to visit Italy, where he steeped himself in Italian art and reinvented himself as a painter. As for the king, soon after Rubens' departure he began to emerge as a picture collector on a grand scale. During the 1630s, as Charles I was stepping back from the art market, Philip IV was plunging in head first.

The surge of interest in pictures was bolstered by the construction of two new royal houses, the palace of the Buen Retiro and the Torre de la Parada. The scale of the Retiro—much larger than the Torre, which was only a small hunting lodge—required the acquisition of hundreds of pictures in a brief period of time. The Buen Retiro was an outsized suburban villa set in a large park on the eastern outskirts of Madrid.[23] It began quite modestly in 1631 as an enlargement of the royal apartment attached to the monastery of San Jerónimo, but no sooner had this project been completed than further extensions were planned and hastily constructed, until by 1633 it had become a sizable if somewhat haphazardly planned dwelling (plate 105).

The inspiration and driving force behind the Retiro was the count-duke of Olivares, who conceived of it as a pleasure palace for the court and a theater for the arts; and it was Olivares who took charge of gathering the objects for the decoration. The monarchy, for all its financial woes, was still rich, and had agents and ambassadors in Italy and Flanders who were able to do its artistic bidding. This apparatus of state was applied by Olivares and the king to the collecting of pictures. Many of the works were commissioned for specific sites and therefore technically became part of the royal collection only after the death of Philip IV. However, some are of sufficient importance to deserve at least a passing reference.

For instance, the ambassador in Rome, Manuel de Moura, Marquis of Castel Rodrigo, commissioned around fifty landscapes from such leading masters of the genre as Claude Lorrain (plate 106) and Nicolas Poussin (plate 107).[24] The agent in Flanders, the king's brother Ferdinand (plate 108), certainly had more important things to do than gather pictures. He had been appointed governor of the Netherlands, where he arrived in 1634, and was responsible for the conduct of the war against the Dutch Republic and later against France. In his spare moments he oversaw the commissions for Rubens which were now arriving at frequent intervals from Madrid. Most of the pictures for the Retiro were farmed out to the master's assistants and collaborators, as well as to independent painters in Antwerp. The major work from Rubens' brush was the *Judgment of Paris* (plate 109); other contributors were Frans Snyders and Paul de Vos, who created a charming series of illustrations of fables from Aesop (*Tortoise and Hare*, Prado), and Jan Wildens, a landscape specialist.

105. Attributed to Jusepe Leonardo,
Palace of the Buen Retiro
Madrid, Museo Municipal

667.

106. Claude Lorraine,
Landscape with St Mary Magdalene
Madrid, Museo del Prado

107. Nicholas Poussin,
Landscape with St Jerome
Madrid, Museo del Prado

108. Anthony van Dyck,
Cardinal-Infante Ferdinand
Madrid, Museo del Prado

109. Peter Paul Rubens, *Judgment of Paris*
Madrid, Museo del Prado

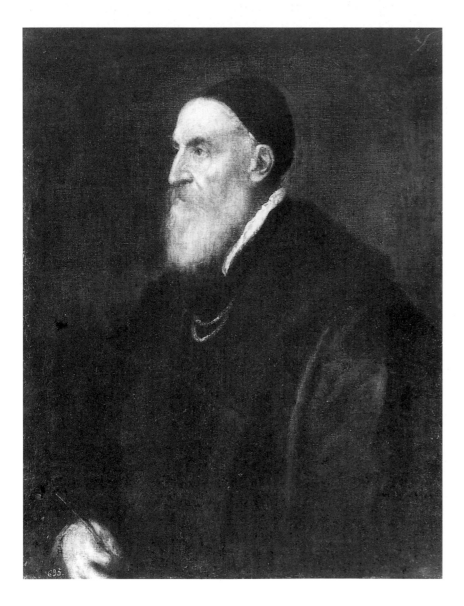

111. Peter Paul Rubens, *Nymphs and Satyrs*
Madrid, Museo del Prado

112. Titian, *Self Portrait*
Madrid, Museo del Prado

113. Anthony van Dyck, *Arrest of Christ*
Madrid, Museo del Prado

In the mid 1640s Philip bowed at last to the realities of the deteriorating political situation and spent considerable time leading his troops against the French, who by this time had pushed into Aragon in aid of the Catalans. Once the invaders had been repelled, he was again able to spend time on his collection, especially on installing it to best advantage in the Alcázar (plate 114).[31] Working closely with his curator, Velázquez, he planned the decoration of several galleries and rooms in the public spaces and private quarters of the palace. In 1649 Velázquez was dispatched to Italy to buy pictures and ornamental sculpture for these projects. However, the major acquisitions of the early 1650s were the gifts from Luis de Haro culled from his purchases at the Commonwealth Sale.

In becoming a picture collector, Haro was obviously following the example of the monarch. Apart from anything else, it gave the two men a common interest, something to talk about other than the depressing condition of the monarchy. However, Haro's use of collecting as a means of access to the king was not unique. As had occurred in London, so in Madrid the royal passion for painting inspired leading courtiers to form their own collections. During the regime of Olivares this form of flattering imitation acquired fresh momentum among a small group of his relatives, Haro included, who became rich on grants of offices and revenues given as a reward for political fealty. Known as the *parentela*, or the clan, they can be seen as the equivalent of the Whitehall Group, trying to emulate the king's obsession with painting and plying him with choice works to keep his memory of them fresh.

114. Anonymous, *Alcázar of Madrid*
Madrid, Museo Municipal

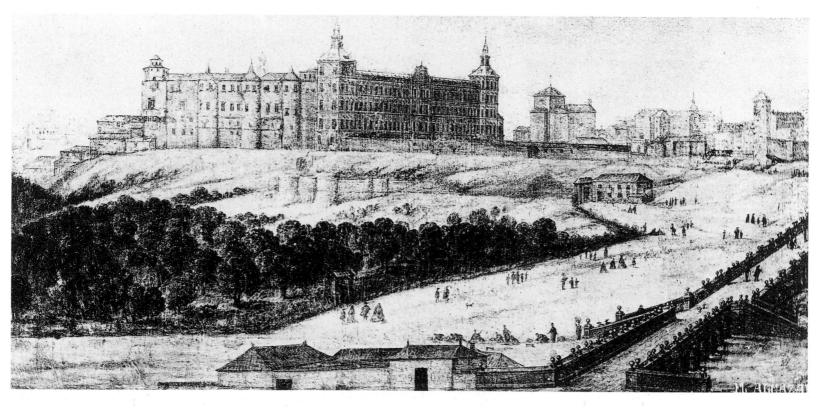

The senior member of the clan was the count-duke's cousin Diego Mexiá Felípez de Guzmán, Marquis of Leganés (*c.* 1585–1655, plate 115). In his early years, before the rise to power of his relative, Leganés began a military career, and it was primarily as an unsuccessful general that he made his mark and fortune. In fairness it must be said that part of his wealth came from his wife's dowry, which amounted to the substantial sum of 200,000 ducats. He and Policena Spinola were married in February 1628, which is just around the time Leganés received the offices and appointments which fueled his collecting ambitions.

Leganés was often in Flanders in these years, where he had spent time as a youth, and frequently saw the collections owned by the infanta Isabella (plate 116), as well as the many smaller collections in Antwerp. Inevitably he met Rubens who, never sparing of hyperbole, identified him in 1628 as "among the greatest admirers of this art that there is in the world."[32]

Rubens presumably foresaw the greatness in Leganés, because at this time his collection was minuscule. An inventory of 15 February 1630 lists a mere eighteen paintings and one set of tapestries.[33] This insufficiency was soon to be corrected by abundant money and extensive travel. Leganés was in Flanders again in 1634, and two years later assumed command of the army in Milan, where he led his Spanish troops to a decisive defeat by the French at Casale in 1640. Greater success awaited the marquis in the arena of collecting, as indicated by a second inventory, dated 30 March 1642, which lists no fewer than 1150 pictures, or 1132 more than he possessed in 1630. The accelerated speed and quantity of purchases puts Leganés in a class with many of the megacollectors of the seventeenth century.

116. Willem van Haecht, *Gallery Painting with Infanta Isabella and the Marquis of Leganés* Location unknown

115. Peter Paul Rubens, *Marquis of Leganés* Vienna, Graphische Sammlung Albertina

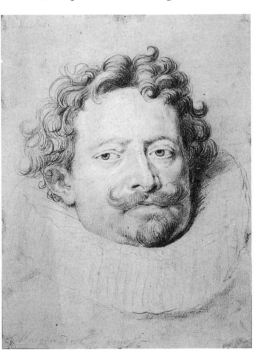

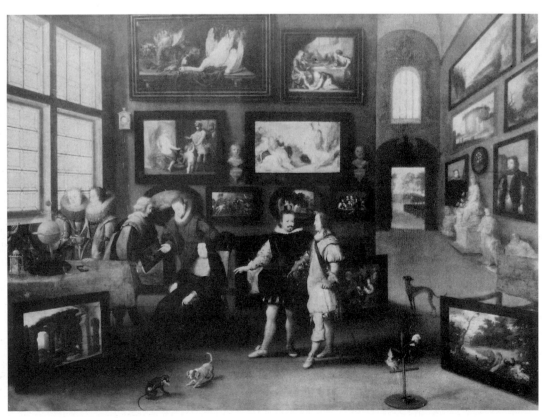

117. Peter Paul Rubens, *Annunciation*
Antwerp, Rubenshuis

While most of his paintings have not been identified, the 1642 inventory reveals the traditional Flemish-Italian bias of Spanish collectors. During his stays in Flanders Leganés acquired nineteen pictures by Rubens (plate 117), seven by van Dyck (*Mystical Marriage of St Catherine*, Prado), and over a dozen animal paintings by Frans Snyders. Rather more unusual were the Flemish primitives, which had fallen somewhat out of favor in Spain by the seventeenth century. There are works in the inventory attributed to Jan van Eyck and Roger van der Weyden, as well as such early sixteenth-century painters as Joachim Patinir and Quentin Massys (*Old Woman*, Prado).

Leganés' Italian pictures presumably were purchased during his five-year stay in Lombardy. He owned all the right names—Giovanni Bellini, Palma il Vecchio, Giorgione, Perugino, Raphael, Leonardo, Veronese, Bassano and, of course, Titian. Very few of these pictures, which probably were incorrectly attributed, are known today. (If the inventories of the seventeenth century are taken literally, Titian would have painted several thousand pictures.)

Although it seems strange, Leganés owned relatively few Spanish paintings, a bias shared by all the major collectors in Madrid, beginning with the king. An exception was made for Velázquez, whose cachet as court painter bestowed the requisite prestige on his works; another was made for that painter of exquisite still lifes, Juan van der Hamen y León (plate 118).

118. Juan van der Hamen, *Still Life with Artichokes and Vases of Flowers* Madrid, Naseiro Collection

After his defeat by the French, Leganés' career went into something of a decline, which may have dulled his appetite as a collector. When he died in Madrid on 16 February 1655 he owned 1333 paintings; that is to say, a mere eighty-three more than are listed in the inventory of 1642.[34] According to the terms of his will, these works were to be incorporated into the permanent patrimony of his house, a sign of the symbolic value he attached to his collection. The pictures remained with his descendants until the early nineteenth century, when they were sold to relieve the indebtedness of a once-proud line.

Like other members of the clan, Leganés was cognizant of the source from which all favors flowed and from time to time presented pictures to Philip IV as a token of his gratitude. Accordingly, two of his best works by Rubens were offered to the sovereign: the *Virgin of the Immaculate Conception* (plate 119) and the *Devotion of Rudolph I to the Eucharist* (Prado), both of which were given in the early 1630s. By this time it was becoming widely known that gifts of pictures to the Spanish monarch were obligatory for those who wished to gain or maintain his favor. These gifts became an increasingly important source of stellar additions to the royal collection.

In 1632 Cardinal Lodovico Ludovisi, one of the most important collectors in Rome, died, bequeathing part of his estate to his brother Niccolò, Prince of Piombino.[35] Among the items in the bequest were two of Titian's most renowned pictures, the *Bacchanal of the Andrians* and the *Worship of Venus* (plates 120 and 121). News of the cardinal's death soon reached Lord Arundel, who instructed his agent William Petty to make a bid.[36] Arundel, however, had nothing to offer but money, and Piombino had his sights set on political favors. Thus, he sent the pictures to the king of Spain via the viceroy of Naples, the count of Monterrey, who brought them to Madrid in 1638. The arrival of the paintings was noted by the English ambassador, who also commented on the virtual epidemic of collecting then spreading through the court.

And the king within these twelve months has gotten an incredible number of ancient and the best modern hands, and over with the count of Monterrey came the best of Italy, particularly the Bacchanalian of Titian. And in this town is not a piece worth anything but the king takes and pays very well for them. And in his imitation the Admiral [the duke of Medina de Rioseco], don Lewis de Haro and many others are making collections.[37]

Monterrey, Olivares' brother-in-law, had made a collection, too, although not of great size. At his death in March 1653, he had about 265 paintings, many of which were installed in a specially constructed gallery in the garden of his villa.[38] Fittingly the site is now occupied by the Banco de España.

119. Peter Paul Rubens, *Immaculate Conception*
Madrid, Museo del Prado

120. Titian, *Bacchanal of the Andrians*
Madrid, Museo del Prado

121. Titian, *Worship of Venus*
Madrid, Museo del Prado

Monterrey was a rapacious soul and is not known to have made gifts to the king. More forthcoming was the upstart Ramiro Núñez Felípez de Guzmán (like Leganés, he changed his patronymic to honor the king—Felipe—and the count-duke Gaspar de Guzmán) (plate 122). This nobleman of modest origins was rescued from obscurity when the count-duke chose him as the husband for his daughter and only child, María. They married in January 1625, but María tragically died in childbirth in July of the following year. Olivares continued to favor the young noble and in August bestowed on him the title of duke of Medina de las Torres. More offices and appointments followed, making the duke a rich man, although his opulent style of living never allowed him to take money for granted.

Medina was a profligate spender, constantly in need of funds given his own limited patrimony, and supplied his financial needs by marrying a succession of rich women, the next of whom was the Italian Anna Carafa, Princess of Stigliano. (In 1660 he was to take the countess of Oñate as his third wife.) As a condition of the marriage, Medina was appointed viceroy of Naples, a position he held from 1637 to 1644. While in Naples the duke bought paintings for the Retiro and made a small collection of some seventy-five paintings (his personal taste ran to jewelry and precious metals).[39] Perhaps this made him willing to give the finest works to the king, notably Raphael's *Madonna of the Fish* (plate 123), which he appropriated from the Neapolitan monastery of San Domenico. (The prior did his best to prevent what amounted to theft, and when he would not accede to Medina's request he was banished from the kingdom.)

Medina returned to Madrid in 1644, a year after the fall of Olivares, and became engaged in a family struggle over the succession to power. He and Monterrey joined forces against Luis de Haro, but they did not prevail. Although Haro had not been close to Olivares, he had cannily fashioned a relationship with the king, which was decisive in securing the royal favor. In 1645, he acquired the title of Count-Duke of Olivares, although he preferred to be known as Marquis del Carpio, and with skill and discretion he stayed in power until his death in 1661.

122. Melchor Pérez, *Duke of Medina de las Torres*
Madrid, Museo del Prado

123. Raphael, *Madonna of the Fish*
Madrid, Museo del Prado

Haro, like other members of the clan, nourished his relationship with the king with gifts of paintings. As the English ambassador had noted in 1638, he was among those then starting to collect, and his holdings are recorded in an inventory of 1647 compiled on the death of his wife, Catalina Fernández de Cardona.[40] Unfortunately, the inventory was done in a cursory fashion and only a few works have attributions.

Once installed as favorite, Haro was able to afford the best and quickly made his tastes known. Too quickly, in fact, for the grand duke of Tuscany who, against the advice of his ambassador in Madrid, offered a present to Haro which failed to measure up. The picture in question is now regarded as a masterpiece of seicento painting, Ludovico Cigoli's *Ecce Homo* (plate 124).[41] It was sent to Madrid in the autumn of 1650, just as the first acquisitions from the Commonwealth Sale were arriving at the palace of the favorite, and the Florentine ambassador, Mgr Ludovico Incontri, could see that Cigoli's composition did not stand a chance of competing with those illustrious works.

And even if this picture happened to be among Cigoli's finest, it could scarcely win a place in Don Luigi's gallery, where there are so many excellent ones by artists of the first class, including Titian, Correggio, Raphael, Andrea del Sarto and others.

This judgment was confirmed by Angelo Nardi, the now-ancient Florentine painter, long resident in Spain, who had become an artistic advisor to Haro. He was invited by Incontri to his house and roundly confirmed the ambassador's judgment.

I am given to understand by Angelo Maria Nardi, who is painter to His Majesty . . . , that modern pictures count for nothing in this place. On his advice, many gentlemen . . . have sent back to Italy works by Guido Reni, Guercino of Cento, Bassano, Cigoli and others, including even Rubens. While taking Nardi around my house, I happened to show him the Ecce Homo, *and he told me that it is not even worth a hundred scudi here.*

Those in Florence were finally convinced that Spanish taste was better than they thought, and ordered the picture to be returned.

Incontri may have exaggerated the low esteem in which the moderns were held at court, but he was not entirely off the mark. Haro, who knew the king's taste intimately, was careful to give him only the best old paintings from London. Thus the gifts of Raphael's *Holy Family* (plate 58) and of Tintoretto's *Christ Washing the Feet of the Apostles* (plate 71); and these were just for starters.

124. Ludovico Cigoli, *Ecce Homo*
Florence, Palazzo Pitti

Gifts of paintings to Philip IV continued to arrive regularly during the few remaining years of his reign. In 1654, for instance, Queen Christina of Sweden, recently and spectacularly converted to Catholicism, sent Dürer's *Adam* and *Eve* (plates 127–8) to Madrid.[45] This seems a splendid thing to have done, although the queen was merely culling her collection, having resolved to concentrate on the Italians. A second donation was made by the prince of Piombino, who presumably was satisfied with the results of the gift of the two works by Titian in 1638. He remembered the king in his will and in 1664 bequeathed six more pictures, among them Guercino's *Lot and His Daughters* (El Escorial) and *Susanna and the Elders* (plate 129).[46]

Despite the parlous state of the royal treasury, depleted by almost four decades of war, Philip continued to buy whenever a good opportunity arose. The dedication of scarce funds for this purpose is quite remarkable when, as one observer noted, there was not enough ready money for food.

For the last two months and a half the usual rations have not been distributed in the palace, for the king has not a real. On the day of St Francis, they served a capon to the infanta María Teresa [future wife of Louis XIV], who ordered them to take it away, as it stank like a dead dog. Then they brought her a chicken, of which she is fond, on sippets of toast [croutons], but it was so covered with flies that she nearly overturned it. This is how things go in the palace.[47]

129. Guercino, *Susanna and the Elders*
Madrid, Museo del Prado

127. Albrecht Dürer, *Adam*
Madrid, Museo del Prado

128. Albrecht Dürer, *Eve*
Madrid, Museo del Prado

Even to those who viewed the court without malice, there could be no doubt that the times as well as the poultry in Spain were tough. Nevertheless, in 1661 Philip purchased a work by Raphael for what may be the highest price ever offered for a painting. This is *Christ on the Road to Calvary* (plate 130), known as the "Spasimo di Sicilia" because it was owned by the monastery of Santa Maria del Spasimo in Sicily.[48] In 1661 the picture was shipped to Madrid as a quasi-gift. The use of this term is advised because the monastery really intended to barter the picture in exchange for a subsidy. Its petition was reviewed by the Council of Italy and sent to the king for a decision. On 15 October 1661, he decreed that the monastery be granted 4000 ducats a year in perpetuity and that a bonus of 500 ducats be awarded to the abbot of the monastery, who had brought the painting to Spain. The price was truly spectacular (consider that *La Perla* was bought from the Commonwealth Sale for roughly 4700 ducats), although it would be interesting to know how much the monks were ever able to collect.

Just a year before he died, Philip made his final recorded purchase. In 1656 one of his Italian generals, Giovanni Francesco, Marquis of Serra, was killed at sea, and eight years later his executors sold his small but choice collection of pictures for the benefit of his son.[49] The sale took place in Naples, and on behalf of the king the viceroy, Gaspar de Bracamonte, Count of Peñaranda, paid 14,000 ducats for thirty-nine canvases. The best of these were Guido Reni's *Atalanta and Hippomenes* (plate 131), Lorenzo Lotto's *Messer Marsilio and His Wife*, Parmigianino's *Count of San Secondo* (Prado) and Annibale Carracci's *Venus and Adonis* (plate 132).

131. Guido Reni, *Atalanta and Hippomenes*
Madrid, Museo del Prado

130. Raphael, *Christ on the Road to Calvary*
Madrid, Museo del Prado

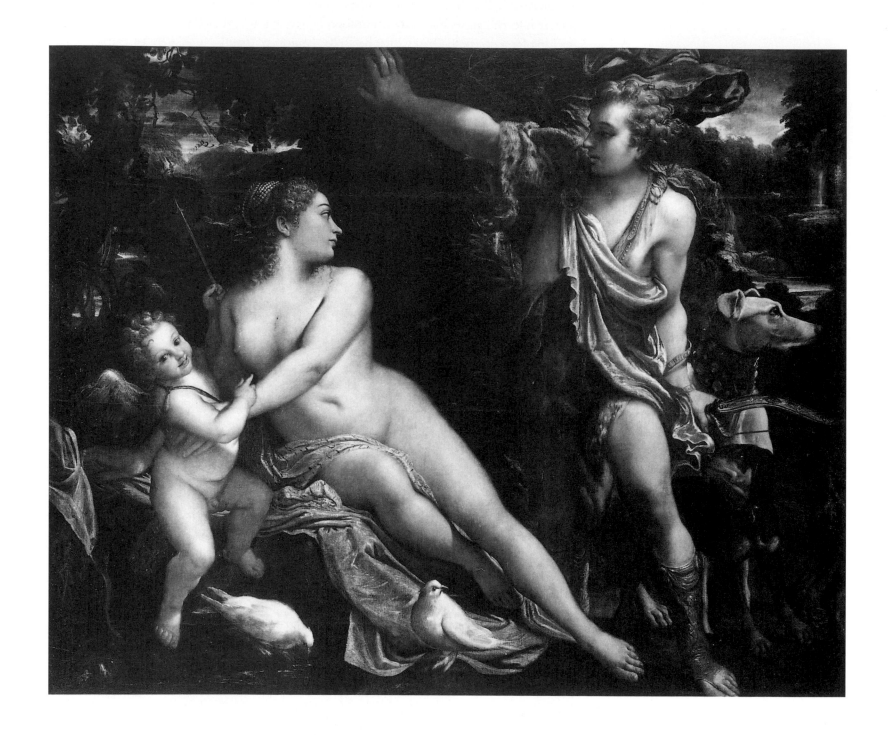

When Philip IV died on 17 September 1665 his panegyrists called him the Planet King. By this epithet they meant to identify him as the Sun King, because Spanish astronomers believed that the sun was the fourth of the planets. Historians are as skeptical about the image of the king as scientists are about the reliability of his astronomers. However, there can be no doubt that his long reign, numbering no fewer than forty-four years, was decisive for Spain's political fortunes. By 1665 the Most Christian King of France, Louis XIV, had replaced His Catholic Majesty as the leading monarch of Europe, and Spain was on the way to becoming a secondary power.

In this scheme of things, Philip's activities as a collector of paintings may seem narrow ground on which to stake his claim to immortality. Be that as it may, he was a fabulous collector and certainly the greatest of his age. Of the quality of his collection there can be no doubt. An inventory of the Alcázar was taken in 1686.[50] Although twenty years had passed since Philip's death, we may be certain that very few works had been added. The roster of major masters, even if given in approximate numbers, is impressive—seventy-seven paintings by Titian; sixty-two by Rubens; forty-three by Tintoretto; forty-three by Velázquez; twenty-nine by Veronese; twenty-six by the Bassanos. To these must be added the treasures of the El Escorial, where there were nineteen more canvases by Titian, eleven more by Veronese and eight by Tintoretto and five by Raphael, to name only the most prestigious Italians.

These pictures represented only the tip of the iceberg. Although the royal collection grew spectacularly under Philip IV, it is difficult to arrive at an exact number of his acquisitions. It was customary to inventory the royal collection after the death of a monarch, but this was not done in 1665, and the next complete inventory of all the palaces and country houses was not compiled until the death of the last Habsburg, Charles II, in 1700.[51] At that time, by one calculation, the twelve royal seats housed no fewer than 5539 paintings, compared to the roughly 1500 left at the death of Philip II.[52] If we generously assign a thousand of the seventeenth-century acquisitions to the reigns of Philip III and Charles II, we are left with a total of around three thousand attributable to Philip IV's activities. This is an incredible number, even if the dross outweighed the gold.

A picture-loving king inspired picture-loving subjects. Philip IV really was a picture man; he evinced little interest in any other artistic medium. Thus picture collecting became the favored avocation of almost anyone in Madrid with social pretensions, from grandees and magnates to bankers, merchants and royal bureaucrats.[53] For the sheer quantity of pictures, Madrid was unmatched at this time, unless by Rome or Antwerp. This at least was the conclusion reached in 1667 by a French cleric, Jean Muret, who paid a visit to Madrid in that year. He wrote as follows to a correspondent in Paris:

I can assure you, Sir, that there were more [pictures in the Buen Retiro] than in all Paris. I was not at all surprised when they told me that the principal quality of the deceased king was his love of painting and that no one in the world understood more about it than he.[54]

Despite Rubens' claims on behalf of Charles I of England, Fr Muret undoubtedly was correct.

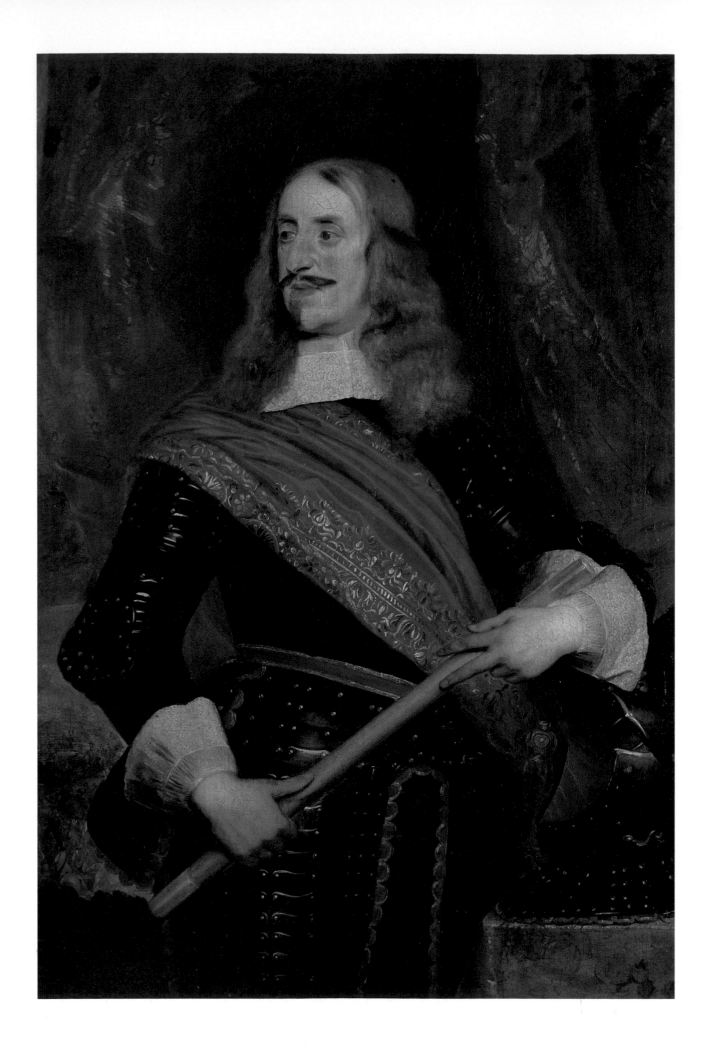

IV. "AMATOR ARTIS PICTORIAE:"
Archduke Leopold William and Picture Collecting in Flanders

On 11 April 1647 Archduke Leopold William of Austria entered Brussels to begin his appointment as governor-general of the Spanish Netherlands. While the northern provinces of the Netherlands (later known as the Dutch Republic) had declared their independence from Spain in the later sixteenth century, the southern provinces (Flanders) had been subdued and were customarily ruled by a member of the royal family or a high-ranking aristocrat. However, the appointment of a member of the Austrian branch of the Habsburg dynasty was by no means unprecedented; as recently as 1598 Archduke Albert had governed in consort with the infanta Isabella Clara Eugenia, a daughter of Philip II. Although Albert and Isabella were granted sovereignty over Flanders, the territory reverted to the Spanish crown after Albert's death in 1621 and was ruled by the infanta until she died in 1633.

The nomination of Leopold William appears to have been motivated by military considerations. While the conflict with the Dutch was virtually over by 1647 (the Treaty of Münster was signed in 1648), the Spanish were in the midst of a protracted war with France, which had started in 1635 and would not end until 1659, to the advantage of the French. As an experienced if not always victorious general, Leopold was the logical choice to lead the military operations on the northern front.

The archduke (plate 133) was born in Graz on 6 January 1614, the second son of Emperor Ferdinand II.[1] Initially he had been intended for the church, and as a member of the imperial family he was not obliged to work his way up to high office. In 1625, at the age of eleven, he was named bishop of Passau and Strasbourg. (The practice of appointing princes to bishoprics at an early age was customary in both branches of the house of Habsburg and was done for symbolic as well as financial reasons.) A dozen years later, in 1637, he added the title of bishop of Olmütz (Moravia) to his dignities.

In 1639, the bishop changed careers and was appointed Generalissimus of the imperial army. Under the tutelage of an Italian mentor, he developed into a capable military commander and, during the next few years, led his troops against the forces of Gustavus Adolphus of Sweden.

Soon after arriving in Flanders, Leopold William was able to score some impressive victories against the French, but these were transitory; Spain no longer possessed the financial resources to support the army in the north, and for the rest of his tenure as governor, which ended on 9 May 1656, Leopold William fought mostly losing battles.

Prior to his arrival in Flanders, the archduke seems to have been a negligible presence in the world of art collecting. In 1636 he received a visit from the earl of Arundel in Vienna, which was recorded in a diary written by a member of Arundel's entourage. Admittedly, the archduke was only twenty-two years old at the time, but the description of his palace is almost dismissively spare.

133. Peter Thys, *Archduke Leopold William*
Vienna, Kunsthistorisches Museum

On the next day, which was Sunday, 26 June, His Excellency [Arundel] had an audience with the queen of Hungary and Archduke Leopold, the emperor's second son. There is nothing noteworthy about the archduke's palace apart from its spacious courtyard. Visiting the archduke's lodging the following day, we saw only a few pictures....[2]

In the succeeding years, Leopold William acquired works by now-obscure court painters at Vienna, but there is no hint of his future as one of the great picture collectors of the seventeenth century and the major beneficiary of the dispersal of the collections of the Whitehall Group. The transformation of the archduke from bishop-warrior to art lover is a complex tale.

Part of the story might be called genetic. Leopold was a member of the Austrian branch of the house of Habsburg. The Habsburgs had emerged as the major ruling family of Europe during the reign of Maximilian I (1459–1519). In 1477 Maximilian married Mary of Burgundy, heiress of the duchy of Burgundy, thus uniting the Germanic Holy Roman Empire to the rich territories of the Netherlands. Through the dynastic marriages of their son, Philip, and daughter, Margaret, to the offspring of Ferdinand and Isabella, the infante Juan and the infanta Juana, a sprawling European and transoceanic empire was created, possessed of immense territories and riches. This inheritance devolved upon the son of Philip of Burgundy and Juana of Castile, who ruled as Emperor Charles V (1519–55). Through extraordinary political and military efforts, Charles was able to maintain his legacy intact until his abdication in 1555. At that point the empire was split in two; the Austrian Habsburgs kept the lands in central Europe and the imperial title, while the Spanish Habsburgs remained with Spain, its overseas colonies and the Netherlands (as well as certain possessions in Italy).

Maximilian I had been an avid lover of the arts and established a pattern of patronage and collecting which inspired both branches of his family.[3] We have already surveyed the achievements of the Spanish Habsburgs, exemplified by Philip II and Philip IV. The Austrian Habsburgs were no less distinguished in the realm of the visual arts, and during the sixteenth century two of their number, Archduke Ferdinand II (1529–95) and his nephew Emperor Rudolph II (1522–1612) amassed extraordinary and diverse collections.

Both were encyclopedic collectors, who sought the rarest and most beautiful natural and man-made objects. These were assembled in spaces specifically dedicated to the display of the treasures, which were baptized by Ferdinand II in his testament with a name still in use, *kunst- und wunderkammer* (chamber of art and marvels).[4] Ferdinand's collection was installed in his castle at Ambras, near Innsbruck, while that of Rudolph, even greater and more splendid, was kept in the imperial palace on the Hradcany in Prague, where he resided. Despite the disparity in size and splendor, these collections were guided by the desire to dazzle and astonish the viewer with the most extraordinary examples of artifice, whether created by the sublime design of artisans or the mysterious workings of nature. Pieces of gold- and silversmith work, exquisitely wrought and set with an abundance of precious stones, were juxtaposed with natural phenomena such as unicorn horns (actually narwhal tusks), exotic sea shells, sinuous pieces of coral (considered to be a kind of divine sculpture) and sometimes dubious freaks of nature. Musical and scientific instruments, coins and medals, books and codices, arms and armor and automata all had a place in this ambitious attempt to recreate the infinite variety of the universe within the compass of a single collection.

The so-called fine arts, painting and sculpture, were also enshrined within the *kunst- und wunderkammer*, although they were not considered as more valuable than other objects in the collection. Ferdinand owned about a thousand paintings while Rudolph, one of the greatest picture collectors of all time, had approximately three thousand, some of which were major examples of the art. These were installed in a large gallery in the palace at Prague, known as the "Spanish Room," which was a public space and thus more accessible than the private chambers which housed the objects and curiosities.[5]

After the death of Rudolph II the empire was engulfed by the tragic events of the Thirty Years' War (1618–48), which made it difficult to keep the collections intact, not to mention enlarge them. Some parts of Rudolph's holdings were removed during the Protestant uprising in Prague in 1618 and others were taken to Vienna for safekeeping. The coup-de-grace was furnished by the sack of Prague in July 1648, during which Swedish soldiers raided the imperial palace and plundered the art collection for the benefit of their sovereign, Christina of Sweden. These recent events and ancestral memories provided a strong impetus to Leopold William to form an art collection. The other factor was proximity to Antwerp, the most dynamic market for art in seventeenth-century Europe.

An active art market almost inevitably develops in places where commercial and financial activity is intense. These activities not only generate the surplus capital needed to support a market for luxury goods; they also provide prototypes of mercantile techniques which are adaptable to the selling of art. Thus, in the eighteenth century the rising English economy supported the growth of the art trade in London, while the burgeoning prosperity of the United States of America after the Second World War created a lucrative market for art in New York City, where dealers adapted elaborate lending and hedging schemes invented for transactions in stocks and bonds. During the sixteenth century Antwerp was the leading commercial center in Europe, and its traders were to provide inspiration for the development of a flourishing art market.

The origins of the Antwerp art market reach back to the year 1460, when what has been called the "first showroom in postclassical Europe to be constructed expressly for the exhibition and sale of works of art" was opened by the Church of Our Lady, later to become the cathedral of the city.[6] The structure, known as Our Lady's *Pand* (or covered market), was a courtyard built in the grounds of the church and rented to art merchants for use during the biannual trade fairs held in Antwerp. Rental fees were charged by the running foot and stalls were occupied by painters, sculptors, joiners and booksellers. (Gold- and silversmiths and tapestry manufacturers sold their goods from other premises.)

By the early decades of the sixteenth century the art trade was booming, following the upward course of the Antwerp economy, which was based on an international trade in commodities. An ancillary institution, known as the Friday Market, also came into being. This was a weekly auction of used merchandise and household furnishings, including art works, which was conducted by dealers in second-hand clothing, the understandably forgotten ancestors of the well-heeled minions who now glide through the sale rooms of the leading auction houses in London and New York. Eventually the seasonal calendar of the *Pand* was replaced by year-round activity, a development completed by the 1540s and precipitated by the opening of the

134. *The New Bourse, Antwerp,*
from L. Guicciardini, *Discritte de M. Lodovico*
Guicciardini patritio Fiorentino di tutti i Paesi
Bassi, etc (Antwerp, 1581)
Princeton University Library

New Bourse, home of the Antwerp Exchange, where dealings in commodities and luxury goods were conducted under one roof (plate 134). The Antwerp Exchange, which unselfconsciously brought bankers, merchants and art dealers together as part of the same commercial enterprise, drove the *Pand* out of business and initiated a new phase in the art market.

This phase is characterized by a notable increase in the volume of trade, inspired partly by the uninterrupted selling season, partly by the imitation of the commodities dealers. Operating from their stalls in the courtyard of the Exchange, artist-dealers booked huge orders of paintings and tapestries from foreign agents who shipped them abroad like so much wheat or iron. For example, in 1553 more than four tons of paintings and roughly 70,000 yards of tapestries were shipped from Antwerp to Spain and Portugal.[7] The quality of these works cannot have been inspiring; however, pictures by prominent artists were readily available in their shops, where a good painting could be bought off the shelf.

The boom in Antwerp's trade was gradually slowed and then halted by economic and political events beyond local control, which culminated with the revolt of the northern provinces of the Netherlands around 1570. No city suffered more than Antwerp, which was racked by conflicts between Calvinists and Catholics. In 1585 the Spanish laid siege to the city and finally subdued its rebellious citizens. It was also in this year that the Dutch blockaded the River Scheldt, Antwerp's outlet to the North Sea and thus to the world. The devastation of the war and the restriction of commerce reduced Antwerp's importance as the principal European center for international trade, a role soon to be assumed by Amsterdam.

A slow if partial recovery ensued during the first half of the seventeenth century, which was fostered by the enlightened rule of Archduke Albert and Infanta Isabella and enhanced by the Twelve Years' Truce of 1609–21, during which Spain and the United Provinces ceased

hostilities. With the restoration of peace came a recovery in the art market, and as a consequence a new golden age of art, and particularly painting, was created, the significance of which can be measured merely by citing the name of its protagonist, Peter Paul Rubens, although the supporting cast were by no means bit players—Anthony van Dyck, Jacob Jordaens, Frans Snyders and Jan Brueghel the Elder. The recrudescence of artistic activity was accompanied by the revival of art collecting.

As in other parts of Europe, large-scale collecting commenced in the Netherlands in the sixteenth century, and the protagonists, once again, were members of the house of Habsburg. The artistic endeavors of Margaret of Austria and Mary of Hungary have been alluded to above; the aunt and sister respectively of Charles V were renowned for the brilliance of their courts and their patronage of the arts. Their practices were revived by Albert and Isabella, who induced Rubens to return to Flanders from Italy and sponsored important ecclesiastical building projects in their domains.

The Flemish court in Brussels (plate 135) was ordered by a complex protocol which heightened awareness of social status and an appreciation of its attributes. As we have seen at the courts of England and Spain, the collecting proclivities of the sovereigns were imitated by the nobles, and this phenomenon can be detected at Brussels, too. More unusual, however, is the resonance among the Antwerp burghers of art collecting as an attribute of social rank.

135. Jan Brueghel, *Coudenberg Palace, Brussels*
Madrid, Museo del Prado

136. Attributed to Adriaen van Stalbent,
Gallery Picture.
Madrid, Museo del Prado

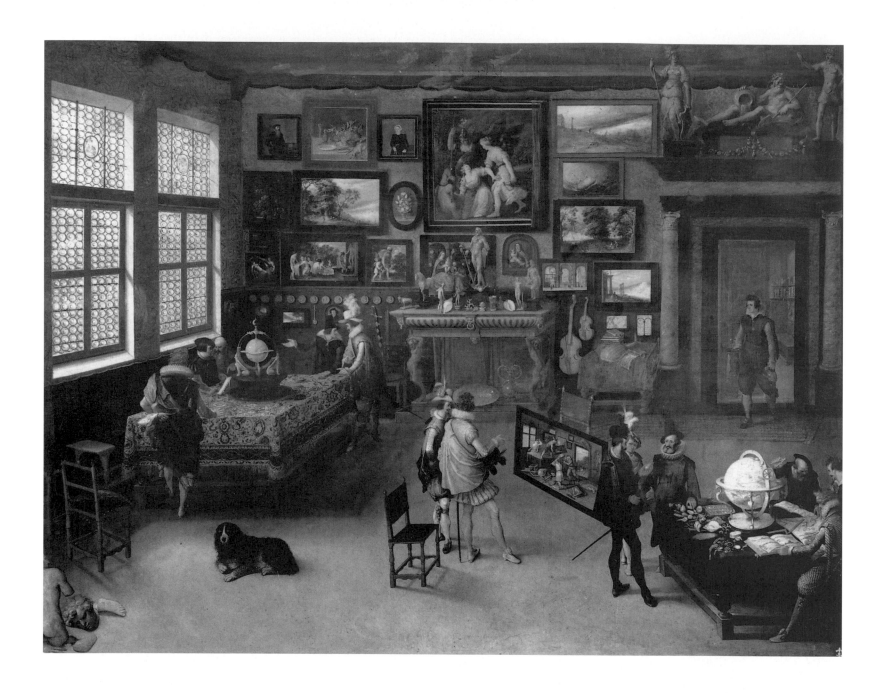

Then, as today, members of the merchant and financial sectors were exceptionally sensitive to the barometer of status, and Spanish court culture, which defined the upper levels of Netherlandish society and controlled access to its reaches, provided finely calibrated readings of an individual's standing in the climate of social opinion. This stimulated a hunger for nobility, which would dignify mere wealth and make a person and a family seem grand. In the seventeenth century these ambitions happily coincided with the desperate needs of the Spanish treasury, resulting in an outbreak of social climbing delicately known by historians as the inflation of honors, which was achieved through the sale of titles by the crown. The temptation to turn money into honor was irresistible and in the Netherlands, as in Spain, a wave of gentrification swept the mercantile classes.

This preamble is necessary to understand the phenomenon of art collecting in Antwerp in the first half of the seventeenth century. Of comparable importance is a type of painting created in Antwerp and nowhere else in Europe, the cabinet picture, which opens a window on the attitudes toward art and collecting shared by the burghers and painters of the city.

The earliest cabinet pictures were executed around 1620 and offer somewhat contradictory evidence about the status of Antwerp collections.[8] A typical example (plate 136), painted by a follower of Frans Francken the Younger (1581–1642), one of the inventors of the genre, demonstrates the peculiar gap between fiction and reality characteristic of the initial phase of development of these compositions. In a large well-lit room a heterogeneous collection of objects is on display. It is immediately apparent that the artist has depicted an encyclopedic collection typical of the sixteenth century, in other words, a *kunst- und wunderkammer*. Works of art are commingled with natural specimens, musical and scientific instruments, medals and books. The purpose of this *mélange* is explained by the inclusion of two allegories of ignorance. One is found in the painting on the floor, in which donkey-headed figures, symbolizing philistines, destroy an encyclopedic collection. The other is represented in the largest canvas on the wall, which shows Painting being rescued from Ignorance by Fame and Minerva (goddess of the arts). Behind the abstruse symbolism lies a simple point—the presentation of the encyclopedic collection as a means for promoting a knowledge and understanding of the world. Another point embedded in the picture is the notion that collecting is a gentlemanly pursuit. The visitors to the gallery wear expensive clothes and swords and strike elegant poses.

The exacting execution of these gallery paintings implies that they record actual collections, although nothing could be further from the truth. Many of the same works appear in different settings, and allegorical intentions are always to be found just beneath the often dazzling verisimilitude of the surfaces. Moreover, Antwerp collectors had already abandoned the encyclopedic ideal and were dedicating themselves to acquiring pictures exclusively. It was not until the 1640s that art caught up with reality, a process which occurred in stages. An important transitional work is the most studied of all the cabinet pictures, the *Gallery of Cornelis van der Gheest* (plate 137), painted in 1628 by Willem van Haecht, a leading exponent of the genre.[9]

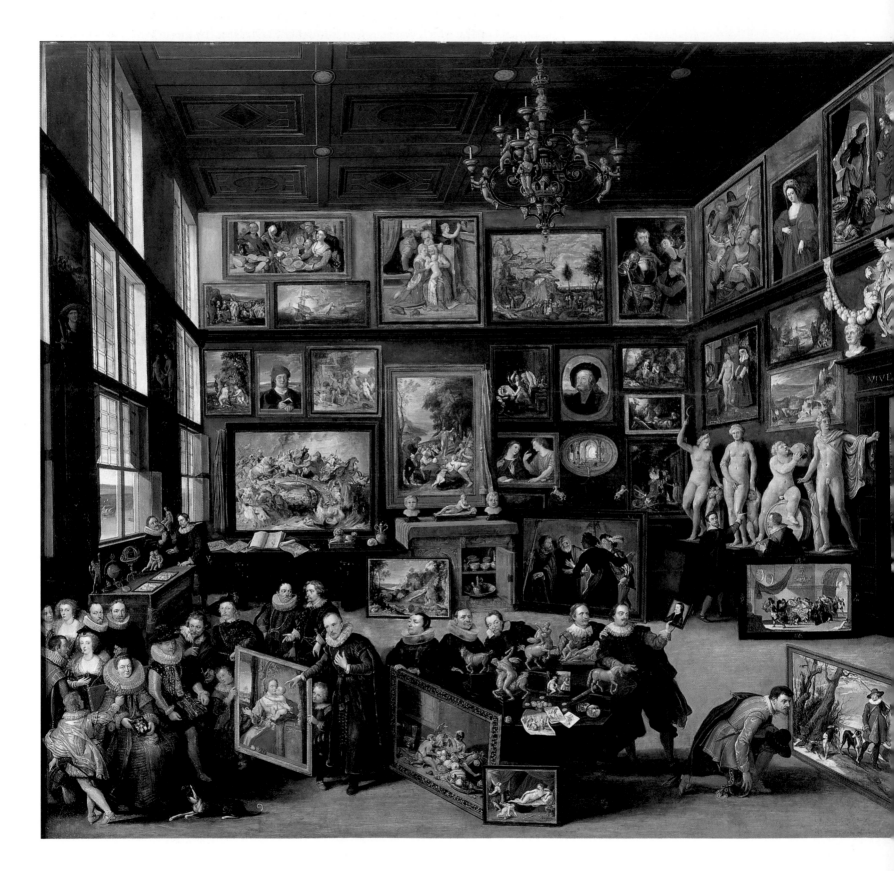

137. Willem van Haecht,
Gallery of Cornelis van der Gheest
Antwerp, Rubenshuis

Van Haecht's painting is above all a carefully plotted tribute to his patron, who was a dealer in spices and dean of the Antwerp guild of merchants. Van der Gheest (d. 1638) was typical of that sort of burgher who collected art as much for social as for aesthetic motives and, as seen here, his aspirations have succeeded beyond his wildest dreams. The cast of characters in the gallery have mostly been identified and an impressive lot they are. The collector, whose portrait with its wonderful, watery eyes was later painted by van Dyck (plate 138), stands to the left and points to a painting of the Madonna and Child. His immediate audience are the two seated figures, none other than the governors, Albert and Isabella, who are known to have visited van der Gheest's house in 1615. However, the painting is more than a document of a transcendental event in the merchant's life; it affirms the nobility of the collector and his collection.

Other members of the principal group are nobles or important people—the duchess of Croy; Wladislas Sigmund, future king of Poland (who visited Antwerp in 1624 and, because he is royal, is allowed to wear his hat in the presence of Albert and Isabella); the countess of Arenberg; and Ambrogio Spinola, the famous Genoese commander of the Spanish army. Another member of this company is Nicolas Rockrox, the burgomaster of Antwerp and an important collector in his own right. Also admitted into this privileged company are two who might be called nobles of the spirit—Peter Paul Rubens and Anthony van Dyck. Of the four figures clustered around the table in the middle, two are identified as Pieter Stevens and Jacques Cachiopin, both merchant-collectors of importance. Away to the right, at a safe distance from their betters, is a troop of five examining a globe, three of whom are the painters Jan Wildens, Frans Snyders and Hendrik van Balen. The figure seen through the door, the lintel of which is inscribed with van der Gheest's punning motto *Vive l'Esprit* (*gheest* is Flemish for spirit), is thought to be the painter van Haecht.

Van Haecht was equally scrupulous about recording the appearance of the pictures in the collection, which constitute an anthology of the Antwerp School from Quentin Massys (author of the painting being shown to Albert and Isabella) to Rubens, whose *Battle of the Amazons* (Munich) occupies a conspicuous place near the windows at the left. As we know from van der Gheest's death inventory, many of these pictures were owned by the prosperous merchant.

Van Haecht's painting might be classified as a "real allegory," that is to say a composition which employs real people (not all of whom, however, could have been present in van der Gheest's house at the same time) and objects to make a point, or rather several points. The elaboration of van der Gheest's status is obviously first on the agenda. Not a trace can be found of the mercantile activities which made it possible for him to own works of art worthy of a royal visitation. By the same logic, the works themselves are glorified because they attract the attention of princes, nobles and dignitaries. This metaphor of the exalted status of painting is a leitmotif of writing on art, and here it is made to seem a living reality.

The *Gallery of Cornelis van der Gheest* is significant in another respect; it captures the shifting balance between the fine arts, on the one hand, and the world of curiosities, on the other. From the start of the seventeenth century Antwerp collectors had increasingly fixed their attention on paintings to the virtual exclusion of other artistic media, not to mention the world of natural wonders. The privileged position of picture collecting was acknowledged by the creation of a special category of membership in the Guild of St Luke in Antwerp, the painters' guild. This

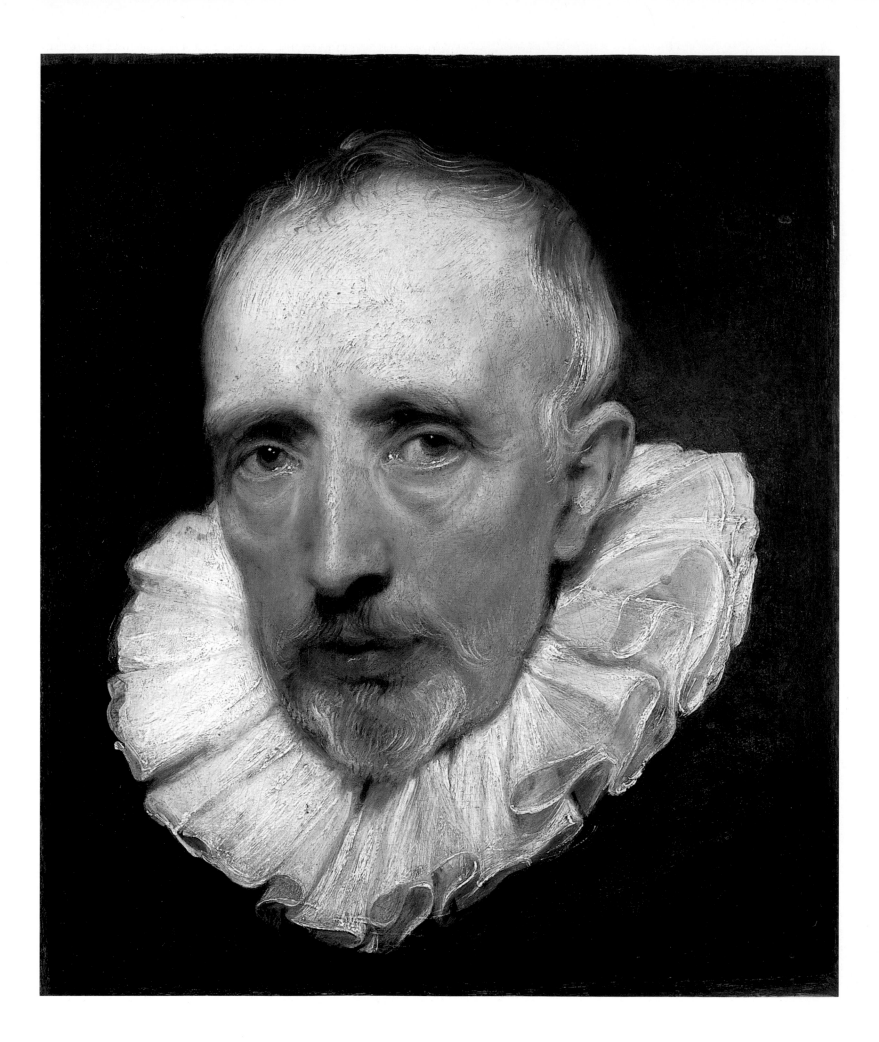

is the *liefhebber der schildereyen*, the lover of paintings, who first appears in the guild registers in the 1610s.[10] The acceptance of collectors was certainly motivated by the painters' self-interest; it made sense to fraternize with the customers. And credit must be given to the patrons for their willingness to put aside the social prejudices which, in other parts of Europe, limited the social interaction between artists and the upper social classes. However, what may have begun as a marriage of convenience evolved into a society of mutual admiration which reinforced the aspirations of both parties. By the 1630s it was a mark of distinction to be recognized as a lover of painting.

During the 1630s van Dyck, who by then had been knighted by the king of England, designed a series of portrait engravings of contemporary notables, which promoted his vision of a new social order. The prints, known collectively as the *Iconography* and published between 1636 and 1644, divide society into three groups, who rub shoulders in the pages of the edition— rulers and aristocrats; statesmen and scholars; and artists and collectors. Three of the collectors had already appeared in van Haecht's picture—van der Gheest, Stevens and Cachiopin— and their portraits appear in the *Iconography* accompanied by the motto *Amator artis pictoriae*, lover of the art of painting (plate 139).

To a certain extent, this propaganda outpaced the achievements of the collectors. Compared to the gigantic collections of rulers and aristocrats at princely courts, those of the Antwerp burghers were small, seldom exceeding a hundred in number. When all is said and done, the difference between the merchant-princes and the princes of the blood, who owned hundreds of paintings, is not to be denied. At his death in 1662 Cachiopin owned roughly seventy pictures, many of them copies, while Stevens' inventory of 1668 lists seventy-four lots.[11] Nicolas Rockrox, renowned as a friend and patron of Rubens, and also present in the picture of van der Gheest's collection, possessed closer to a hundred works when he died in 1640.[12] Given the posthumous reputation of these Antwerp collectors, it might be said that their investment in the art of painting was shrewder than any business deal they ever made.

In fact, the only Antwerp collector to approach major status was Peter Paul Rubens (plate 9), whose activities as a collector defy simple categorization.[13] For one thing, some of the most valuable pieces in his picture collection were works by his own hand (sixty-four of a total of around 330); he could add to his holdings and create value with the investment of intellectual rather than financial capital and scarcity was never a problem. Rubens had also learned a few tricks of the Antwerp trade and become a crafty *marchand-amateur*. As shown by his dealings with Sir Dudley Carleton, he could drive a hard bargain. Rubens is further distinguished from other Antwerp collectors by his passion for classical antiquities, a passion acquired during his years in Italy. Although most of the collection of antique sculpture which he had obtained from Carleton was sold to the duke of Buckingham, Rubens continued to own a choice assortment of engraved gems. (Nicolas Rockrox was another Antwerp collector interested in this material.)

IACOBVS DE CACHIOPIN
AMATOR ARTIS PICTORIÆ ANTVERPL.

139. Lucas Vorsterman (after van Dyck),
Jacomo de Cachiopin, from *Iconography*
Washington, D.C., National Gallery of Art

Maison Hilverue a Anuers ... dit l'Gostel Rubens 1684.

140. Jacobus Harrewijn, *Rubenshuis, Antwerp*
New York, Metropolitan Museum of Art

Despite these differences, however, Rubens fully perceived the value of a fine collection as a way to illuminate his social and economic achievements. His house was one of the grandest in Antwerp (plate 140), and between 1617 and 1621 he added to it a magnificent Italianate wing and courtyard, adorned with a painted decoration replete with classical allusions (now vanished), in which parts of the collection were displayed. Within the person and place of Rubens, the ventures of painting and collecting in pursuit of glory were conjoined.

For all the diversity of Rubens' collection, it was centered, as was only logical, on the art of painting. But it was not until after the painter's death in 1640 that the gallery picture began to express the reality of Antwerp collecting. An extraordinary image painted by Frans Francken the Younger (plate 141) depicts the triumph of picture collecting with unmistakable clarity.[14] In a small room adorned only with pictures and a few pieces of sculpture, three *liefhebbers der schildereyen* examine a small picture. Off to the right and seen through a door, two donkey-headed figures flail away at a scrap heap of once-precious objects swept out of the gallery, where they are no longer welcome. The donkeys of ignorance are doubly ignorant for wasting their energy in destroying what is now perceived as bric-a-brac. Painting, in this order of things, is the universal art and the only way to knowledge.

The passion for painting in Antwerp was not confined to the most prominent citizens. As in Madrid, it seems that almost anyone with cash to spare invested in a few canvases. Well over a thousand collections were formed between 1600 and 1660 and are documented in the archival repertory now being compiled by the Belgian scholar, Erik Duverger.[15] Supplying this demand required an active art market, and none was more active than Antwerp. As we have seen, the art trade had made a place for itself in the sixteenth-century economy and, once peace had come, the structures were at hand to rebuild the market. The commerce in pictures, for the

158

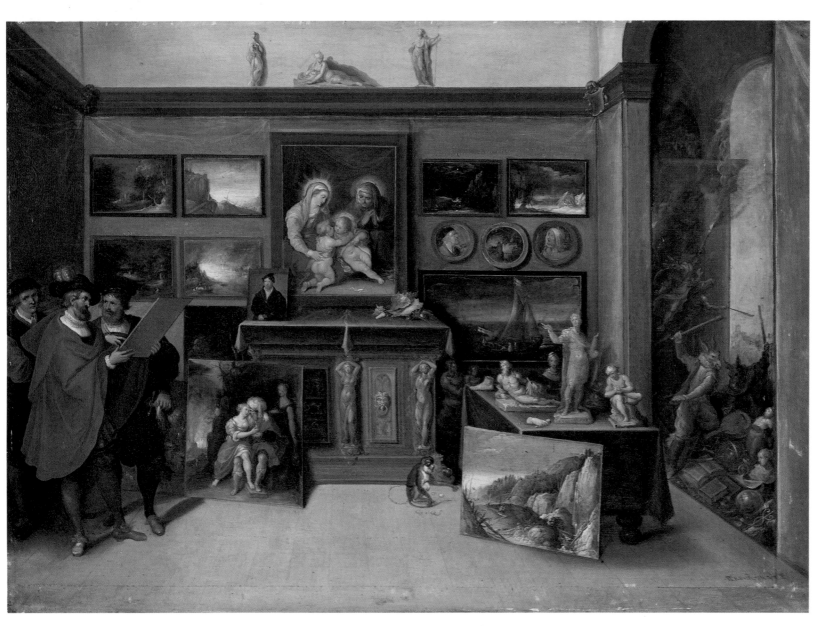

141. Frans Francken, *Gallery Picture*.
Munich, Bayerisches
Staatsgemäldesammlungen

most part, was handled by painters, as it had been before. They were considered experts in authentication, were adept at making copies and possessed the skills to restore and frame the works they handled. Many a painter dabbled in the market, dealing mostly in works by contemporaries but always on the lookout for the rarer works of the fifteenth and sixteenth centuries.

Following the precedents established in the sixteenth century, a few enterprising painters put their brushes aside and launched major export operations. Two firms enjoyed tremendous success in this endeavor, the Forchondt and the Musson.[16] The former was founded by Melchior Forchondt, a furniture-maker from Silesia who came to Antwerp around 1600. However, the genius of the operation was his son Guillaume (d. 1678), who was trained as a painter. Using his offspring as agents, he created a wide network for the export of pictures. Most of these were mass-produced by Flemish painters; however, the firm traded also in old pictures, which became available for purchase after 1650 as the Antwerp economy again pitched into serious decline and local collectors were forced to liquidate. The best results were obtained by the Viennese branch, which commenced operations in the 1660s and was manned by three of the Forchondt sons. By 1668 they had obtained a franchise for the entire empire and did their best to slake the growing desire for pictures which arose as the German lands gradually recovered from the devastation of the Thirty Years' War. Other outposts were set up in Lisbon and Cádiz (for trade with the Spanish colonies in America) and also in Paris.

In every respect, then, Leopold William, who was to lead the revival of collecting in central Europe, had come to the right place to build a great collection of pictures, and this is what he started to do.[17] One of the first notices of the archduke's sallies into the art market is dated 4 January 1648, when Jan van den Hoecke, the court painter, wrote to the dealer Matthys Musson, advising him of Leopold's forthcoming visit.

His Highness has said to me that when he comes to Antwerp, he wishes to see all the most beautiful things that can be seen in Antwerp in the art of painting and that he wishes to buy all the most beautiful things that suit him best, according to his taste.[18]

Nothing is known of the results of this shopping trip, nor of any acquisitions made during the first full year of his governorship. However, the year 1648 was marked by an event which had a profound impact on the archduke's motivations for acquiring paintings. This was the Sack of Prague, which cost the imperial collection 570 pictures. Leopold was determined to make good this loss, and just a year later opportunity knocked with the ending of the English Civil War.

Strange to say, Leopold William was not a participant in the Commonwealth Sale. A conceivable explanation for his absence is that he was warned off by Madrid, and specifically by Luis de Haro, who channeled funds for his purchases through the exchequer in Brussels. If so, this prohibition proved a blessing in disguise, because the archduke was left alone to feast on two of the major English collections, those of the dukes of Buckingham and Hamilton.

In the early phase of the Civil War the House of Commons had sequestered the estates of Buckingham's heir, the second George Villiers, who had been born in the very year of his father's assassination, 1628, and ordered the pictures to be sold.[19] Fortunately for young Villiers, he had friends and relatives who had declared for Parliament and were able to forestall

the judgment. On 4 October 1647 the property was returned to the duke, who as an insurance policy against what seemed impending disaster removed a sizable part of the collection to the continent. On 25 February 1648 he received permission to send abroad a further sixteen crates of pictures, which were entrusted to William Aylesbury, a member of his household. Buckingham now joined the royalist army as it made a last desperate attempt to save the crown from defeat. When this effort failed, he fled to the continent in August, planning to sustain himself and his relatives on the capital represented by the pictures.

By this time Aylesbury had brought the paintings to Amsterdam, but in June 1648, on the advice of Dr Stephen Goff, a financial advisor to Queen Henrietta Maria, he was preparing to send them to Antwerp for possible sale. As Goff astutely wrote:

Amsterdam would not be the proper place to vent those commodities in, and that all the time spent there is unprofitably lost. Without question Antwerp will afford many chapmen [merchants] and the archduke's good success in Flanders [he refers to the military successes against the French] will make him prodigal in these curiosities. I should therefore advise the removal of all your cases thither.[20]

Aylesbury followed this sage advice (as Goff observed, Amsterdam was not then an important market for old pictures) and removed the collection to Antwerp. His first thought was to rent Rubens' house to store the pictures, but this appropriate venue was not being let for less than six months at a time. So the treasure was deposited with the merchant Justus Collimar.

From this point, the fate of the collection is known in detail.[21] On 12 December 1648 the duke himself appeared in Antwerp and pledged part of the collection to Lionel Corham, an English merchant, and Frans Wouters, a local painter, in return for a loan of 30,000 florins, to be repaid with eight per cent interest when the duke achieved his majority in May 1649. In the event of default, Corham and Wouters were entitled to sell the collection at a public auction in Antwerp after 15 May and recover their principal plus interest from the proceeds. On 29 April 1649 Aylesbury asked for and received an extension of the loan. Eight months later, in December, Buckingham, by dint of complex financial maneuvers, was able to redeem the pictures, which numbered almost two hundred. His next course of action was to send them to Brussels for inspection by Leopold William and his advisors. On 1 July 1650 the deal was closed; the archduke, represented by his painter, Jan van den Hoecke, acquired the lot for 70,000 florins.

Regarding the acquisition of the Hamilton collection we are less well informed. As we know, the luckless James, Duke of Hamilton, was executed on 9 March 1649. In his will he named his brother William as universal heir, and he was able to escape to Holland, taking a sizable part of the art collection with him. As early as 19 April of the same year, Archduke Leopold William had acquired a group of Hamilton's paintings, as witnessed by a passport issued at The Hague, allowing transport of the works in question to Brussels.[22] As only a part of the archduke's acquisitions from the Hamilton collection is listed in this document, it is obvious that further transactions occurred in the following months, although these have yet to come to light. In the end, Leopold William came to possess just over two hundred Italian paintings from the Hamilton collection.[23]

It would be difficult to overestimate the magnitude of this coup. In little more than a year Leopold William had acquired just over four hundred paintings, many of excellent quality—

paintings which today constitute the core of the Italian holdings of the Kunsthistorisches Museum in Vienna. From a numerical point of view, these acquisitions far outstrip any other major block purchase of the seventeenth century, including the Mantua sale to Charles I so relentlessly glorified by English historians. Nor was quality sacrificed in the haste to build a great collection overnight. After all, Buckingham and Hamilton had owned some extraordinary pictures which now dropped wholesale into the lap of the archduke.

Leopold's acquisition of Italian pictures ultimately totaled about 617 pictures; in other words, around two-hundred came from sources other than the two English collections. The rest of the collection comprised 885 northern pictures, mostly Flemish, with some by German artists.[24] A majority of these were by contemporary painters, including those whom he employed in Brussels. Nevertheless, the archduke tried to buy retrospectively and had his share of luck in putting together an anthology of Flemish painting from *c.* 1450 to 1650.

This begins with Jan van Eyck's *Portrait of Cardinal Albergati* (plate 142) and includes other important primitives such as Roger van der Weyden's *Crucifixion Altar* (plate 143) and Hans Memling's "*Johannesaltar*" (all in Vienna). Much more numerous, because more available, were works by sixteenth-century Flemish painters, beginning with Quentin Massys, founder of the Antwerp school (*St Jerome*, Vienna) and including the landscapist Joachim Patinir and Hieronymus Bosch (plate 144). The middle years of the century were represented by Pieter Brueghel the Elder's great series of the months of the year including the *Hunters in the Snow*, the *Gloomy Day*, and the *Return of the Herd* (plates 145–7), which had in fact been acquired in the late sixteenth century by his forebear, the archduke Ernst. Passing over such late sixteenth-century figures as Frans Floris, Martin de Vos and Paul Bril, and several excellent if secondary painters of the early seventeenth (Joos de Momper, Jan Brueghel I), we arrive at the major artists of the period—Rubens and van Dyck.

142. Jan van Eyck, *Cardinal Niccolò Albergati* Vienna, Kunsthistorisches Museum

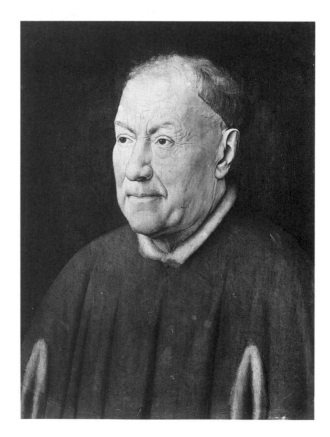

146. Pieter Brueghel the Elder,
Return of the Herd
Vienna, Kunsthistorisches Museum

148. Peter Paul Rubens, *Landscape with
Jupiter and Mercury with Philemon and Baucis*
Vienna, Kunsthistorisches Museum

Given his propensity for stockpiling the creations of famous names, the archduke's collection of pieces by Rubens and van Dyck is disappointing. It may seem ungenerous to reproach a collector who acquired Rubens' magnificent late work, the *Landscape with Jupiter and Mercury with Philemon and Baucis* (plate 148) and the dramatic *Lamentation* (Vienna); however, Antwerp collections abounded in works by the master, and Leopold William owned fewer than ten. His holdings of paintings by van Dyck were even smaller, although they did include such masterpieces as *Samson and Delilah* (plate 149) and *Venus in the Forge of Vulcan* (Vienna).

The marked preference for painting of the sixteenth century shows up again in the comparatively small collection of German masters, where the archduke played safe by concentrating on works attributed to Albrecht Dürer, Hans Holbein the Younger and Lucas Cranach the Elder. Unfortunately, none of the works ascribed to Dürer has withstood the test of modern connoisseurship; all have been reassigned to lesser hands. The portraits by Holbein, much coveted by seventeenth-century collectors in northern Europe, have been treated somewhat more kindly by historians of art. Two splendid works in Vienna, *Dr John Chambers* and *A Young Man* (plates 150 and 151), the latter of which had belonged to Arundel, were acquired by Leopold William. Among the several panels attributed to Cranach a few stand out, such as *Lot and His Daughters* (plate 152) and *Adam* and *Eve* (Vienna), wings of an altarpiece with *Christ and His Mother* painted on the reverse.

149. Anthony van Dyck, *Samson and Delilah*
Vienna, Kunsthistorisches Museum

150. Hans Holbein the Younger,
Dr John Chambers
Vienna, Kunsthistorisches Museum

151. Hans Holbein the Younger,
A Young Man
Vienna, Kunsthistorisches Museum

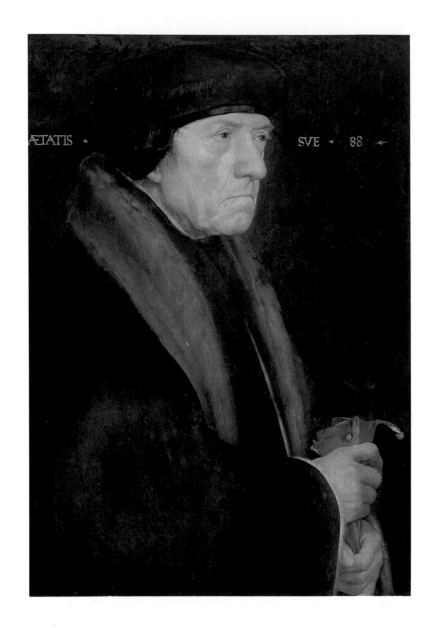

Notwithstanding the quality of these and other paintings by northern European masters, the fame of the archduke's collection was founded on the Italian works. It was not only that Italian painting, particularly of the sixteenth century, was considered supreme by princely collectors; it was also the extraordinary effort to publicize the archduke's Italian pictures undertaken by his curator, the painter David Teniers the Younger.

Teniers was baptized in Antwerp on 15 December 1610, the son of a painter, David Teniers the Elder, and Dymphna de Wilde.[25] The younger Teniers was trained by his father and began to establish a reputation as a specialist in scenes of everyday life. In 1628 Teniers the Elder suffered a serious financial reverse, an event which left a profound impression on his son, who resolved to repair the family's fortune and to elevate its social standing.

His first step was marriage in 1637 to Anna Brueghel, daughter of Jan Brueghel the Elder (1568–1625) who had prospered as one of the most successful painters in Flanders. During the 1640s Teniers expanded his clientele and reputation, and in 1644 was appointed to a term as dean of the guild of St Luke in Antwerp. Soon after the arrival of the archduke in Brussels, Teniers added him to the list of his clients. However, his eye was on the main chance, appointment as court painter, which he obtained in 1651 on the death of Jan van der Hoecke. Teniers moved his household to Brussels, where he remained for the rest of the decade.[26]

Teniers produced a steady stream of pictures for the archduke—*Peasant Playing with a Dog* (plate 153) is a typical example. In addition, he served as curator of the burgeoning archducal collection, in which capacity he provided even more outstanding service. It was not so much in the mundane tasks of curatorial work that he distinguished himself as in his extraordinary efforts to publicize the collection and thus to magnify the glory of his patron.

152. Lucas Cranach the Elder,
Lot and His Daughters
Vienna, Kunsthistorisches Museum

153. David Teniers the Younger,
Peasant Playing with Dog
Vienna, Kunsthistorisches Museum

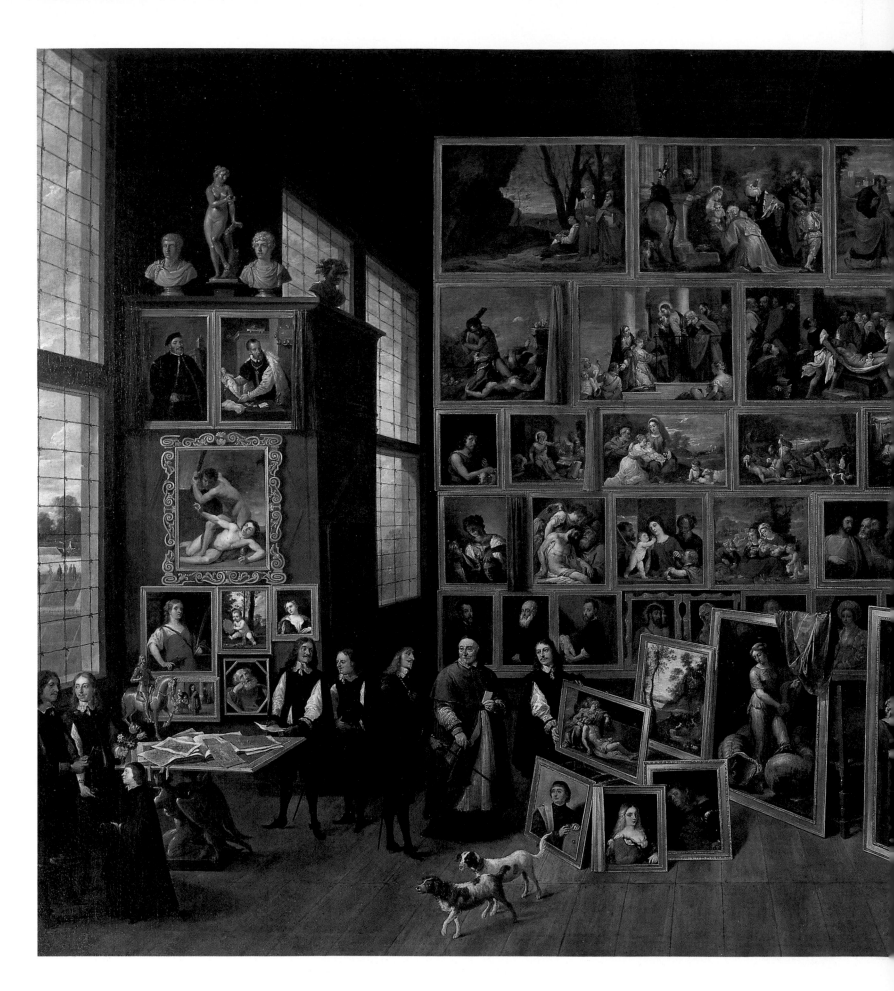

154. David Teniers the Younger,
Gallery of Archduke Leopold William
Petworth House

As a painter born and bred in Antwerp, Teniers was familiar with the gallery picture, and this he adapted to transmit the glories of the collection which the archduke had so rapidly acquired. The earliest of the ten extant views of the archduke's gallery was done in 1651 (plate 154).[27] In a vast high-ceilinged room, intended to evoke if not represent a salon of the Coudenberg Palace, Brussels, the archduke shows a selection of his masterpieces (virtually all of which—as in the other gallery pictures—had until recently been in the collection of the duke of Hamilton) to Antonius Trent, bishop of Ghent and a well-known collector in his own right. Members of the court look on, including Teniers, who presents Annibale Carracci's *Lamentation* (Vienna) for inspection. However, the real stars of this show are the Italian paintings, forty-seven in number, which hang like wallpaper in the gallery and spill over on the floor.

Each and every one of these paintings can be identified, and many are still extant. Without attempting to be exhaustive, let us look at some of the highlights. On the top row of the large wall are Giorgione's *Three Philosophers* (plate 40) and Titian's *Diana and Actaeon* (plate 155). Skipping over the second row to the third, we see Dosso Dossi's *St Jerome* (plate 156), Bassano's *Good Samaritan* (Vienna) and Palma the Elder's *Virgin and Child with Saints* (plate 157). Underneath are Titian's *Madonna of the Cherries* (plate 158) and Ribera's *Christ Disputing with the Doctors* (Vienna). Propped up on the floor is Veronese's large *Esther before Ahasuerus* (Uffizi) and Raphael's *St Margaret* (plate 44), the painting acquired for the duke of Hamilton from the Venetian senator Priuli.

The documentary accuracy of this picture (and its companions) comprises the essential innovation introduced by Teniers into the established format of the Antwerp cabinet picture.[28] Virtually all the collections in previous cabinet pictures, with the exception of the *Gallery of Cornelis van der Gheest* and a few others, are imaginary and intended to convey an allegorical message. In Teniers' pictures both the human and the pictorial protagonists are real, even if the installation is almost certainly manipulated to cram as many works as possible into the composition. Also significant is the repertory of collectible objects which Teniers represents. Only paintings are shown; conspicuous by their absence are the natural specimens and rarities which had played so large a part in the encyclopedic collections of the princes and potentates of earlier generations. Paintings, and paintings alone, are now seen as sufficient to guarantee the fame of a collector.

No great genius is required to understand the motivations behind Teniers' restructuring of the cabinet picture. His intention is to show the world that Leopold William has joined the ranks of the greatest princely collectors. No room for error is left on this point; each painting has the name of the author clearly inscribed on the frame.

156. Dosso Dossi, *St Jerome*
Vienna, Kunsthistorisches Museum

157. Palma the Elder,
Virgin and Child with Saints
Vienna, Kunsthistorisches Museum

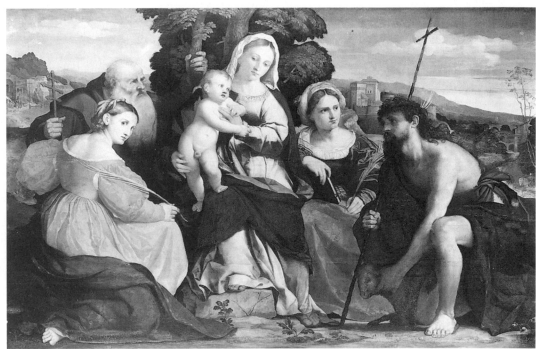

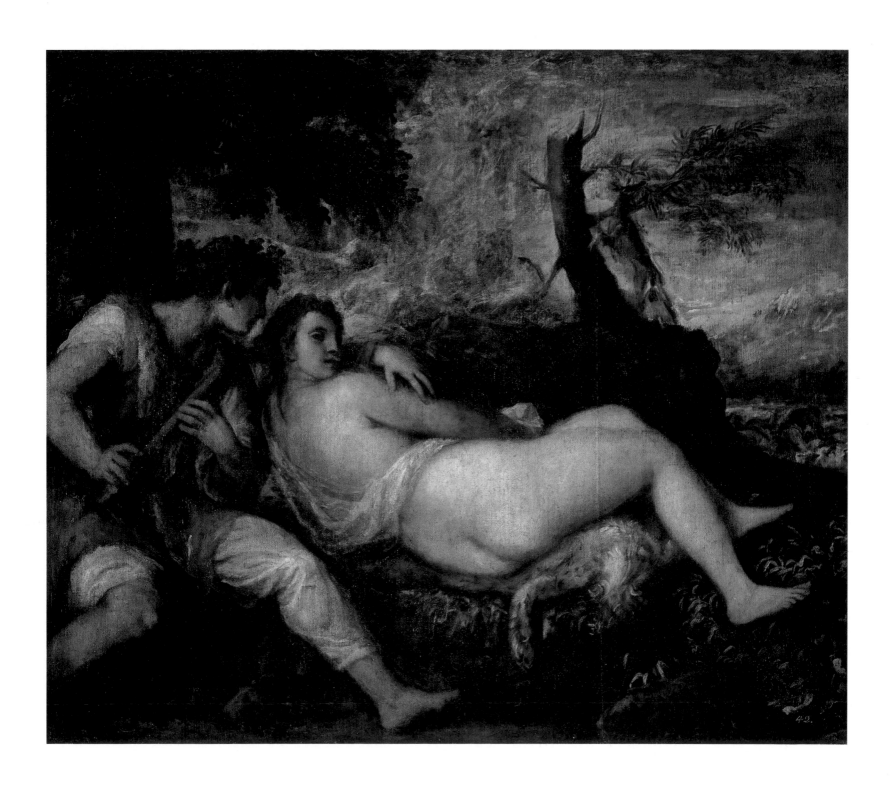

160. Workshop of Titian, *Diana and Callisto*
Vienna, Kunsthistorisches Museum

Once the gallery pictures left Teniers' studio, they were apparently were sent to rival collectors in other courts, although there is no specific documentary evidence of this practice. However, none is listed in the 1659 inventory of the archduke's collection, and there is every reason to believe that the example now in the Prado (plate 45) was made expressly to tweak the nose of Philip IV.[29] It is recorded as being in Madrid in 1653, and portrays among the assembled dignitaries the ranking Spanish nobleman at the Flemish court, the count of Fuensaldaña, who had dispatched Teniers to London on his art-buying mission in 1651.

Moreover, the pictures within the picture take dead aim on works by the painter most favored by the Spanish Habsburgs, Titian. Ranged along the top row, in the most conspicuous place, are Titian's *Nymph and Shepherd* (plate 159), *Diana and Callisto* (plate 160) and *Danäe and the Golden Rain* (lost), although Philip would have been somewhat consoled had he known that *Diana and Callisto* would be demoted to a workshop piece by Titian specialists of the twentieth century. The Spanish king might even have suspected its authenticity, in as much as he owned the original, which had been painted for Philip II (plate 161).

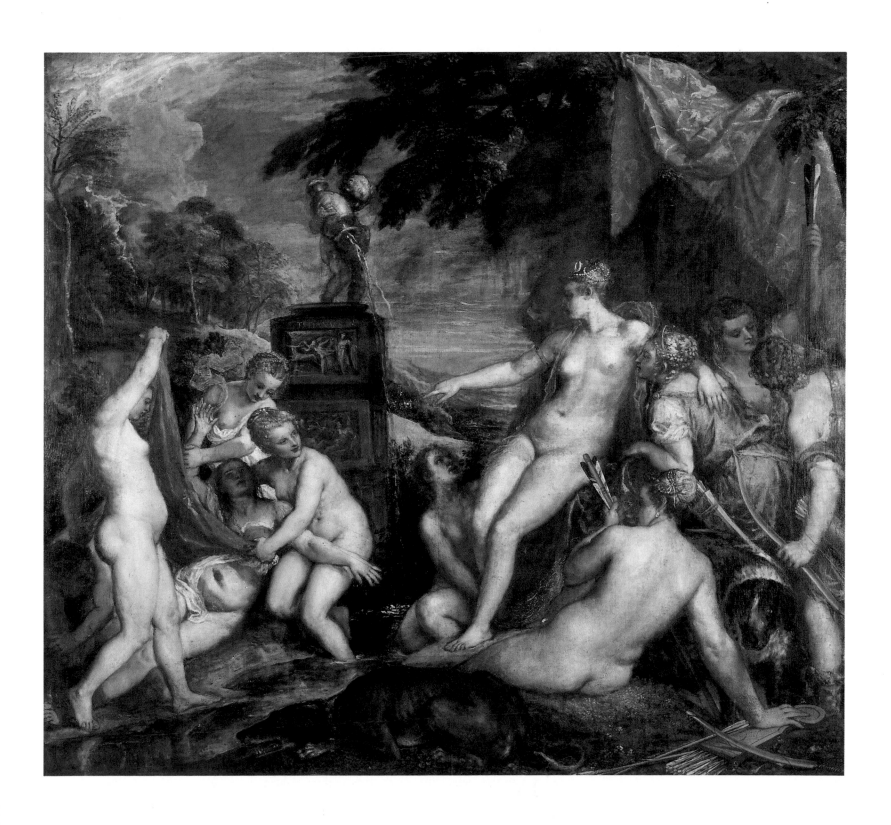

The absence of works from the Buckingham collection in these gallery pictures requires a word of explanation. Most of them appear to have been sent to Prague in 1651, to replace the pictures stolen by the Swedish soldiers and taken to Queen Christina in Stockholm.[30] The sack of Prague clearly rankled in the mind of Leopold William, and by an astonishing turn of events he was soon required to offer hospitality to the owner of those ill-gotten goods. On 16 June 1654 Christina abdicated and, to the amazement of all Europe, left Sweden with the intention of converting to Catholicism.[31] She made her way to the Spanish Netherlands, stopping in Antwerp. However, on 23 September she moved to Brussels where, on 24 December, she professed faith in the Catholic religion. During this time she was the guest of the archduke, who, whatever his private feelings, punctiliously fulfilled his obligations as a gracious host, and went so far as to present the former queen with a jewel of his collection, *Diana and Actaeon* by Titian (plate 155), which thereafter disappears from Teniers' gallery pictures.

If Teniers' dedication to publicizing Leopold's collection seems a disinterested act of service, it must be remembered that he, too, had a stake in the enterprise. He included his own portrait in many of the gallery pictures, where he takes his place among the noble company. Teniers' presence also creates the impression that he played a part in the formation of the lustrous group of Italian works, although all the pictures from the English aristocrats were purchased before he was appointed as court painter. Status seeking, in fact, was one of the driving forces of Teniers' personality, and clearly he regarded his curatorial responsibilities as a key to success.[32] The efforts devoted to publicizing the collection implicitly elevated the status of painting and, by extension, of painters. This confluence of motivations explicitly informs his second, and more important, project on behalf of the archduke and his collection.

Around 1655 Teniers began to prepare a publication that would bring Leopold's collection to the attention of a much wider audience than could be reached by the gallery pictures, which must have been time-consuming to create. This project was published (1660) in four languages, Latin, French, Spanish and Dutch, the languages of the international art market. It bears the title *Theatrum Pictorium* and consists of 243 engravings after Italian paintings belonging to the archduke.[33] The production of *Theatrum Pictorium* was a complicated venture. Teniers assembled a team of eleven engravers who worked from small-scale reproductions executed in oil by the artist, which are known as *pasticcios*. Many are still in existence, such as the one after Raphael's *St Margaret* (plate 162), engraved by Jan van Troyen (plate 163). At the bottom of each print, the name of the painter, the dimensions of the original and the initials of the engraver are inscribed. *Theatrum Pictorium* thus became a combination catalog and coffee table book of the archduke's pictorial collection and is the first of its kind ever published (although others had already been produced to illustrate collections of antique sculpture).

Such a frivolous term, however, fails to do justice to the significance of this milestone in the history of collecting or to the seriousness of its purpose. The obvious aim of *Theatrum Pictorium* is to exalt the archduke as a great collector, but this is only part of the story. The other part is a calculated attempt to elevate painting as supreme among the visual arts. This emphasis could have sprung only from the brain of Teniers, who spared no effort to advance the rank of painters on the social scale. By the time of the publication of *Theatrum Pictorium*, he had made considerable progress in his quest.

162. David Teniers the Younger
(after Raphael), *St Margaret*
Glasgow, Art Gallery

163. Jan van Troyen (after Raphael),
St Margaret
from *Theatrum Pictorium*

164. Jan van Troyen,
Archduke Leopold William of Austria
from *Theatrum Pictorium*

165. Lucas Vorsterman the Younger
(after Peter Thys), *David Teniers the Younger*
from *Theatrum Pictorium*

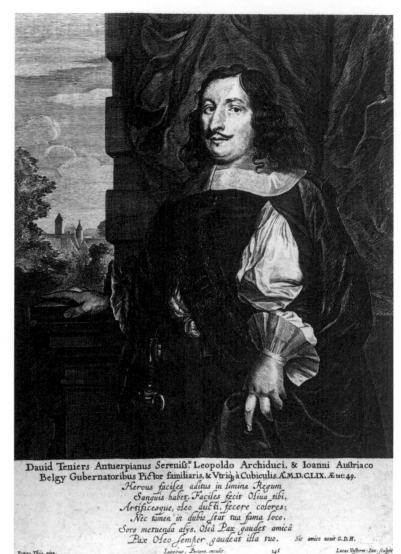

In 1655 he had been promoted to the position of *ayuda de cámara* in the archduke's household, which opened the door to greater privileges. Two years later he applied to Philip IV for permission to revive the use of his family coat of arms, which would have elevated him to the lesser nobility.[34] Although the petition was swiftly approved by the Council of Flanders, it was swallowed up in the Spanish bureaucracy and not authorized until 1680. (Teniers lived until 1690.) A further step was taken in 1662, when Teniers lent his support to the founding of an academy of art in Antwerp and drafted a letter on behalf of the project to Philip IV, who sanctioned it in 1663. Two years later the academy inaugurated its activities with lessons in drawing, held in a building belonging (prophetically) to the Antwerp stock exchange.

Theatrum Pictorium is part of this campaign for the social advancement of painting. It is thus no surprise to learn that the costs of production and publication were apparently borne by Teniers and not the archduke.[35] Undoubtedly Leopold William endorsed the venture—it could not have gone forward without his permission—and even left some pictures behind to be copied after his departure for Vienna in 1656. Still, the control of the project and, more important, of the content was in the hands of the painter, who was not bashful about promoting his own cause.

Teniers' determined program to advance the claim of painting as a noble art confronts the reader as soon as the book is opened at the prefatory portrait of Leopold William (plate 164). To the left stands Minerva, goddess of the arts, who points to the image of the archduke as one of her followers. On the left side of the frame is a commander's baton, symbol of Leopold's military prowess, while on the right Teniers has placed paintbrushes, a palette and a mahlstick, signifying the archduke's devotion to the art of painting. At the base of the aedicule are two paintings from the archducal collection, the so-called *Bravo* (Vienna), then attributed to Giorgione, now to Titian, and *Violante* (Vienna), then given to the elder Palma and now to a follower of Titian. A book of drawings lies open and, above, a putto plays the role of a flying curator, carrying aloft a picture to complete the installation of the niche.

The frontispiece, and of course the reproductions of the 243 pictures that follow, adduce in visual form a well-tried argument in favor of the nobility of painting and painters. It is the art of kings and, *ipso facto*, an exalted art. The closing illustration in the book draws the logical conclusion—it represents Teniers, dressed as a gentleman, wearing a chamberlain's key and a gold chain and medal given to him by the archduke (plate 165). Behind him is a large house with towers, an allusion to his country seat called the Three Towers (Drij Toren), which he acquired in the later 1650s. With this proud portrait, Teniers clinches his argument in favor of the practice of painting as a noble pursuit.

For all its relevance to the practice of painting, *Theatrum Pictorium* is addressed primarily to collectors and especially to those who desire to share the plateau of prestige occupied by the great princes of the world. Magnificent collections, the book asserts, comprise paintings—Venetian paintings in particular—not odd-shaped pieces of coral or nautilus shells or even exquisite pieces of the gold- and silversmith's art. Teniers' publication epitomizes the partnership between painters and princely collectors which, in time, was destined to establish the art of painting at the summit of the hierarchy of collecting.

166. Robert Nanteuil, *Cardinal Jules Mazarin*
New York, Metropolitan Museum of Art

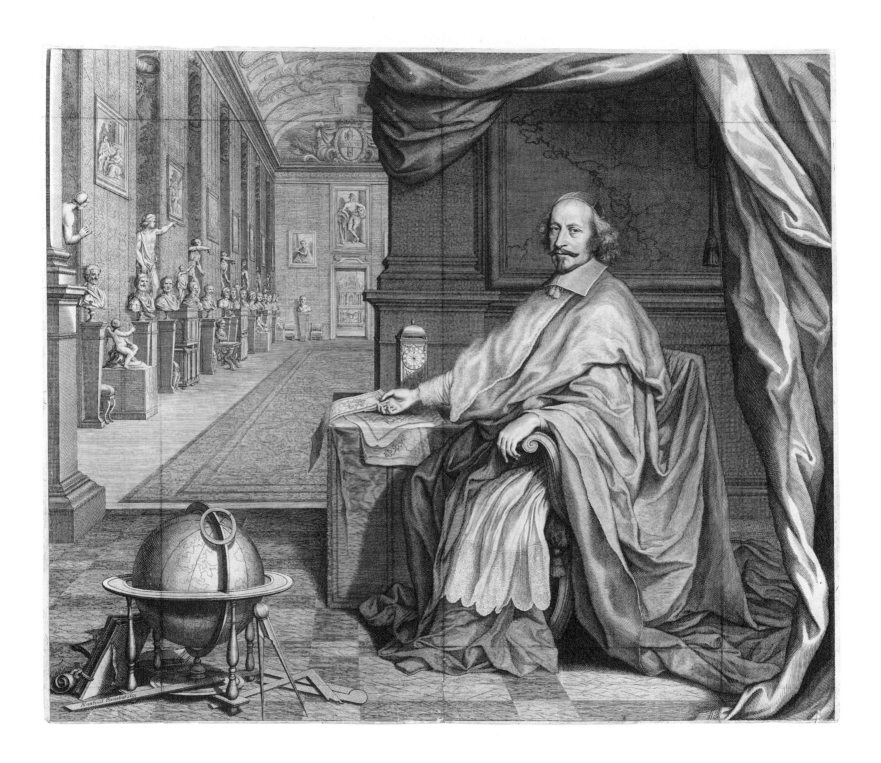

V. Reasons of State

The career of Cardinal Jules Mazarin must be reckoned as the greatest rags-to-riches story of the seventeenth century (plate 166).[1] Son of a poor but honorable Roman family, he rose to become the most powerful politician, and one of the richest men, in France.

Giulio Mazarini, as he was baptized, was born on 14 July 1602, the oldest of six children. His father, Pietro, made a living in the service of the Colonna family, but a humble living it was, never quite sufficient to support his wife and children. Although educated with the Jesuits, young Giulio was a worldly sort; a contemporary described him as "gracious, agile, lively, likable, polite, with a penetrating mind, a bright humor, clever at dissimulation, in a word fit for everything"[2] or, to put it in other terms, the perfect opportunist.

Lacking financial resources, Mazarini attached himself to a succession of important noble clans in Rome, culminating with the Barberini, then headed by Pope Urban VIII. As a member of the papal administration during the 1630s, Mazarini mastered the subtleties of international diplomacy and court intrigue which he was to deploy so effectively as the principal minister of France. He was also initiated into the practices of art patronage and collecting and again achieved impressive results once he had settled in Paris.

Mazarini's French connections were initiated in 1630, when he met Cardinal Richelieu, the first minister of Louis XIII; their relationship was consolidated in 1634, the year that Mazarini was sent to Paris on a diplomatic mission. In 1639, encouraged by the favor of Richelieu, he moved permanently to France and was naturalized. Two years later, in the closing days of 1641, Mazarin, as he was now to be known, not then forty years old, was elevated to the dignity of cardinal.

The final stage of Mazarin's ascent to power occurred after the death of Richelieu in December 1642. Richelieu had recommended Mazarin as his successor, and, through an unforeseen constellation of events, he consolidated his position in very little time. The death of Richelieu was succeeded six months later by that of Louis XIII (14 May 1643). The heir to the throne, the future Louis XIV (born 5 September 1638), was then only five years old, and the queen, Anne of Austria, became regent. A deep affectionate relationship developed between Anne and Mazarin and ensured his accession to power, which he maintained until his death in 1661. Mazarin was never loved by the French, who came close to unseating him during the complex revolt known as the Fronde (1649–52), but this nimble Italian politician proved to be more resourceful than his enemies had realized.

After the Fronde, the cardinal completed the rise of France to European hegemony initiated by Richelieu, bringing the long war with Spain to a successful conclusion. In 1660 Mazarin traveled to the Franco-Spanish border to sign the Peace of the Pyrenees, which sealed the French victory. The Spanish delegation was led by his political rival Luis de Haro, who had bested the cardinal at the Commonwealth Sale and was now forced to admit defeat in a contest with higher stakes than old pictures.

As a protégé of the Barberini, Mazarin had witnessed one of the most fruitful exercises of artistic patronage of the seventeenth century, and this experience was crucial in shaping his taste. Prior to his departure for France, he had supplied Richelieu with Italian paintings and decorative objects, and once installed in Paris he attempted to recruit the best of the Barberini artists, Gianlorenzo Bernini and Pietro da Cortona, into his employ.[3] When they turned him down, he hired the painters Gian Francesco Romanelli and Gian Francesco Grimaldi, who executed fresco decorations in his sumptuous palace (now incorporated into the Bibliothèque Nationale), which was modeled after the great Roman houses where he had served as a youth (plate 167).

The Barberini also inspired Mazarin's desire to collect pictures, and at his death he owned the finest and largest collection assembled in France to that date. Unlike the archduke Leopold William, Charles I or the duke of Hamilton, all of whom acquired collections through large purchases *en bloc*, Mazarin appears to have bought his pictures in smaller lots. Before leaving Rome, he organized a network of agents, who kept a close eye on the availability of pictures and antique sculpture and bid shrewdly for the most desirable pieces.[4] Mazarin's collection was confiscated by the *frondeurs*, but fortunately was recovered in 1653, when an inventory was made listing 431 pictures described as originals and seventeen as copies.[5] The death inventory of 1661 lists 546 originals, ninety copies and 241 portraits of popes, the latter perhaps acquired as a set.[6] As these inventories make clear, Mazarin favored the works of painters he had known in Rome, especially the so-called Bolognese-Roman classicists, who would be popular in Paris as nowhere else outside Italy. He owned important examples of the art of Annibale Carracci, founder of the school, and his best pupils and followers—Domenichino, Guido Reni, Guercino, Francesco Albani and Pietro da Cortona.

167. Jean Marot, *Palais Mazarin*
from *Cabinet des singularités d'architecture etc.*,
1699 and 1702

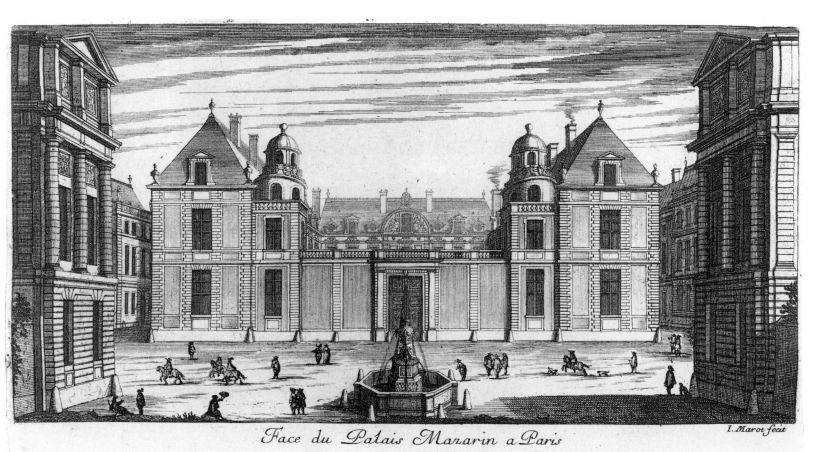

Face du Palais Mazarin a Paris

I. Marot fecit

Like other courtier-collectors, Mazarin sought pieces by the renowned Italians of the sixteenth century, but this ambition was partly thwarted by the unfortunate timing of the Fronde, which erupted just as the English Civil War ended. Mazarin was furnished with a list of some of the pictures in the collection of Charles I,[7] only to be deprived of the opportunity to purchase by the uprisings, which twice forced him to leave Paris. While he was struggling to save his skin and rescue his authority, the sales from the collections of Charles I, Buckingham, Hamilton and Arundel all took place, and (as we have seen), by the time order was restored, the Spanish ambassador Alonso de Cárdenas had carried the day. Mazarin did well to buy, if at elevated prices, Titian's *Pardo Venus* (plate 25) and *Tarquin and Lucretia* (plate 57), and the masterpieces by Correggio, *Allegory of Vice* and *Venus, Cupid and Satyr* (plates 82 and 58). As the supply of old pictures dried up, Mazarin's agent in London, Antoine de Bordeaux, was forced to fall back on portraits by van Dyck.

It is to Mazarin's credit that he followed Bordeaux' pursuit of works by van Dyck with the same attention he paid to the attempts to buy paintings by sixteenth-century Italian artists. Despite his immense wealth, the cardinal consistently urged his agent to pay reasonable prices. And, like any true connoisseur, he was worried about copies, which he rightly perceived as a problem with portraits attributed to van Dyck. "It is necessary to be on guard not to allow yourself to be fooled, because it is very difficult to discern a copy from an original when the copy is well done."[8]

Mazarin's side of the correspondence with Bordeaux reveals an eager but prudent collector, who is well aware of that always crucial relationship between the desirability of a work and its price. On 12 March 1654 Bordeaux informed him of the availability of a piece by Giulio Romano and asked if pictures by this artist were held in esteem. Ten days later, the cardinal offered his exigent reply:

As for the picture by Giulio Romano, for which they are asking 800 livres, I would be pleased to know the dimensions and with which figures it is filled [i.e., the composition], and if it is a very beautiful and original piece and as well done as other portraits of which you have spoken.[9]

Just a month before he died, the cardinal paid a final visit to his gallery in the Palais Mazarin and was observed by another avid connoisseur, the count of Brienne, a royal secretary. Brienne was no admirer of Mazarin, and thus his touching account of the cardinal's valedictory to his pictures is probably entitled to belief. As Brienne tells the story, he was walking in the Palais in search of Mazarin when he heard the gravely ill minister shuffle into the room.[10]

I hid myself behind the tapestry and heard him say, "All this must be left behind" [il faut quitter tout cela]. He stopped at every step, for he was very weak, and turned first to one side, then the other, and casting a glance on the object that caught his eye, he said from the depth of his heart, "All this must be left behind." And turning around, he finished [by saying], "And also that. What trouble I suffered to acquire these things! Can I abandon them without regret? I will never see them again where I am going."

At this point Brienne revealed his presence and announced that he had an urgent letter for the cardinal's attention. As he drew near, he noticed that Mazarin wore no clothing beneath his robe. Brienne offered his arm to the doddering minister and heard him declare that he no longer cared to discuss matters of state.

"I now have many other things on my mind." And returning to his train of thought, he said: "Look, my good friend, at this beautiful painting by Correggio and also at the Venus of Titian [the Pardo Venus] and at that incomparable Deluge of Antonio Carracci [now in the Louvre]. Oh, my poor friend, all this must be left behind. Farewell dear pictures that I have loved so well and which have cost me so much."

The bulk of Mazarin's collection passed to his heirs, although some of the best works were bequeathed to the crown. Following the cardinal's death, the youthful Louis XIV made his much acclaimed decision to govern without a favorite, initiating a personal rule of some fifty-four years. With the assistance of Jean-Baptiste Colbert, the apparatus of state was thoroughly reorganized and the visual arts were subsumed into a mechanism for the glorification of the king.[11] One part of this multifaceted program was the acquisition of a picture collection, for, strange to say, the French crown possessed only a small number of important paintings, most of which had been gathered by François I (d. 1547). While French rulers of the later sixteenth century were distinguished patrons of the arts, their collections were encyclopedic and pictures were but a minor part.

168. Frans Pourbus the Younger,
Marie de'Medici,
Paris, Musée du Louvre

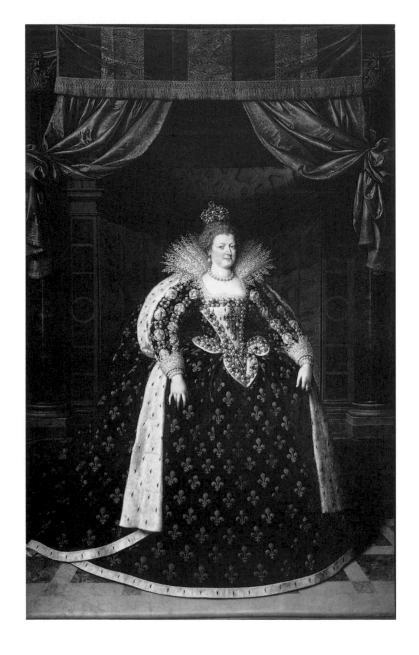

The interest in owning pictures can be traced to Marie de' Medici (1573–1642), who married Henry IV in 1600 and became regent when her husband was assassinated in 1610. Marie (plate 168) has earned a place on the honor roll of domineering mothers. Her son Louis XIII came to regard her as an intolerable meddler and twice sent her into exile. On the first occasion, in 1617, she was placed under house arrest at Blois, but was able to negotiate a return to Paris in 1620. Ten years later the definitive rupture occurred after the queen lost a struggle for power with Cardinal Richelieu on the so-called Day of Dupes (10–11 November 1630). She was held under house arrest in Compiègne but decided to flee to the Spanish Netherlands. Eventually she joined her daughter Henrietta Maria in London, where her open display of Catholicism and overbearing ways made her too great a liability. She was again sent packing and ended her days in Cologne on 3 July 1642, supposedly dying in the house of the banker Everhard Jabach.

If Marie de' Medici's political aspirations ended in failure, her activities as a patron of the arts were destined for a better outcome.[12] During the 1620s, she introduced the sophisticated patronage of the Medici into Paris, centering her activities in the Palais du Luxembourg, built in imitation of the Palazzo Pitti. The queen had acquired the property in 1612, and after her return to court in 1620 she began to embellish it in spectacular fashion, commissioning works from French and foreign artists alike. In 1622 she contracted with Peter Paul Rubens for the famous series of paintings now in the Louvre, which would recast her checkered career in the language of triumphant allegory.[13]

Rubens, as has been seen in Chapter I, delivered the final canvases in 1625, in time for the proxy marriage of Henrietta Maria and Charles I, an event which brought the duke of Buckingham and his artistic advisor, Balthasar Gerbier, to Paris. Gerbier, of course, was scouting for old pictures, of which Marie de' Medici had but few. In this respect, she was not alone. In December 1624 Gerbier had sent a prospectus to Buckingham entitled "Memorandum of things which are in Paris in the hands of the lords."[14] While his search had uncovered several notable works, his report does not suggest that fine old pictures abounded in Parisian collections, and this impression is probably correct. Until the 1630s, French picture collecting lagged behind that of Spain and England (and Italy, too).

It was Richelieu who changed all this. Louis XIII, despite the urgings of his minister and some indication that he liked to draw, never evinced interest in collecting of any kind, and thus it fell to Richelieu to lead the way. The cardinal had received his training in the visual arts while he was in the service of Marie de' Medici. In 1620 he was appointed Superintendent General of her household, from which position he administered her activities as patron. Once installed as the principal minister of the king, Richelieu began to collect in earnest.

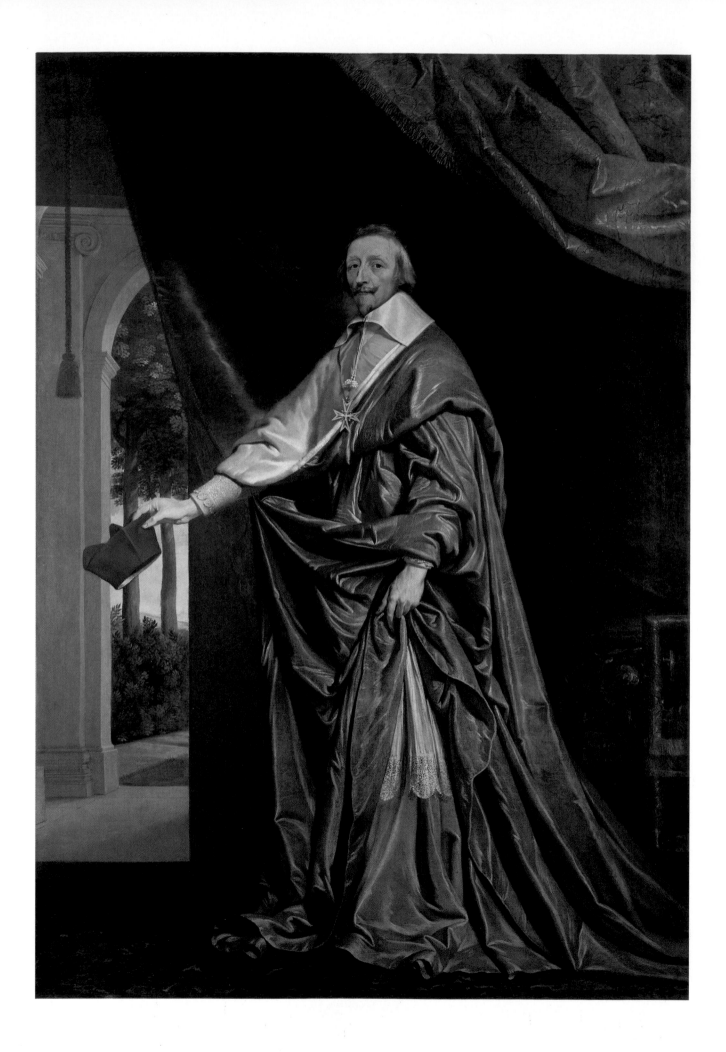

Richelieu's collections are best understood within the context of a strategy to enrich his family and exalt its social position. Armand-Jean du Plessis, the future cardinal Richelieu (plate 169), was born on 9 September 1585, the youngest son of François, lord of Richelieu.[15] The premature death of Richelieu's father in 1590 left his heirs in difficult financial conditions. Armand-Jean entered the church in 1602 as bishop of Luçon, a poor see which belonged to the family. He was ordained in Rome in April 1607, and commenced his career at court in 1613.

Around 1626, four years after he had achieved his cardinal's hat, Richelieu began to build a huge fortune through intricate financial maneuvers and used some of the proceeds to enlarge his hereditary landholdings in Poitou.[16] As an experienced courtier, he knew how fickle royal favor could be and sought to establish the family's future on the solid foundation of real property. His second ambition, which followed from the first, was to elevate the family to the rank of the highest nobility. With huge sums at his disposal, he constructed a great palace in Paris, an imposing chateau at Richelieu, a villa with beautiful gardens at Rueil (just west of Paris) and smaller houses in the provinces.[17] The centerpiece of Richelieu's highly conspicuous consumption was the Palais Cardinal (now Palais Royal) near the Louvre (plate 170).[18] The cardinal acquired the land in 1624 and the edifice was completed in stages over the next sixteen years. As Richelieu built, he collected works to adorn the interior.

The death inventory of the contents of the Palais Cardinal is a compelling document.[19] There was a fairly sizable group of paintings, some of which, as we shall see, were superb. However, the inventory makes it clear that the cardinal was convinced that precious objects were made of precious materials. Hence the staggering quantity of gold- and silverplate, of precious stones and jewelry. In providing for a rainy day, Richelieu was not prepared to throw himself on the mercy of the art market, where judgments of quality cannot be calculated in troy ounces and carats. Porcelain and crystal objects were equally numerous, and even a few pieces of exotica are listed.

169. Philippe de Champaigne,
Cardinal Richelieu
London, National Gallery

Veuë du Palais Royal

170. Boisseau, *Palais Cardinal*
Paris, Musée Carnavalet

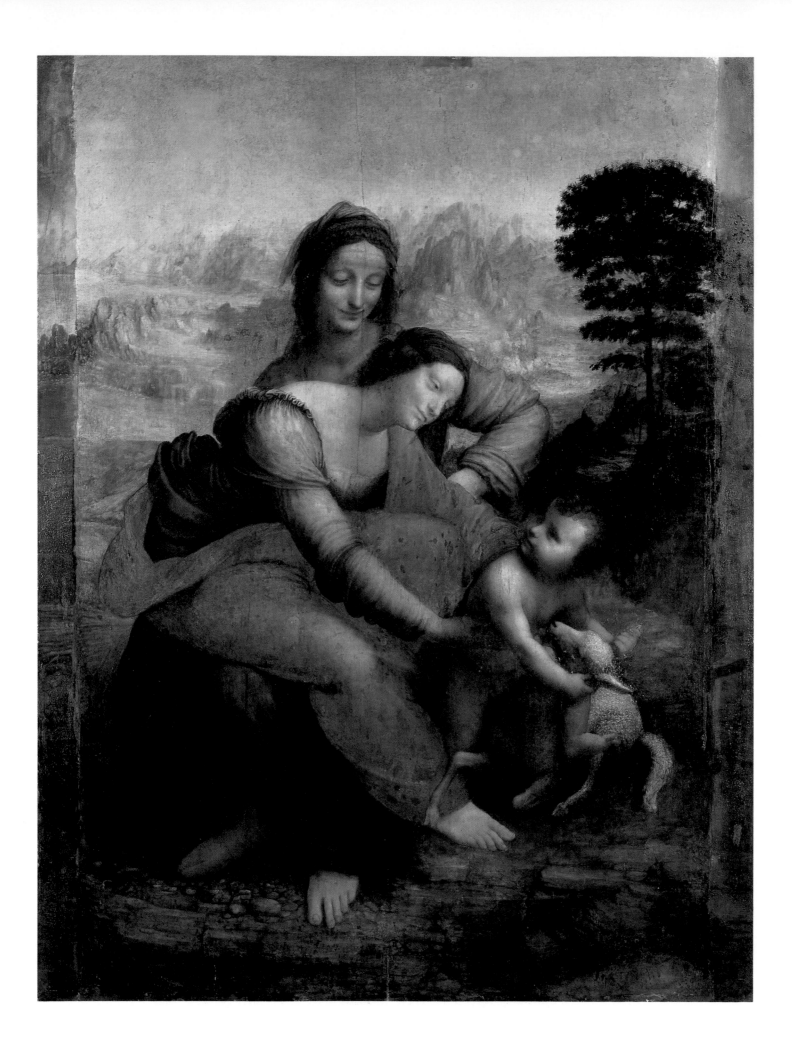

Yet the wholehearted dedication to *objets de luxe* does not entirely overshadow the picture collection.[20] By the standards of the great collectors in London and Madrid, Richelieu was not a major figure. The inventory of the Palais Cardinal contains the modest number of 272 canvases (excluding those fixed in place as part of the permanent decoration). Furthermore, only eighty-four could be attributed by the compilers of the inventory, the painters Simon Vouet and Laurent de la Hyre. Nonetheless, the cardinal possessed some significant works, particularly by sixteenth-century Italians. The most important was Leonardo's *Virgin and Child with St Ann* (plate 171), followed by Veronese's *Supper at Emmaus* (plate 172). The inventory also lists unidentified canvases by Raphael, Correggio, Bellini and Titian. His best group of the early Italians, however, was kept at the chateau at Richelieu and consisted of the decoration of the studiolo of Isabella d'Este.[21] These are five paintings by Mantegna, Perugino and Lorenzo Costa (plates 173–7), which had been owned by the duke of Mantua and somehow escaped the agents of Charles I.

Richelieu was among the first French collectors to own works by seventeenth-century Italian painters, who were to enjoy tremendous popularity in Paris. Several were acquired for him by Mazarin, while others came from the estate of the French general the marshal of Créquy, of whom more will be said shortly. These included Caravaggio's *Musical Concert* (plate 178), Annibale Carracci's *Adoration of Shepherds* (Louvre) and Lionello Spada's *Aeneas and Anchises* (Louvre).

172. Paolo Veronese, *Supper at Emmaus*
Paris, Musée du Louvre

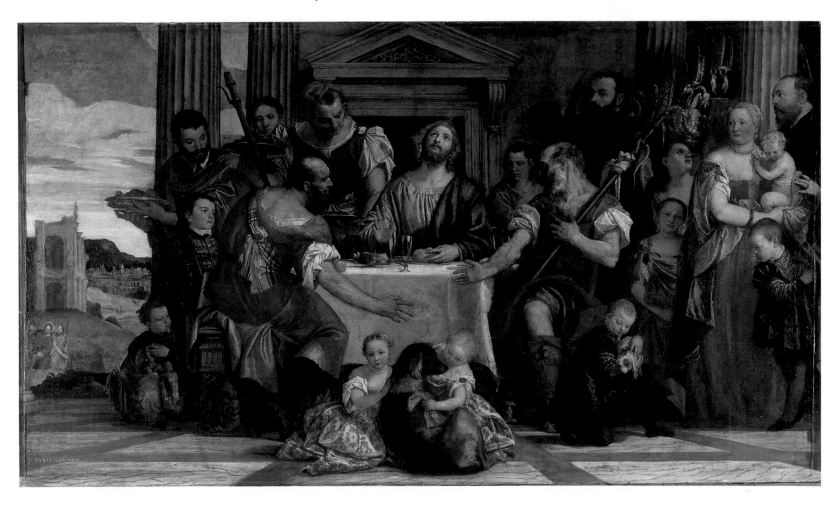

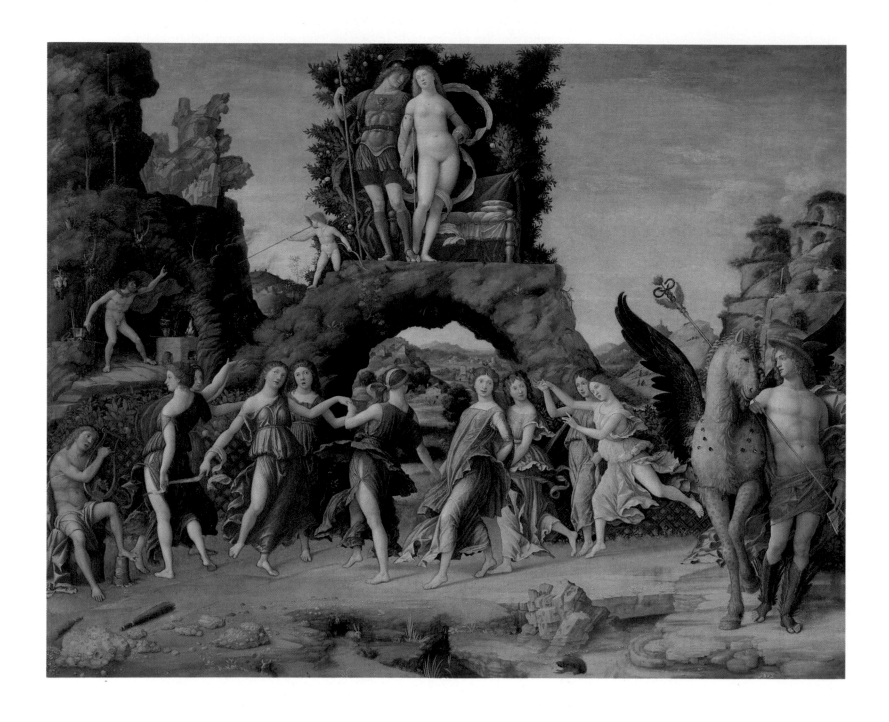

175. Perugino, *Combat of Love and Chastity*
Paris, Musée du Louvre

It would be difficult to sustain lofty claims for Richelieu's collection of paintings within a European context. However, as far as the French court is concerned, Richelieu's interest in the art of painting, as both patron and collector, inspired courtiers and royal officials to follow his lead, and from the 1630s on Paris began to experience a rising interest in picture collecting.

One of the best-studied of these new collectors is Charles, Sieur de Créquy, who was a confidant of Richelieu as well as a military commander (plate 179).[22] Créquy made one of those overnight collections so characteristic of the seventeenth century. This was accomplished during an embassy to Rome, which lasted from June 1633 to July 1634. Upon arriving in Rome the marshal engaged the services of the painter Giuseppe Cesari, Cavaliere d'Arpino, who steered him in the direction of works by local artists, mostly of the seventeenth century. In a mere fourteen months, Créquy acquired 163 paintings by artists such as Giovanni Lanfranco, Guido Reni and Annibale Carracci, as well as by French painters residing in Rome, notably Poussin and Claude, who were just beginning to develop their reputations.

After his return to Paris Créquy installed the pictures in his town house, and they caused a sensation among artists and collectors alike. Regrettably, Créquy did not have long to enjoy them. He was sent to fight the Spaniards in northern Italy and died of a gunshot wound on 17 March 1638. Leading the Spanish army in this encounter was the prodigious Spanish collector, the marquis of Leganés, who was thus rid of a rival commander and collector with a single, well-placed shot.

Most of the royal officials wisely remained at their desks in Paris, helping to run the government and reaping the rewards of loyal service. With the wealth thus acquired they constructed magnificent town houses and stocked them with choice collections of art. Certainly the most illustrious of this group is Louis Phélypeaux de La Vrillière (1599–1681), who became royal secretary in succession to his father in 1629.[23] La Vrillière's claim to fame lies in the decoration of the gallery in his Parisian *hôtel* (now the Banque de France), which consisted of ten large paintings of antique subjects commissioned from leading artists in Italy, including Cortona, Reni, Guercino and Poussin. Brienne, opinionated as always, thought it far superior to that of Mazarin. "I would have preferred four paintings from the gallery of M. de La Vrillière to all those of the cardinal."[24] In addition, his collection of old masters distinguished. At his death La Vrillière had accumulated nearly 250 paintings; the stars among them were Titian's *Perseus and Andromeda* (plate 180) and Raphael's *Madonna with the Blue Diadem* (plate 181), the latter inherited from his father-in-law, Michel Particelli d'Emery (*c.* 1595–1650). Particelli, who became minister of finance in 1643, was no less an avid collector than La Vrillière and owned a goodly number of paintings by the requisite Italian masters.[25]

179. Claude Mellan, *Charles, Sieur de Créquy*
Paris, Bibliothèque Nationale

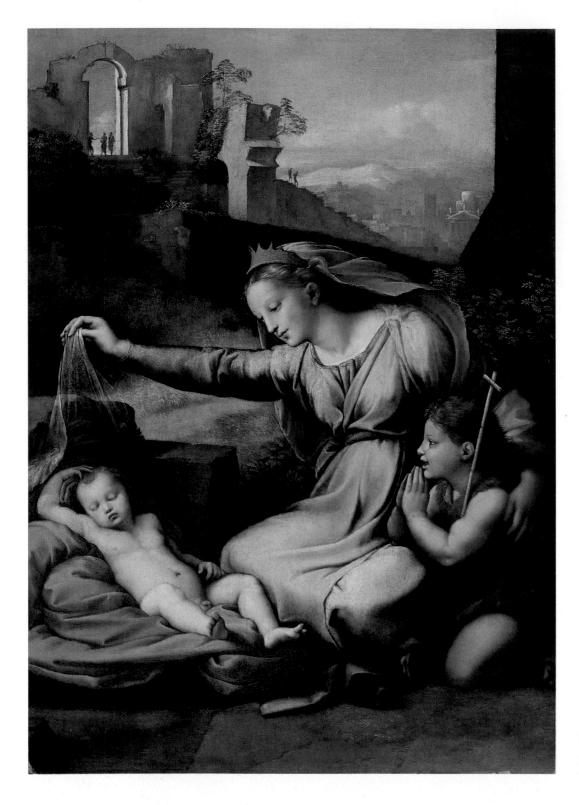

181. Attributed to Raphael,
Madonna with Blue Diadem
Paris, Musée du Louvre

182. Leonardo da Vinci, *Mona Lisa*
Paris, Musée du Louvre

The picture collecting initiated under Richelieu gained momentum during the ministry of
Mazarin, although the king of France still had no picture collection to speak of. True, a modest
number of exceptionally choice pictures, assembled in the sixteenth century by François I,
remained in the palace at Fontainebleau. Among these was the work now regarded as the most
famous painting in the world, Leonardo's *Mona Lisa* (plate 182), which kept company with
other sixteenth-century masterpieces such as the *Madonna of the Rocks* (plate 183) and Raphael's
"*La Belle Jardinière*" (plate 184). The epithet "small but choice," however, carried little weight
when applied to monarchical collections of the seventeenth century.

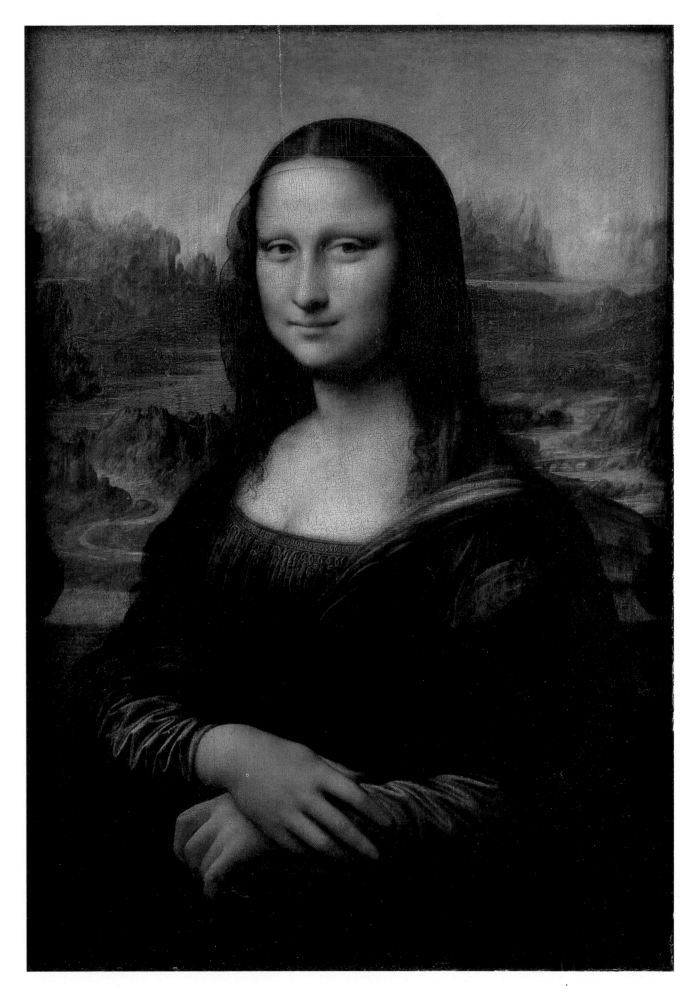

184. Raphael, *"La Belle Jardiniere"*
Paris, Musée du Louvre

This point was not lost on Jean-Baptiste Colbert (1619–83), the orchestrator of the symphony of glory dedicated to the heroic deeds of Louis XIV.[26] Colbert (plate 185), who came from a bourgeois family from Rheims, had learned about art and politics from a master, Cardinal Mazarin. By serving as *intendant* of Mazarin's household, Colbert was following a well-marked path to power. Richelieu had performed this function for Marie de' Medici, while Mazarin had done the same for Richelieu. Colbert's apprenticeship did not carry him to the position of principal minister, which ceased to exist in 1661, but there is no doubt that he was the organizer of the artistic affairs of the monarchy from 1661 until his death twenty-two years later.

Colbert's plans for a royal collection, like all his activities in the artistic sphere, were formulated with daunting foresight and consistency. Five collections, or *cabinets*, were projected—antiquities, books and manuscripts, paintings, medals and curiosities. The systematic accumulation of medals and curiosities was somewhat anachronistic by the emerging standards of princely collections and reflects the continuing interest in these categories among French collectors and scholars, the most important of whom was Gaston d'Orléans (1608–60), the king's uncle. Gaston, an inveterate and weak-willed plotter against Richelieu and Mazarin, was the most conspicuous *curieux*, or encyclopedic collector, in France during the seventeenth century.[27] At his death, he bequeathed to the king his vast holdings of books, medals, engraved stones (cameos and intaglios), natural specimens and a collection of exquisite botanical and ornithological drawings on vellum. Gaston's legacy was to serve as the foundation and inspiration for the extraordinarily varied collections of Louis XIV.

While Gaston's collection was rich in what might be called its literary and scientific content, it was not so well furnished with pictures, which, thanks especially to the interests of Mazarin, were now considered an essential component of a princely collection. If pictures were needed, then Colbert would buy them, and his *modus operandi* was to harvest works from collections which had sprouted in Paris since the regime of Richelieu. However, before he opened the royal purse, he recruited a qualified advisor in the person of the royal painter, Charles Le Brun,

185. Philippe de Champaigne,
Jean-Baptiste Colbert
New York, Metropolitan Museum of Art

186. Charles Le Brun,
Everhard Jabach and Family
Formerly Cologne, Wallraf-Richartz Museum

who on 1 July 1664 was elevated to the post of "directeur et garde général du cabinet de tableaux et desseins de Sa Majesté" (director and general guardian of His Majesty's cabinet of paintings and drawings).

Colbert's first purchase was made in 1662, and it put the royal collection on the map. The vendor was Everhard Jabach, the most flamboyant Parisian collector of his time. Jabach has previously crossed our path—in 1636, as a visitor to London and its collections; in 1637, as an advisor to Lord Arundel on the purchase of drawings; in 1642, as the owner of the house where Marie de' Medici supposedly died; in the early 1650s, as a major purchaser at the Commonwealth Sale; and in 1662, as a protagonist in the partial sale of the Arundel collection in Holland. Obviously art was in his blood; indeed, it was his obsession.

Jabach (plate 186) was born in Cologne around 1618, the son of a successful international banker also named Everhard.[28] The elder Jabach had been a collector and his so-called Jabacher Kunstkammer provided a school for his scion. The father died in 1636, when our Everhard inherited the business. Two years later he moved to Paris, rightly perceiving it as a promising market for his talents. He became a French citizen in 1647, and by 1659 had prospered to the point where he could buy and remodel an impressive *hôtel* on the rue Neuve-St-Merry (plate 187).

As his fortune expanded, so did his passion for art, especially paintings and drawings, and he became famous as a connoisseur, as we see in this comment written on 1 June 1668 by the Dutch physicist Christian Huygens:

We examined with him at the house of M. Colbert a large quantity of drawings [from the Arundel collection] that a gentleman from Flanders has brought here and is offering to sell to the king. You would have unparalleled pleasure to see how Jabach determines the authenticity of these pieces with a magisterial conceitedness, concluding that, of the three hundred drawings that were attributed to Raphael, there were but two originals.[29]

Jabach loved art, to be sure, and he also loved art dealing. Unlike the usual dealer, who is required to turn over his stock with some regularity, Jabach could afford to buy and hold, waiting for the right moment to bring his goods to market. During the 1650s he was drawn like a vulture to the English collections, outmaneuvering the Spanish ambassador in London and arriving on the scene whenever Arundel pictures were being sold.

In 1661 Jabach sensed that the time was ripe to capitalize on his investment and became involved in a large transaction which was beset by political intrigue and high finance.[30] Early in the year Nicolas Foucquet, *surintendant des finances* of the Crown, obtained sixty-one important pictures from Jabach as a gift to his protector, Cardinal Mazarin. The price was 240,000 livres. The pictures were delivered to the Palais Mazarin by Le Brun, and on 6 March, just three days before the cardinal's death, were bequeathed to the king. By this gift, Mazarin apparently intended to enrich the royal collection and, more important, to inspire the young king to become a picture collector.

It was soon revealed that Foucquet had not personally paid for the pictures; the money had been advanced by one of his clients, Nicolas Doublet, whose hopes for reimbursement were dashed when Foucquet was accused of peculation and dismissed from office in September 1661. Le Brun quickly petitioned Colbert to pay Doublet; in effect, Mazarin had bequeathed a collection of pictures to which he had uncertain title, and now Colbert was being asked to pay for the gift. Colbert decided to provide the funds (in effect, to buy the paintings), and on 20 April 1662 made a payment of 330,000 livres, not to Doublet but to the wily Jabach, who mysteriously once again had come into possession of the pictures. As the new and higher price suggests, Jabach took advantage of the circumstances to enlarge the sale (which, according to the receipt, included statuary as well as painting). It is also probable that he increased the number of pictures from sixty-one to as many as one hundred.[31]

187. Jean Marot, *Hôtel Jabach*
in *Recueil des plans, profils, et elevations des plusiers palais, chateaux, eglises, etc.* n.d.
(c. 1660–70)

Unlike many block purchases, this one had few dud pictures; Jabach's connoisseurship was a guarantee of quality. About three-quarters of the surviving canvases are today in the Louvre and are the cornerstone of the museum's holdings of Italian painting. While Jabach had gathered the works from many sources, the most distinguished had come from the collection of Charles I, as we saw in Chapter II. These included Correggio's *Allegory of Virtue* (plate 81); Leonardo's *St John the Baptist* (plate 83), returned to France after having been sent to Charles I in exchange for Holbein's *Portrait of Erasmus*; and several important compositions by Titian: *Woman at Her Toilette* (plate 188), *Christ at Emmaus* and the *Entombment* (plates 62 and 31). The Venetian school was rounded out by examples from the brushes of Tintoretto, Veronese, Bassano and Lorenzo Lotto. While less numerous, there were good pictures by such central Italians as Sebastiano del Piombo, Rosso Fiorentino, Parmigianino and Giulio Romano. The Jabach purchase went some way to compensate for over a century's indifference to picture collecting by the monarchs of France.

188. Titian, *Woman at Her Toilette*
Paris, Musée du Louvre

Everhard Jabach was not one to rest on his laurels; it is hard to imagine a more potent combination than the scruples of a financier and the cunning of an art dealer. Besides, Jabach's fortunes were reaching their apogee. In 1664 he was named director of the French East India Company, and three years later he obtained a lucrative concession to manufacture buffalo hides for the royal cavalry. Money to buy pictures was no problem for Jabach; finding good pictures was to prove more difficult.

Jabach began to build his so-called second collection shortly after liquidating the first. One of his sources was that colorful royal secretary, Louis-Henri de Loménie, Count of Brienne (1636–98), whose inherited wealth and position were negated by a mammoth ego.[32] Brienne (plate 189) was a man of high intelligence and had enjoyed a brilliant literary and artistic education. While still a youth he undertook a three-year tour of the European continent which reached as far north as Lapland and as far south as Naples. On his return to Paris he succeeded his father as royal secretary, a position held by the head of the family since the reign of Henri IV.[33]

Brienne was passionate about paintings. As he wrote in later life:

I spent a great deal of money on paintings. I love them; I love them to the point of madness. I know them very well; I can buy a painting without consulting anyone and without fear of being fooled by the Jabachs and the Perruchots, by the Forests and the Podestas, those great horse-traders of paintings who, in their time, have often sold copies for originals.[34]

By 1662 he owned what he considered to be a magnificent collection, which then numbered about fifty works. With the grandiosity that is his hallmark, Brienne published a catalog in Latin.[35] Yet even as he composed it, he was contriving his ruin by gambling, the reckless side of his compulsive personality. Early in 1663 he was exiled from court, and on 19 April he sold his post. Soon after, his wife died and the now-shattered nobleman entered the Congregation of the Oratory. His retreat to religion life turned into a rout; he was expelled from the order in 1670. After a three-year exile in Germany, he returned to Paris, and in 1676 was committed to the asylum of St Lazare, where he remained for sixteen years. Bereft of hope, he turned to writing his memoirs, which are recommended reading for amateur psychologists and professional historians alike. Released at last in 1692, he returned to monastic life and died in April 1698.

As his fortunes sank Brienne divested himself of his possessions, and where could he turn to sell his paintings but to that despised horse-trader, Everhard Jabach? At least eight pictures were acquired by the banker from the bankrupt nobleman, including Veronese's small, elegant *Virgin and Child with Sts Justine and George and a Benedictine* (plate 190), mentioned by Brienne in a discourse on painting written in his final years. Ever the supreme egotist, he described the transaction as follows:

No one had more beautiful paintings by Paolo Veronese than I ... such as a Virgin that I had and that Jabach got from me I bought it for 3000 livres from the duke of Liancourt. Commander Hautefeuille [another collector] estimated its price at 30,000 livres at least.[36]

189. Gilles Rousselet (after Charles Le Brun), *Louis-Henri de Loménie, Count of Brienne*

Another vein of pictures mined by Jabach in the 1660s was the Arundel collection. It was in 1662 that he acquired the four portraits by Holbein (plates 49–52) and Titian's *Concert Champêtre* (plate 53) at the sale in Utrecht.

These pictures represent only a small part of Jabach's acquisitions during the 1660s, as we know from the record of the second sale to the crown, which occurred in 1671.[37] Jabach's conduct shows that he was more than a match for Colbert. Late in 1670 the financier was experiencing a crisis in his business affairs and, in order to raise cash, approached the minister with an offer to sell 5542 drawings (Jabach was the greatest early collector of this material) and 101 paintings, plus a quantity of diamonds, sculpture and furniture. The asking price was the elevated sum of 581,025 livres, of which 465,000 pertained to the drawings and pictures, the only items of interest to the minister. Jabach surely calculated this sum on the certainty that Colbert would beat it down, and this is what happened. Colbert obtained an estimate from an unnamed person (perhaps Le Brun), who produced a figure of 280,839 livres. By 10 March 1671 Jabach claimed to be in dire straits and was pressing Colbert to close the deal. "Consider, in the name of God, that I find myself between the hammer and the anvil, and I have to deal with people who give no quarter."

190. Paolo Veronese, *Virgin and Child with Sts Justine and George and a Benedictine*. Paris, Musée du Louvre

Colbert was merciless, and a few days later made his offer—220,000 livres, less than half Jabach's initial price. The minister was so pleased with this outcome that he failed to notice that he was paying the going price for fine pictures and grossly overpaying for the drawings.[38] He was also oblivious to the fact that many of the choice drawings had been extensively retouched by one of Jabach's painters in order to improve their appearance.[39] Despite the skulduggery, Jabach's collection put the French king at the top of the table of this nascent field of collecting; and if, on the whole, the pictures were not up to the level of those in the first sale, they did round out the royal collection with significant examples of the Italians and Flemish of the seventeenth century.

Once he had recovered his financial footing, the irrepressible Jabach re-entered the art market and, at his death in 1695, had run his collection up to nearly seven hundred paintings and 4500 drawings.[40] The emphasis in this third collection was on Flemish and French pictures, although he did have copies of some of the great Italian works he had formerly owned. This collection was bequeathed to his heirs; by then Louis XIV had all the pictures he required.

Of the acquisitions made by Colbert during the 1660s and 1670s, just over forty per cent were made from Jabach. The remainder came from a variety of sources and in smaller quantities. The most important were a number of canvases from the collection of Cardinal Mazarin, a few of which were bequests to the king, more of which were sold by his heirs in 1665.[41] In leaving selected pictures to the monarch, Mazarin followed the precedent of Richelieu who, toward the end of his life, had presented Louis XIII with six important works. This paltry gift is more convincing than it appears, because along with the pictures went the Palais Cardinal. Mazarin, who despite his enormous wealth was tight-fisted, was less forthcoming, although some of his best paintings, particularly those acquired at the Commonwealth Sale, went to the king—Titian's *Pardo Venus* (plate 25) and two works by Correggio, the *Allegory of Vice* (now reunited with the *Allegory of Virtue*, purchased from Jabach) (plates 81–2) and *Venus, Satyr and Cupid* (plate 59). The peregrinations of these masterpieces, which began with the Mantua sale to Charles I in 1627, were now over. The lot sold by Mazarin's heirs, some twenty-six works, also contained some gems, notably works by Raphael—the *Portrait of Balthasar Castiglione* and two small, exquisite panels, *St Michael* and *St George Slaying the Dragon* (Louvre).

Another important purchase consisted of twenty-five canvases which belonged to the great-nephew of Cardinal Richelieu, Armand-Jean du Plessis, the duke of Richelieu (1629–1715) (plate 191). The duke was only thirteen years old when the cardinal died, and thus Richelieu had no way of knowing that his principal heir would dissipate the immense fortune so carefully created during his ministry. Much of the money was lost by gambling (a favorite vice among the nobles of Louis' court), but some of the funds were diverted into buying pictures.

The duke's taste ran to the classicizing painters of seventeenth-century Rome, a preference which had been created in the later 1630s by Cardinal Richelieu and his *surintendant des bâtiments*, François Sublet de Noyers.[42] In 1640, in furtherance of his objective to bring classicism to France, Sublet had sent his nephews Paul Fréart, Sieur de Chantelou, and Roland Fréart, Sieur de Chambray, to Rome with instructions to buy antiquities and to bring the émigré French painter Nicolas Poussin to Paris. Poussin moved to the French court in 1640, but his stay was not a success and he returned to Rome for good two years later. With the death of Richelieu, Sublet was removed from office and the grandiose plans for a French classicism went into abeyance, not to be decisively revived until the reign of Louis XIV.

Nevertheless, some of these ideas seeped into the consciousness of Parisian collectors (the Italian classicists were also favored by Mazarin), creating a demand not only for works of Poussin, but also for Annibale Carracci, Domenichino, Guido Reni and Francesco Albani. The gallery of La Vrillière is probably the most coherent statement of the taste for the classical, although it is not the only example. On 22 February 1658 the dealer Nicolas Perruchot (the same person damned by Brienne for selling copies as originals) wrote to his Antwerp supplier, Matthijs Musson, emphasizing the demand, albeit selective, for the works of Francesco Albani: "As for the paintings of Francesco Albani, they are esteemed in Paris, as long as they are not his latest works."[43] In a postscript he adds, "The paintings of Annibale Carracci, of Domenichino and of Guido Bolognese [Reni] are still greatly esteemed in Paris."

191. Charles de la Fosse,
Armand-Jean du Plessis, Duke of Richelieu
Tours, Musée des Beaux-Arts

Thus the duke of Richelieu was no ground-breaker in his collecting proclivities.[44] However, he acquired with great discernment, winning the praise of the most exigent connoisseur to visit Paris in the 1660s, Gianlorenzo Bernini (plate 192). Bernini had been lured to Paris in 1665 to complete the building of the Louvre, and the events of his stay were chronicled by Chantelou in a diary which is one of the liveliest documents of seventeenth-century artistic life.[45]

Bernini, with boundless energy and curiosity, took the opportunity to visit some of the important Parisian collections, judging them from an uncompromising Roman point of view. For instance, he disapproved of the continuing practice of placing painting and sculpture together with what he perceived to be the minor or decorative arts. Articulating the criteria of display which would not be universally accepted until the eighteenth century, he criticized the installation of the royal collection, and in front of the king: "As for the other matter, instead of so many cabinets, vases, cut-glass, etc., he would have wished the king to have examples of some Greek statuary in one or two rooms and pictures by first-class masters in others."[46] Candor has never been common coin in the realm of the court, and Bernini's forthright pronouncements gradually alienated Louis XIV and his minister, who politely dismissed him after only five months.

The collection of the duke of Richelieu, however, passed the acid test of Bernini's judgment. He and Chantelou went to see it on the evening of 13 October 1665. Over dinner beforehand, Chantelou offered some interesting remarks on Parisian collections: "I told him there were ten or a dozen good collections in Paris; during the last fifteen or twenty years no expense had been spared to obtain works in Rome, Venice and other parts of Italy."[47] In other words, Chantelou confirms what we have learned from studying the inventories, that picture collecting at the French court was a recent fashion and still not widely followed.

But to return to the visit to the house of the duke. After finishing their meal the two connoisseurs set out to view the collection. Chantelou's record of Bernini's observations could not be more engrossing, touching not only on matters of taste (Bernini was a thoroughbred classicist despite the fact that he is now understood as the greatest representative of an emotional Baroque style), but also on his awareness of the importance of installation and of an issue that we fancy results from our superior knowledge of conservation science: that is, how pigments change with the passage of time and affect the appearance of a picture.

M. de Richelieu was not at home, but he [Bernini] looked at all the pictures in his collection. He pointed out that a picture of the Plague [of Ashod] *[by Poussin, in the Louvre], which was hung very high, should be lowered, so that it could be better seen. He studied all the others and particularly one of the Titians [the* Virgin and Child with St Catherine and a Rabbit *in the Louvre (Plate 193)]; the sky, he said, had changed and blackened, so that it came forward instead of receding. He very much admired two landscapes by Annibale Carracci, in one of which there is a St. John in the Wilderness [Grenoble], a St. Sebastian [Quimper, attribution now rejected], and a St. Jerome [lost], and a big landscape of his. When he came to the end, he said, "This is just how a collection should be, with nothing in it but the best."[48]*

192. Gianlorenzo Bernini, *Self Portrait*
Windsor, Royal Library

194. Nicolas Poussin, *Eliezer and Rebecca*
Paris, Musée du Louvre

Chantelou's brief description does justice to the quality but not the quantity of the duke's holdings, and especially where the works by Poussin are concerned. Richelieu was one of the most important collectors of the compositions of this master of French classicism. Among the pictures omitted from mention are the Four Seasons (Louvre), *Eliezer and Rebecca* (plate 194), the *Finding of Moses* (Louvre), and the *Landscape with Diogenes* (plate 195), as well as two magnificent landscapes by Claude Lorrain, *Ulysses Delivers Chryseis to Her Father* (Louvre) and *Landscape with Paris and Oenone* (plate 196), obtained from the duke of Liancourt, one of the veteran Parisian collectors.[49]

A week after visiting Richelieu's collection, Bernini returned to Rome, and two months later twenty-five of the duke's best paintings were sold to the crown for 50,000 livres. This totally unexpected development was explained by Brienne with his customary flair. As Brienne would have it, the duke lost his collection in a tennis match with the king, betting it all on a single point. The existence of the receipt of 26 December 1665 makes this story improbable— more likely Brienne invented it to demonstrate that there was a gambler at court more reckless than he. This sale, however motivated, coincided with the beginning of a ten-year period of relative austerity in the conduct of the duke's affairs. For years he had been divesting himself of inherited properties in order to support his extravagances, and now he decided to consolidate his position.

195. Nicolas Poussin, *Landscape with Diogenes*
Paris, Musée du Louvre

196. Claude Lorrain,
Landscape with Paris and Oenone
Paris, Musée du Louvre

By 1675, however, the duke was starting a new collection, which virtually repudiated the old. In place of Poussin the classicist, he coveted the works of Rubens the colorist. The French invasion of the Netherlands in 1672 (the Dutch War) had again brought hardship to Flanders, forcing owners of works by Rubens to sell off their holdings. Between 1625, when the decoration of the Luxembourg Palace was completed, and the 1670s, when Richelieu began to gather the painter's work, Rubens had been of only moderate interest to Parisian collectors, in part because of the propagation of the classical style in the academy. Now his art returned to the Parisian scene and occupied the center of a famous theoretical conflict between the *Poussinistes* and *Rubenistes*, or the classicists and the colorists. The duke of Richelieu, once famous as an owner of works by Poussin, went over to the other side by acquiring a substantial number of important paintings by the newly appreciated Flemish master.[50]

Many of the best of these were purchased from Philip Rubens, the painter's nephew, through the agency of the dealer Michel Picart. However, the duke did not simply buy and hold, but rather shuffled his collection, intending to reap a profit from the new interest in Rubens. Indeed, it has been suggested that the popularity of the Flemish painter was manufactured by a "cabal" consisting of Picart, Richelieu and the writer on art Roger de Piles, the latter of whom puffed up Rubens' reputation in a polemical series of writings which claimed his superiority over Poussin and the classical school of painters.[51] The idea, of course, was to elevate the price of the large supply of pictures by Rubens which was now available, to the profit of the so-called conspirators. The financial collaboration among dealers, collectors and critics, now a frequent practice in the art world, may have been launched in this way, although there is room to doubt that the trio of Parisians was quite as calculating as its modern counterparts. In any event, some of the master's most familiar masterpieces were to be seen in the duke's house in the Place Royale, including the *Battle of the Amazons* (plate 197) once owned by the Antwerp collector Cornelis van der Gheest (plate 137), the *Landscape with St George* (H.M. the Queen) formerly the property of Charles I and a version (now lost) of that succulent pudding of figural art, the *Fall of the Damned* (plate 198).

Colbert's death in 1683 brought to a close the first and most fecund phase of picture collecting by the crown and prompted an inventory of the royal collection. This was drafted by Le Brun, who was moved after the death of his protector to the sidelines of royal favor. His meticulous inventory, signed and dated 18 October 1683, lists 426 paintings, and an appendix of 1686 added another fifty-seven, bringing the total to 483.[52] (Approximately five hundred works, consisting of secondary material, were kept in storage in the *garde-meuble*.) From this point to the death of the king in 1715, the rate of accumulation declined.[53] The last important acquisition of "old" pictures dates to 1693, when the royal garden architect, André Le Nôtre, bequeathed twenty-one canvases and assorted pieces of sculpture to the crown.[54] True, the final inventory of Louis' holdings, drafted in 1709–10, lists nearly 2400 paintings; however, virtually the entire increment consisted of pictures commissioned for the decoration of the royal houses.[55] Thus we are left to ponder a conundrum—why did the collection of existing works by acknowledged masters virtually cease twenty-one years before the conclusion of the reign?

197. Peter Paul Rubens, *Battle of Amazons*
Munich, Bayerisches
Staatsgemäldesammlungen

198. Peter Paul Rubens, *Fall of the Damned*
Munich, Bayerisches
Staatsgemäldesammlungen

The answer lies with the king himself (plate 199). Unlike Charles I or Philip IV or Leopold William, the Sun King had no eye for pictures. Or, to put it more accurately, he valued paintings as a necessary attribute of a great monarch, but as having no higher value than medals or decorative objects made of precious or semi-precious materials.[56] It is even possible that he paid only scant attention to the development of his picture collection. The task had been delegated to Colbert and Le Brun, who may be considered as its true architects.

During the first twenty years of its existence, the collection did not even have a permanent home and was moved from one site to another in the Louvre and the Tuileries.[57] It was not until December 1681 that the king made his first official visit to the picture collection, part of which was then installed in a suite of rooms in the Louvre (plate 200). Presumably he had cast an eye on it before, but there is little to suggest that, like Charles I, he hastened to see new acquisitions as they arrived, or that he derived great satisfaction from his pictorial treasures. It was not until he moved to Versailles in 1682 that most of the picture collection was installed by stages in his apartments.[58] Even so, the king never lost his interest in the decorative arts and medals. Between 1682 and 1685 a cabinet of curiosities was created near the Salon d'Abondance, and this room would have chilled the blood of Bernini. Twenty-four small-scale pictures were used as decorative objects in a setting that included vases made of semi-precious stones, relief sculpture and medals, the latter of which were housed in twelve special cases designed for the purpose. Soon after, proper picture galleries were created, which the king visited with pleasure. Nonetheless, it appears that the picture collections never enjoyed the same prestige at Versailles as they did at Whitehall, St James', the Alcázar, the Escorial or the Stallburg, where Leopold William displayed his collection on his return to Vienna.

Veüe et Perspectiue de la partie du Louure ou sont les apartemens du Roy et de la Reyne du costé du Iardin

Israel excud.

These circumstances permit only one conclusion to be drawn—the French royal collection of paintings was made for reasons of state. By 1660 the lack of a collection was evident; the king of France, like other important princes, was required to have a large number of famous pictures, and this is what Colbert set out to achieve. Nevertheless, the king's indifference to collecting pictures was not shared by every member of the court. The growing prestige of painting influenced many important courtiers to take his place. Philippe, Duke of Orléans, the king's brother, called Monsieur, who lived and suffered in the shadow of the *Roi Soleil*, was one such person.[59] (Part of his collection was an inheritance from his wife, Princess Henrietta Anne of England, the daughter of Charles I.) In 1692, the king granted him the use of the Palais Royal, which in turn was inhabited by his son, Philippe, the regent, who became the major picture collector during the first quarter of the eighteenth century, in effect filling the void created by his aged uncle.[60]

There is, however, another dimension to the French royal collection, although it was provided by the painters and theoreticians who, under Colbert's aegis, constituted the Royal Academy of Painting and Sculpture. On 7 May 1667 Le Brun offered a lecture to academicians and students in the Cabinet des Tableaux du Roi in the Louvre, selecting Raphael's *Archangel Michael* (plate 201) as the subject for a pedagogical analysis intended to explicate the true principles of the art of painting.[61] Over the next six months other academicians, among them Philippe de Champaigne, Nicolas Mignard and Sebastien Bourdon, repeated the exercise in front of a different work of art. This course of lectures was published in 1669 and therefore served not only a didactic purpose; it also transformed the collection from an adornment of the monarchy into the catalyst of a dialogue between painters and amateurs. As such it offers a vivid example of how, during the seventeenth century, painting acquired intellectual credentials which, when combined with the social prestige conferred by princely collectors, elevated the art above other categories of collectible objects.

201. Raphael, *Archangel Michael*
Paris, Musée du Louvre

VI. The Prestige of Painting

In the early years of the seventeenth century, the great Italian scientist Galileo made some observations on the practice of collecting. The context of his remarks was a comparison of two classics of Italian epic poetry, Ariosto's *Orlando Furioso* (1532) and Tasso's *Gerusalemme Liberata* (completed *c.* 1575), and the metaphor employed, that of a collection.[1]

When setting foot into the Orlando Furioso, *I behold, opening before me a treasure room, a festive hall, a regal gallery adorned with a hundred classical statues by the most renowned masters, with countless complete historical pictures (and the very best ones, by the most excellent painters), with a great number of vases, crystals, agates, lapis lazulis and other jewels; in fine, full of everything that is rare, precious, admirable and perfect.*

Tasso's masterpiece, on the other hand, with its Mannerist intricacies, was not at all to his taste, and evoked the image of

the study of some little man with a taste for curios who has taken delight in fitting it out with things that have something strange about them, either because of age or because of rarity or for some other reason, but are, as a matter of fact, nothing but bric-a-brac—a petrified crayfish; a dried-up chameleon; a fly and a spider embedded in a piece of amber; some of those little clay figures which are said to be found in the ancient tombs of Egypt; and, as far as painting is concerned, some little sketches by Baccio Bandinelli or Parmigianino.

Many collectors of the time would have regarded these views as misguided if not insulting, however prophetic they may seem now. The cabinet of curiosities, or *kunst- und wunderkammer* (plate 136), was then considered to be a redoubt of knowledge, although Galileo, as a true scientist, recognized these assemblages of heterogeneous objects for what they were: that is to say, as pseudo-science. As for his definition of an exemplary collection, this was obviously inspired by the humanists' prescription for princely splendor as articulated notably in the treatise on this most important of attributes written around 1500 by Giovanni Pontano. While Galileo was inclined to be more restrictive than Pontano, his conception of "ornamental objects" as a source of prestige had obviously been shaped by the ideas of Pontano, the apostle of the creed of magnificence.

We call ornamental objects those which are not acquired for their use, but for embellishment and splendor, such as statues, pictures, tapestries, divans, chairs of ivory, cloth interwoven with gems, many-colored boxes and coffers in the Arabian style, crystal vases and other things of this kind, which adorn a house according to the circumstance. The sight of them is pleasing and brings prestige to the owner of the house.[2]

Beetles and lizards might infest these splendid furnishings, but they were not a source of pride or wonder. When Galileo made his observations, this ideal of splendor had been realized by a select number of Italian princes and prelates whose names are famous in the history of

collecting—the Farnese, the Medici, the Gonzaga and the Borghese, among others.[3] Their noble galleries proudly displayed superb classical statuary and beautiful paintings, discreetly complemented by rich decorative objects.

During the course of the seventeenth century, as we have seen in the preceding chapters, the gallery had begun to supplant the cabinet as a necessary component and expression of princely splendor, with the consequence that antique sculpture and paintings by the most famous artists, especially of Italy, emerged from a crowded field of contenders as the most prestigious possessions of a courtly collector. The pre-eminence of antique sculpture had been assured by 1600, although its value was also magnified in the seventeenth century by the covetousness of collector-princes outside the Italian peninsula.[4] However, the rise in esteem of paintings occurred only after 1600 and was propelled by forces that emanated from the sometimes frenetic activities of the large-scale collectors at the courts of Europe.

From our perspective, the prestige of painting is taken for granted and is continually reinforced by news of ever-higher prices commanded by the most desirable examples. The prestige of painting is equally emphasized when we go to museums. A visitor who unwittingly wanders into a great encyclopedic museum like the Louvre on a Sunday or holiday will have to fight the crowds to see the famous pictures, but can roam at will in the cavernous spaces occupied by the antiquities, which have lost ground as knowledge of and respect for the classical age have diminished. The elder Brueghel's paintings of the Months in the Kunsthistorisches Museum, Vienna, acquired by Archduke Leopold William, usually draw a throng, while on the floor below the precious examples of the goldsmith's art commissioned by Rudolph II are viewed only by those entrusted with their security.

In the seventeenth century, however, the status of painting as the most prestigious and costly art was by no means universally accepted. For one thing, pictures were inexpensive compared to other classes of objects. Not illogically, collectors tended to equate price with material value. To take a dramatic but not unrepresentative example, the inventory of Cardinal Richelieu established a value of approximately 80,000 livres for the painting collection in the Palais Cardinal, which numbered about 250 works. The silver, however, came in at 237,000 livres, with a single piece, described as "*buffet d'argent blanc ciselé*," valued at 90,000 livres (and prudently bequeathed to the crown). At the top of the list was a set of liturgical objects encrusted with diamonds, described as a "*grande chapelle de diamants*," which was worth 250,000 livres.[5] Cardinal Mazarin's inventories tell the same story, although he was a far more distinguished picture collector than Richelieu. Most of his jewels and goldsmithwork were assessed at 417,945 livres; his original paintings, at 224,873. The top price, however, was reserved for eighteen large diamonds, known as "*les dix-huit Mazarins*"; these baubles were bequeathed to the king at the value of 1,931,000 livres.[6]

Even among the pictorial arts, paintings could not hold their own; in this category, tapestries carried the day. Nowadays, no artistic medium is less appreciated than the tapestry, which seems to enjoy about the same esteem as second-hand clothing. In the Renaissance and Baroque, however, tapestry was the art of kings, prized for its scale and intricate craftsmanship as well as its insulating properties (plate 202). Tapestries were expensive because they required considerable expenditures on labor and materials. Give a painter a few yards of linen, a pot of glue, some cheap home-made pigments and a brush or two, and, in a few hours or days, you could have a picture. To produce a tapestry required miles of thread, a team of skilled workers,

a large site for production and months if not years of labor. The difference in real value between the two media is again indicated in inventories. The tapestries bequeathed by Mazarin to one of his heirs, the duke of Mazarin, were priced at 452,566 livres, or just about twice the value of the paintings.[7] More emphatic still is the price of the most expensive tapestry listed in the collection of Charles I versus the most expensive painting. The tapestry was a nine-panel set of Raphael's Acts of Apostles, woven in gold and silver; it was valued at nearly £7000. The most expensive price by far for a painting was also by Raphael, the *Holy Family* (plate 58), valued at £2000, although it was a rare picture indeed that was worth more than a few hundred.

This scale of valuation did not end abruptly in 1700. However, during the seventeenth century significant steps were taken in the long process by which the symbolic value of an art work was uncoupled from its material value, and at the heart of this process are the collecting activities pursued at the courts of London, Madrid, Brussels and Paris.

Every study of art at the courts of Europe during the ancien régime begins and ends with the figure of the monarch, around whom political and social life revolved. Although the date of initiation and degree of dedication to picture collecting varied from court to court, the activities of the rulers we have studied were crucial in promoting the revaluation of the status of painting. It was not simply that rulers were inspired to buy pictures, but the scale on which they bought them that was crucial. Many of the Italian collections—the Gonzaga, the Medici, the Farnese—had been patiently accumulated over generations. The great monarchs and princes of the seventeenth century, whose wealth far exceeded that of the Italian princelings, did not have to wait for decades to amass large holdings of art. Regarding magnificence and splendor as preconditions of glory, they were prepared to spend lavishly to build great palaces and furnish them with dazzling possessions, including paintings, which became increasingly important as markers of cultural enlightenment.

As they built and spent, foreign ambassadors and agents watched with anticipation and envy, dispatching the latest news of projects and acquisitions to ensure that their masters would not be diminished in the rivalry between courts. Mazarin writes to Cardinal Antonio Barberini in Rome on 26 March 1636: "I want to be in any case the conduit [*conduttore*] for bringing the Berninis and Cortonas [to Paris] and the best musicians, because they are erecting statues and making pictures and writing melodies to celebrate the glory of such a king as Charles I."[8] During the Commonwealth Sale, he issued instructions to his agent, Antoine de Bordeaux, about a painting by Correggio, and closed with an admonition—"but in no case let it go to the Spanish ambassador."[9] From Madrid, the agents of Charles I kept a watchful eye on the patronage and collecting of Philip IV, advising the royal secretary in London of the arrival of Titian's *Bacchanal of the Andrians* and the *Worship of Venus* (plates 120–1) in 1638. These works were from the Ludovisi collection and had been hungrily eyed by the earl of Arundel in 1636. "I shall be glad," he wrote to his man in Rome, "[if] you buy some of the principal paintings of Ludovisi's for the king our master."[10] As it turned out, Mazarin's agents were also able to outmaneuver the English and obtained thirteen pictures for the cardinal's collection.[11] Examples of competition between courts and courtiers are innumerable as the agents fought endless skirmishes over prized works of art.

The rising fashion for painting was fortunately accompanied by a significant increase in supply. External forces played a part in this phenomenon, especially the deterioration of the Venetian economy in the early decades of the seventeenth century, which made the city a rich

hunting ground for collectors.[12] The sale of the collection of Bartolommeo della Nave to the duke of Hamilton is a salient example. Even more dramatic is the collapse of the house of Gonzaga, which provided Charles I with his greatest opportunity. By 1660 the Venetian writer Marco Boschini observed that "everyone is trying to have paintings and drawings by our singular painters," and that "everyone wants to form a collection of pictures."[13] Most dramatic of all was the dispersal of the English collections in the aftermath of the Civil War, which released many hundreds of paintings on the market and heightened the already keen interest in owning fine pictures.

An inevitable by-product of the passion for painting was the growth of the art market. The art market as we know it today coalesced in the eighteenth century around the figures of the auctioneer and the dealer, who made their livings exclusively in the traffic of art.[14] In the seventeenth century, however, it was considerably less organized. Auction houses did not exist, unless the free-wheeling Friday Market in Antwerp and occasional ad hoc sales be counted.[15] Professional art dealers, who are known to have plied their trade in the sixteenth century, became more numerous in the seventeenth, although we must be careful not to mistake them for the smooth operators garbed in pinstripe suits now occupying posh premises on Madison Avenue, Bond Street and the rue du Faubourg St Honoré. In fact, the majority of dealers were painters, many of whom sold pictures on the side. Transactions by painters as well-placed as Rubens and Velázquez are documented, although they should be regarded as dabblers rather than as full-scale dealers. More deeply involved in the trade were the French painter Claude Vignon, who when he died in 1670 had a stock of paintings attributed to del Sarto, Rubens, Rembrandt, Bassano and Parmigianino,[16] and the Flemish painter Nicholas Regnier, who had settled in Venice and sold thirty-two paintings to Viscount Feilding, destined for the collection of the duke of Hamilton.

Unrivalled as picture dealers were the painters of Antwerp. (I exclude the Dutch market from consideration because it dealt mostly in works of local artists.) As yet, there is no history of art dealing in Antwerp (or anywhere else in seventeenth-century Europe), although numerous documents attest that it was exceptionally active.[17] In addition to individual painters who bought and sold pictures to supplement their incomes, there were the wholesale houses of Musson and Forchondt, who supplied agents all over the continent. Musson's contact in Paris, Michel Picart (a Fleming originally named Pickaert), opened for business in 1650, and became a wholesale importer of Flemish paintings, notably by Rubens but also by a host of lesser masters. (Occasionally, however, Picart's mind wandered: in 1674, he wrote to Musson asking for a keg of pickled herring.) Forchondt's high-volume business with the Austrian empire has already been mentioned; his exclusive franchise made him a fortune supplying collectors in Vienna and Prague.[18]

Another category might be called the layman-dealer, by which is meant a professional who was not or had not been an artist. This individual is the direct ancestor of the art dealer of today and, like his modern counterpart, preferred to operate out of the limelight. He is an elusive creature who emerges from the shadows only in times of trouble, when his modus operandi becomes clear. Such a personality is Daniel Nys, the agent in the sale of the Gonzaga collection to Charles I.

Daniel Nys (or Nijs) was born in the Spanish Netherlands in 1572, and opportunistically settled in Venice as its beleaguered citizens were having to sell their possessions.[19] His first known transaction occurred in 1615, and involved a shipment of Venetian paintings and

antique marbles acquired by Sir Dudley Carleton for Robert Carr, Earl of Somerset. (The pictures, as mentioned in Chapter I, were sold by Carleton to Arundel after the fall of Somerset, while the statuary was ultimately exchanged with Rubens.) Nys was to become a sort of unofficial purveyor to the court of St James' and obviously made a good business of the collecting boom at Whitehall. By 1620 he was prospering; a description of his house by the Dutch humanist Constantin Huygens mentions his splendid cabinet of curiosities (later acquired by Lord Arundel) and the wealth of ancient statuary. Five years later he was able to buy a palatial house on an island in the Venetian lagoon.

Nys' English connections led him to the biggest deal of his career as agent in the Mantua sale. As we have seen, a first installment, consisting of the famous pictures by Correggio, Titian, del Sarto and others, was purchased and sent to London in April 1628. On 2 May, Nys wrote of the consummation of the sale to the king's confidant Endymion Porter, emphasizing how he had outmaneuvered the agents of the emperor Ferdinand II and the queen of France, Marie' de Medici, and yet managed to buy the works at a moderate price: "Had it been known that I was acting for His Majesty, they would have demanded so much more."[20]

The amount of Nys' commission or mark-up is not known, although he claimed not to have profited at all. Perhaps this is true, but if so it was only to set up what he expected would be a great coup.[21] He returned to Mantua and, on his own initiative, bought more paintings and antique sculpture, although Charles I had not formally committed himself to take them. Nys then had the idea of playing Charles off against other collectors, hoping to make a big profit on the purchase price of £10,500 which he had audaciously advanced. His first ploy was a miserable failure; he sent inferior antique pieces to Charles I, expecting to be paid a lot of money, while retaining the better works for sale to another party. He was found out and grudgingly sent most of the rest of the works from the second Mantua purchase to London. Unfortunately, the payment was subject to interminable delays and Nys was forced into bankruptcy. When his creditors seized his house, they discovered several pictures and pieces of sculpture which had been paid for by the king but appropriated by the dealer. In 1636, Nys still had not received full payment and the wolves were at the door. He had pawned his property for a third of its value against the receipt of monies from the king, and now he forfeited and was ruined.

The manipulations of this shady Flemish dealer are surely not to be taken as typical of the art trade, although the count of Brienne was not convinced. His memoirs are peppered with anecdotes of double dealing, and one of his *bêtes noires* is Everhard Jabach, the great collector, who represents yet another class of seventeenth-century dealer. Jabach's activities fall roughly into the category of *marchand-amateur*, although the fit is not quite exact. The quantity of his transactions transcends the usually modest scale of the collector who occasionally buys and sells works, often under the pretext of upgrading his holdings. Let us say that Jabach spent a fortune on art and dealt according to his means.

As one who scrutinized the Parisian market with a microscope, Brienne claimed to have missed nothing, and his eye was closely trained on that despised "horse-trader," Jabach. According to the count, Jabach was guilty of the most heinous crime in art dealing, trafficking in forgeries. In response to the growing demand for paintings by the best artists, a few Parisian painters, including some who are still well known, began to supply collectors with more or less skillful copies which, Brienne alleges, were sold by Jabach as authentic works.

I saw a copy by [Sebastien] Bourdon of a small Virgin by Annibale [Carracci] that Jabach sold for 1500 livres to the duke of Liancourt, and another of the portrait of Gaston de Foix by the hand of Giorgione, which the same [Jabach] sold for 1500 livres to the same duke of Liancourt. I saw, I tell you, these two little paintings so well imitated and counterfeited that all the collectors, except M. [Michel] Passart [a maître de comptes and prominent collector] and myself, were fooled. Le Brun and Jabach helped the deception and the poor duke of Liancourt was much disconcerted. I perceived that Bourdon had applied his manner in some of the drapery folds and that made me aware of the deception.[22]

Brienne's anecdote shows that the ebullient demand for fine paintings was proving irresistible to forgers and fakers. Even in the absence of skulduggery, there was the problem of distinguishing between the creations of the masters and those of their assistants, pupils and followers. As more collectors and greater amounts of money entered the market, and as pride of ownership swelled in the heat of competition, the demand for certain knowledge of authorship became ever more urgent.

In response to these circumstances the expert, armed with the tools of connoisseurship, became crucial in determining attribution and hence value. This function had long been performed by painters, who were not only skilled in the practice of art but who, as part of their training, closely studied the work of the great masters. It is a piquant irony of art history that the pioneers of the discipline of connoisseurship were later to become its most conspicuous victims. Many collectors and agents consulted a painter when considering a major purchase, and all the princes employed a practitioner of the art as the keeper or curator of their collections. Thus, Velázquez served in this capacity for Philip IV; Teniers, for Leopold William; Le Brun for Louis XIV; Abraham van der Doort for Charles I. At the same time, individual collectors—Brienne and Jabach are good examples—honed their skills as experts in furtherance of their collecting pursuits. For that matter, some of the rulers became renowned for their discernment. In 1636 an intermediary in the proposed sale to Charles I of a painting supposedly by Raphael warned a dealer in Perugia not to send a dubious work. The Italians, he said, should no longer presume that the English were ignorant about painting because "His Majesty himself and the other gentlemen of the court so exquisitely understand it."[23]

A sure sign of the increasing importance of authenticity are the attempts to codify the principles and practice of connoisseurship. The history of connoisseurship, like the history of picture collecting itself, passed through a transitional phase in the seventeenth century.[24] The issue of authenticity had, of course, been a live one during the 1500s, and is implicit throughout the text of Vasari's *Lives*. However, the question of determining authenticity was systematically explored only in books on ancient coins, such as Enea Vico's *Discorsi* (1555), which applied the critical methods of humanist inquiry to the detection of fakes and forgeries.[25] Ancient writers, notably Plato, had established a higher moral value for the original versus the copy, laying the groundwork for the privileged status of the authentic work of art, and ultimately for its increased economic value.

The earliest attempt to codify the procedures of authentication was written around 1620 but unfortunately not published until as recently as forty years ago. Significantly, it was written by a collector, the Italian physician Giulio Mancini, who entitled his manuscript *Considerazioni sulla pittura*.[26] While copies appear to have circulated in Italy, the text was unknown in other parts of Europe.

Credit for the first publication on connoisseurship belongs to the French engraver Abraham Bosse, whose short, somewhat disorganized work *Sentimens sur la distinction des diverse manières de peinture, dessein et gravures, et des originaux d'avec leurs copies* was published in Paris in 1649 (plate 203).[27] Bosse's text, which appeared at about the time the term *connoisseur* was introduced into the French language, is clearly a response to the heightened interest in picture collecting at the French court. *Amateurs* needed expert guidance, although they were also a threat to the hegemony of the painter as expert, and Bosse's treatise moves uncomfortably between altruism and self-defense.

For Bosse, the "distinction of the diverse manners of painting, drawing and engraving, and of originals from copies," was not terribly challenging. Like Mancini, he identified the dexterity of brushwork as the most revealing element of authorship, and this quality, as he saw it, was largely self-evident to the expert connoisseur. Thus, Bosse did not perceive great problems in detecting copies. "It is impossible that a copyist, however good he may be, could make his copy pass as an original before the clear-sighted, especially when the said original is seen alongside."[28] This is clearly an overstatement, particularly because the opportunity to view an original and a copy in the same room does not often present itself, especially when one of the works is being offered for sale.

In contrast to Bosse's pragmatic connoisseurship are the essays of Roger de Piles (1635–1709), one of the most important French writers on art. De Piles' approach to the subject, set forth in *L'Idée du peintre parfait* and *Abrégé de la vie des peintres*, published together in 1699, is only incidentally concerned with the problems of attribution, which were of distinctly secondary importance to him. Writing as a theorist and aesthete, de Piles extended the purview of connoisseurship to the question of quality in painting, by which he meant quality of the intellect and spirit, and not of execution. Therefore the connoisseur had to study long and think hard about the art of painting, as opposed to Bosse's instinctual approach to the pursuit. As a guide to connoisseurship in the more narrow sense, de Piles' writings are neither innovative nor important. His true significance lies elsewhere, particularly in the elevation of the amateur over the practitioner as the best judge of painting.[29] However, this idea would not bear fruit until the eighteenth century, nor would thoroughly systematic treatises on the methods of attribution appear until that time.[30]

De Piles' dismissive attitude toward the study of making attributions would have been hard to sell in the cut-throat world of collectors and dealers, where high-minded conceptions about artistic judgment were quickly routed by greed and pride. Attribution is not to be taken lightly when money is on the line, and collectors, merely as a matter of self-defense, did their best to become good connoisseurs. Then as now, however, there was an insuperable problem—connoisseurship is not an exact science, no matter how carefully its procedures may be described. At the core of the enterprise is human judgment, the progenitor of human error. Collectors and dealers sometimes sought insurance policies in the form of certificates of authenticity, but, as every serious student knows, they are usually not worth the paper they are written on. Still, the hope of gaining a foothold in the quagmire of connoisseurship was irresistible, and sometimes it seemed within the reach of a pen. Writing in August 1637 Viscount Feilding informed his brother-in-law, the duke of Hamilton, that a painting of St Peter (now Vienna), attributed to Guido Reni, had been guaranteed as authentic by the seller, who "promis'd a certificat thereof from Guido Rheno, and that it is of his most fierce and best way."[31] With any luck, Reni, then living in Bologna, obliged.

203. Abraham Bosse, Titlepage,
Sentimens sur la distinction . . .
(Paris, 1649)

204. Attributed to Raphael, *Virgin and Child with Sts Elizabeth and John the Baptist* Paris, Musée du Louvre

205. Follower of Raphael, *Virgin and Child with Sts Elizabeth and John the Baptist* Location unknown

However, if the artists were dead and gone, it was another matter, as seen in this incident recorded in Chantelou's diary of Bernini's visit to Paris.

I forgot to note that when we got up from dinner, the abbé Buti came in with a long list of pictures which I recognized as those belonging to M. Gamart [Hubert Gamart, Sieur de Crezé, a well known collector]. He told him that [Lorenzo] Tonti [an Italian banker in Paris and perhaps interested in buying the works] wanted him to write underneath that he liked them, with which he complied; he also asked the Cavaliere to say that a certain portrait was of Annibale Carracci, although on a former occasion, he had said that it was not of that great man.[32]

Certificates written under such circumstances would probably not have carried much weight in the sometimes searching discussions about attributions which were conducted among the amateurs of the seventeenth century.

One of the most instructive of these debates concerns two versions of the *Virgin and Child with Sts Elizabeth and John the Baptist*, both attributed to Raphael, which were in Parisian collections. One (plate 204) belonged to Brienne, who sold it to the king, while the other (plate 205) was owned by the duke of Mazarin, who had inherited it from his uncle. The duke of Mazarin's picture soon lost favor with the connoisseurs, one of whom was Bernini. Chantelou succinctly records his opinion, which relies on the conventional assumption that copyists always betray themselves in the handling of the secondary passages of a composition.

234

The Cavaliere pointed to a hand [in the picture], saying, "You can always tell from the painting of these parts whether a picture is original or not. This could never have been painted by Raphael; it must be Giulio Romano."[33]

Here Bernini follows an unspoken rule of connoisseurship; when there are doubts about quality, downgrade the attribution. However, in this instance, he spoke for the majority.

The painting sold by Brienne to Louis XIV proved to be more problematic. In his so-called *Discours*, Brienne provides a heated account of a dispute with Le Brun and André Félibien, secretary of the Academy, who supposedly assigned the authorship of his painting to Giulio Romano as well.[34] Félibien, as it happened, had offered a nuanced view of the attribution, believing that both paintings had been executed mostly by assistants after a design by Raphael. However, the version owned by Brienne (and now by the king) had been entirely completed by Raphael, whereas he had supplied only finishing touches to the Mazarin version.

A few years later, the painter Philippe de Champaigne presented another point of view in a lecture delivered to the Academy on 2 March 1669. Philippe attributed the landscape to a pupil (an idea already entertained by Brienne) and criticized the composition, assigning certain faults to the reworking of the always convenient Giulio Romano. A reading of the various opinions of modern authorities, which include attributions not only to Raphael and Giulio but also to Gian Francesco Penni and a vague ascription to the workshop, suggests that connoisseurship remains a matter of opinion.[35]

The quest for certainty, the holy grail of collectors, could be carried to almost grotesque lengths. In 1671 the Dutch dealer Gerrit Uylenburgh sold thirteen Italian paintings and a lot of antique sculpture to Frederick William, Elector of Brandenburg, for the sum of 30,00 guilders.[36] When the pictures arrived, the Elector's artistic advisor, the Dutch painter Hendrik van Fromantiou, declared twelve to be copies and sent them back for a refund. The elector had obviously made the mistake of trusting the dealer and now found himself in the purgatory of collecting, arbitration by experts.

Fromantiou brought the paintings back to Amsterdam in the spring of 1672 and boldly put them on public display to be judged by local artists, and such well-known practitioners as Gerbrand van den Eeckhout, Johan Lingelbach and Philips Koninck were not entirely skeptical. A second jury was then assembled to adjudicate the conflict, whose members went to view the painting on 12 May 1672 at an inn on the Kalverstraat. This group included Willem Kalf, the still-life painter Adam Pijnacker and Gerard de Lairesse, who rejected the attributions. Now the ball was in the dealer's court, and two days later he invited still another group to pass judgment. Unfortunately they too disparaged the pictures. Still hopeful that fresh eyes would provide fresh opinions, Uylenburgh sent the pictures to The Hague and sought the opinion of painters in that city. Johannes Vermeer was summoned from Delft to join the jury, which once more delivered a negative verdict. Uylenburgh was now well and truly stuck and finally took back the pictures. He sold them publicly in Amsterdam in February of the following year, by which time, as is now said in the trade, they had been "burned" (previously offered on the open market without having found a buyer).

It has never been easy to assemble a great collection of pictures, and the princes of seventeenth-century Europe were justifiably proud of their accomplishments. Distinguished visitors were

Quid Virgo Sparsis prætendit compta capillis:
Et Christum querens consequi sola putat?

Soli Deo Seruire cupit, seseque beatam
Reddere, nam Crucis gaudia sola beant.

Albertus Durerus pinxit, Wsollerus fecit, ex Collectione Arundeliana, 1646.

206. Wenceslaus Hollar,
Woman with Loosened Hair, after Dürer
Windsor, Royal Library

207. Albrecht Dürer,
Woman with Loosened Hair
Frankfurt, Staedel Institut

always taken to the galleries and could be relied on to return home with tales of the wonders they had seen. Another vehicle for advertising their treasures and arousing the admiration and envy of rivals was the illustrated book, which still proves expedient for stroking the egos of vain collectors. The idea of publishing a book devoted to a single collection seems to date to the 1620s. (Reproductive prints of single paintings have a separate and longer history.) One of the early examples was produced by Cardinal Federico Borromeo, under the title of *Museum Bibliothecae Ambrosianae* (Milan, 1625), a guide to the archbishop's collection which lacks, however, the key element of illustrations. Four years later the earl of Arundel published an illustrated book of antique sculpture, *Marmora Arundeliana*, and around 1637 started to plan a comparable anthology of selected paintings and drawings in his collection, to be illustrated by the Bohemian printmaker Wenceslaus Hollar. Hollar made drawings of numerous paintings but produced only four prints before fleeing to Antwerp as the Civil War broke out. During his stay in the Netherlands, he independently published a number of prints after pictures in the Arundel collection to help him to earn a living (plates 206–7).[37] Inspired by these and other examples, Everhard Jabach in 1656 launched an effort to produce engravings of selections from his collection of paintings and drawings, although they were never published in book form.

236

It was not until *Theatrum Pictorium* (1660), organized by David Teniers, that the first illustrated book on a single picture collection appeared. As we have seen, *Theatrum Pictorium* communicates several messages concerning the nobility of painting and painters as well as the glory of the collector, which distinguishes it from other efforts of this kind. A more focused instance of the collection book was produced in the 1660s by the heirs of Gerard (1599–1658) and Jan Reynst (1601–46), two Dutch merchants who had made a modest but interesting collection of Italian painting and antique sculpture.[38]

The Reynst collection is one of the few of this kind formed in the Dutch Republic during the seventeenth century, and illustrates how the ideal of the princely gallery took hold among the mercantile class.[39] The core of the works was acquired in the later 1630s in the usual way, as a block purchase from a Venetian collector. During the 1650s Gerard Reynst decided to publicize the collection through the production of two illustrated books, one devoted to the pictures (plates 208–9), the other to the antiquities, and this project was carried out by the heirs in the 1660s. However, by this time twenty-two of the best paintings had been sold to the States of Holland and West Friesland and presented to Charles II of England as he embarked for London to occupy the throne left vacant by his father's execution in 1649. In this way, the English royal collection began the slow process of recuperation from the losses inflicted by the Commonwealth Sale.

208. Pieter Holsteyn II after Giulio Romano,
Isabella d'Este
New York, Metropolitan Museum of Art

209. Giulio Romano, *Isabella d'Este*
London, Hampton Court Palace

The most ambitious publication of a collection in the seventeenth century was executed at the court of Louis XIV and is known by the misleading term of the *Cabinet du Roi*.[40] Far from reproducing the contents of a collector's cabinet in any of the established ways, it is a huge *mélange* of prints; eventually over 950 were produced, representing a wide variety of activities sponsored by the king. The inception of the project dates to 1665, when André Félibien began to organize teams of engravers to make plates of French cities, the royal houses, the collections of paintings, sculpture and medals, a series of tapestries designed by Le Brun and the public spectacle known as the Grand Carrousel, which occurred in Paris in 1662. A year later the newly founded Academy of Science commissioned engraved plates of plants and animals as well as a translation of Vitruvius, which were incorporated into the project.

In December 1667 Colbert took control, and in 1670 he decided to print the plates, which then numbered almost three hundred, and to publish them in thematic series. The guiding idea was conventional enough—to broadcast the glory of the king by displaying his possessions, both territorial and material. These volumes were distributed to other European courts via the French ambassadors and are known to have reached such places as Holland, Bavaria, Poland, Sweden and Rome. Eventually the costs of the *Cabinet du Roi* became excessive, and in 1679 the volumes were offered for public sale. Despite unending financial problems, production continued until 1712, and when it was done the *Cabinet* was the largest, if least coherent, collection-book published in its time.

The place of the picture collection in this publication is admittedly small, although the quality of the prints is superb (plates 210–13). Over the years a mere thirty-eight paintings from the royal collection were engraved. However, the proportion is a consequence of the universal ambitions of the French royal collection, on the one hand, and the relative indifference of the king to the art of painting, on the other.

In fact, the heterogeneous character of the French royal collection, as reflected in the *Cabinet du Roi*, cautions us about assuming that the triumph of painting was fully accomplished everywhere by the end of the seventeenth century. Different courts proceeded at different paces. In Madrid and Brussels, for instance, it is certain that painting had predominated by mid-century. The case of London is harder to judge because of the interruption of collecting caused by the Civil War and the Protectorate. Both Charles I and Lord Arundel had wide-ranging interests, whereas Buckingham concentrated on paintings and antiquities, and Hamilton on paintings alone. However, evidence suggests that even for the king pictures eventually became more important than other types of objects. In 1637, Arundel wrote to William Petty, informing him that the king had decided not to take a prized antique sculpture which the agent had procured in Rome, preferring to have an important sixteenth-century painting.

His Majesty thanks you for the care in it, but desires I should take it [the sculpture], saying he hath much more mind to some good picture, and means to employ you to buy for him that of Bronzino, which you mentioned. . . .[41]

In this respect, the portraits of Lord and Lady Arundel (plates 11 and 12) commissioned from Daniel Mytens are both deceptive and significant. The Arundel collection encompassed books, manuscripts, drawings and even some curiosities. However, these formal portraits, set in a sculpture gallery and a picture gallery respectively, show the Arundels adhering to the Italian definition of a princely collection.

210. Etienne Picart *St Cecilia*
after Domenichino,
Print Collection, Miriam and Ira D Wallach
Division of Art, Prints and Photographs
The New York Public Library

211. Domenichino, *St Cecilia*
Paris, Musée du Louvre

Ste Cecile chantant les Louanges de Dieu. Cæcilia Virgo Domino decantans.

212. Guillaume Chasteau *Ecstasy, of St Paul*
after Poussin,
Print Collection, Miriam and Ira D Wallach
Division of Art, Prints and Photographs
The New York Public Library

213. Nicolas Poussin, *Ecstasy of St Paul*
Paris, Musée du Louvre

Sainct Paul enleué jusqu'au troisième ciel
Gravé sur le tableau du Poussin qui est au cabinet du Roy,
de 4 pieds 3 p. de haut, et de 3 pieds 3 p. de large

Sanctus Paulus raptus usque ad tertium coelum.
Cité juxtum ex tabulâ Nic. Poussin asservatâ in Pinacothecâ regiâ,
4 pedes et 3 poll. alta, 3 pedes, et 3 poll. lata. G. Chasteau sculp.

Another crucial point to bear in mind is that collecting of every sort—books, medals, natural specimens—continued as before, as did the accumulation of objects made of precious metals and gemstones.[42] However, collections of scientific material increasingly became the province of specialists—botanists, geologists, physicists—and by the end of the seventeenth century scientific collecting had acquired a history of its own.[43] The principal casualty of the seventeenth century was the cabinet of curiosities, that heterogeneous assemblage of natural and man-made objects, which could not withstand the rationalism of the scientific revolution, and the resultant specialization of knowledge also manifested in the attempts to codify connoisseurship. Christina of Sweden's attitude toward naturalia is decisive on this point; shortly before abandoning the country she gave her holdings of this material to the keeper of her collections in lieu of back wages.[44] Leopold William was even more explicit about the new standards of princely collecting. In his last will and testament he bequeathed to his nephew, Emperor Leopold, his paintings, sculpture and medals, which he referred to "as the finest and most beloved part of all my belongings."[45] At the risk of laboring the point, it may be mentioned also that the marquis of Leganés and Luis de Haro incorporated their formidable collections of paintings into the permanent patrimony of their titles (*mayorazgo*).

So, even after every caution, exception and reservation has been heard, it is evident that the status of painting improved remarkably between 1600 and 1700, and that the immediate causes of this phenomenon are to be found in the princely courts. The quantity and quality of pictures owned by the ruling class increased significantly, and the pre-eminence of the art was further enhanced by its conspicuous display in the gallery, a large noble space in the public sector of the palace.[46] From the late sixteenth century on, the palatial gallery was increasingly decorated with ensembles of easel painting and antique statuary, either in original examples or in replicas. The point can be made by Teniers' paintings of the collection of Leopold William (plates 75 and 154) as well as by the engraving of its installation in the Stallburg, Vienna (plate 215); by Carreño de Miranda's several portraits of Charles II, set in the Hall of Mirrors of the Alcázar, Madrid (plate 216); by Nanteuil's print of Cardinal Mazarin, elegantly posed before the gallery of his Parisian palace (plate 166); and by Mytens' portraits of Lord and Lady Arundel (plates 11 and 12).

The importance of these views is not so much in their evidentiary character—except for the gallery paintings by Teniers, they are not very helpful for identifying individual works—but in the display of paintings as a significant attribute of a great personage. While it has been remarked that a collection of pictures, however valuable, was always overshadowed by the scale and magnificence of a great palace,[47] this overlooks an important point—that a large palace without appropriate decoration is only a grandiose shell. (Imagine entering the Louvre to find it decorated with travel posters and ready-to-assemble furniture!) Italian writers of the sixteenth century made the point more elegantly by using the terms "magnificence" and "splendor." This concept has been summarized as follows: splendor is "the complement of magnificence, being the logical extension of magnificence into the private world."[48] In other words, the impression of magnificence on the outside had to be reinforced by the opulence of the interior if the appearance of power, wealth and status was to be sustained. As these views suggest, paintings (together with antique sculpture) were now acquiring a symbolic content which made them at least as valuable as more costly possessions, although the value was measured in different, essentially non-material ways.

214. David Teniers the Younger,
Gallery of Archduke Leopold William
Vienna, Kunsthistorisches Museum

215. Frans van de Steen Ossenbeck
after Nicolaes van Hoy,
Gallery of Archduke Leopold William,
Stallburg, Vienna
from *Theatrum Pictorium*

The case for antique sculpture had already been established before the seventeenth century; classical antiquity represented the acme of artistic perfection, and furthermore good pieces were difficult to obtain. But why did paintings, among all the visual arts, become as coveted as ancient marbles? They certainly were not particularly rare; on the contrary, as we have seen, thousands were in circulation in the seventeenth century. It is true, of course, that not all paintings were valued equally and that the heightened demand reduced the supply of the best masters. Rarity was intensified because princely taste was surprisingly homogeneous. Italian paintings of the sixteenth century, and Venetian paintings especially, were the most coveted. Works by seventeenth-century Italian painters, up to around 1630–40, came next, with a premium placed on pictures by Annibale Carracci and his followers. The early Netherlandish school was prized in Spain and Flanders, perhaps for chauvinistic reasons. Once again the conduct of Christina of Sweden is a barometer of the prevailing opinion. She received the paintings from the collection of Rudolph II at Prague just before leaving for Flanders and quickly sorted them out, taking only the Italian works except for a few paintings by Holbein and Dürer (plates 127–8), intended as gifts for the king of Spain. Later in the century, a few more seventeenth-century painters, notably Rubens and Poussin, were admitted into the company of the elect. Rather surprisingly, none of the top collectors much favored the contemporary artists of their realms, unless for decorative commissions.

This sketch of princely taste tells us which pictures were sought but leaves unanswered the crucial question just posed—how do we explain the significant increase in the social, material and symbolic importance attached to the medium of painting? Why did the princes of Europe choose to bestow their favor on this art and to elevate it to the pinnacle of prestige?

Behind the rise of painting to a privileged position lies a process of some complexity and duration. At its heart is the conceptual transformation of painting from a manual craft to a liberal art. Throughout the Middle Ages painting was generally excluded from the constellation of pursuits which were considered as intellectually and spiritually ennobling. However, in fifteenth-century Italy painters and sculptors began the quest to reposition their art within the hierarchy of European civilization. This story has often been told; to be brief, writers on painting, many of them practitioners of the art, applied the ideals and expository methods of humanist discourse on history, philosophy and rhetoric to their endeavor.[49] In addition, painting was transmuted into a sibling of poetry, which was universally considered a major art.[50]

During the sixteenth century the elevation of painting to a higher status was furthered not only by the exemplary careers of Leonardo, Raphael and Michelangelo, but also by the growing sophistication of art theorists. The most renowned, of course, was the Florentine painter Giorgio Vasari, whose *Lives of the Artists* (1550) constructed a noble history of painting and propagated the idea of the artist as hero. Vasari was also instrumental in founding the Florentine Academy of Design (1563), the first academy of art, which was modeled on literary prototypes and had avowedly humanistic ambitions.

These arguments were accepted in the petty courts of Italy during the fifteenth and sixteenth centuries, where the union between painting and humanist culture was first consummated, and from there they spread gradually to other parts of Europe. As a consequence, painting began to be seen in a different light than other forms of visual display. Jewelry and table settings made of gold and silver and finely-spun cloth hangings and fancy clothing could be acquired

216. Juan Carreño de Miranda, *Charles II*
Madrid, Museo del Prado

by anyone with wealth, but they were not cultural creations. Fine paintings, on the other hand, were now immersed in the mainstream of European civilization and thus it behooved princes who regarded themselves as promoters of cultural progress to own and understand them. In the end, a powerful symbiosis was achieved between the cultural prestige of painting and the social prestige of princes, although painting was the greater beneficiary of the process.[51]

The ramifications went in several directions. Once painting had acquired intellectual trappings, it could be talked about in an intelligent way. Indeed, the ability to do so was taken as a mark of a person's quality.[52] A fabulous gemstone might be admired for its size, rarity, brilliance and cut, but it provided no information or insight into human history and conduct or the mysteries and meaning of the faith. Neither could the intellect and skill of its maker be discerned and praised in any but an elementary way. The appreciation of a picture, by contrast, was possible only through careful study and experience, the results of which were conveyed in a literary language. A classic example of this phenomenon are the *conférences* delivered by members of the Académie Royale de Peinture in front of pictures in the royal collection in the Louvre. The texts, as published and perhaps burnished by André Félibien, the academy's secretary, are case studies in the assimilation of humanistic rhetorical style into the discourse about painting.

The mastery of this lore of painting not only became a prerequisite for ladies and gentlemen, but it even acquired a political dimension in the courts of collector-princes. In earlier chapters we have seen examples of the way in which pictures were used to gain the favor of monarchs, especially in the cases of Charles I and Philip IV. A telling instance comes from the correspondence between the duke of Hamilton and Basil Feilding over the acquisition of paintings in Venice. Hamilton, a somewhat rough-hewn Scottish lord, recognizes that pictures offer possibilities for abetting his political ambitions, but he can never quite decide whether or not they are wonderful things to own. His ambiguity illustrates the moment when pictures were passing from being considered as decorative objects to a valuable currency in courtly transactions. "I pray you look after a good collection for I am much in loofe with pictures," he writes on 18 April 1636.[53] However, his letter of 14 August 1637, written in his brogue-inflected prose, offers this remark: "I will rather chouse to ad 1000 or 1500 pound ffurther to what I alredie sent than faill of having a better collection booght over than ther ar, for I have undertaken itt to the King and tho itt be a frivolous matter he woold be displeased if itt should not be donne. . . ."[54]

Hamilton's letters reveal how the possession of fine pictures became a badge of identity for the social elite. (Legions of ordinary people owned pictures, too; however, these were ordinary examples, intended as mere illustrations of aspects of life or religious doctrine and without pretension to higher things, whether monetary value, social status or artistic excellence.) This is not to say that the traditional trappings of wealth and power disappeared from view; the conspicuous consumption of luxury goods is an enduring characteristic of every hierarchical society. However, the prestige acquired by painting during the seventeenth century was unusual in this respect; by infusing display with a literary culture, it transformed notions about magnificence and the valuation, both social and material, of painting itself. During the next hundred years, the triumph of painting would be consolidated and it would assume an unassailable place among the five "major" arts (sculpture, architecture, literature and music being the others).[55]

Its ascendancy in the eighteenth century is represented in two remarkable paintings. In 1749 the Roman painter Giovanni Paolo Panini completed his dazzling view of the picture gallery of Cardinal Silvio Valenti Gonzaga (plate 217).[56] Although the setting is known to be imaginary, the pictures, most of them identifiable and still in existence, were part of the cardinal's collection. As for Johann Zoffany's equally intricate picture of the Tribuna of the Uffizi (plate 218), executed between 1772 and 1777,[57] it represents the treasure gallery of the famous Medici collection, although the artist has cheated to some extent by including pictures normally kept in the Pitti Palace. (The inclusion of antique statuary is also representative of noble taste.) The models for a princely collection provided by David Teniers in his depictions of the gallery of Leopold William, something of a novelty in their day, are here accepted as the norm.

It was thus in the milieu of the seventeenth-century monarchical court that the long-nurtured aspirations of painting ripened into fruition. However, the result was not an unequivocal triumph. For one thing, the benefits accrued largely to dead practitioners. Elite collectors valued rare examples by painters whose reputations were sanctioned by history. This is why the struggle over the status of painting was continued by artists of the seventeenth century.

Another consequence was to convert the appreciation of painting into a marker of social status. In time the exercise of taste, as it came to be known in the eighteenth century, degenerated into snobbery, and it is only recently, after concerted efforts at public education, that pictorial masterpieces have begun to engage the interest of a wider audience.

Finally, the voracious demand of seventeenth-century collectors turned the art of painting into a mercantile commodity. Paintings had always changed hands for money, but there is a world of difference in a transaction between an artist and a client and one between a dealer and a collector. At the moment when painting was becoming recognized as a superior human activity, it became a vehicle for investment and speculation. André Félibien, dusting off an old idea and recasting it with eloquence, spoke of painting in 1667 as something almost divine:

As God made man in his image, it seems that man for his part may make an image of himself by expressing his actions and thoughts on a canvas in a manner so excellent that they remain constantly and forever exposed to the eyes of the world, so that not even the diversity of nations impedes that, by a mute language more agreeable than all the [spoken] languages, they may be rendered intelligible and be understood in an instant by everyone who regards them.[58]

Contrast Félibien's noble sentiments with a story told by his contemporary the count of Brienne, the prototype of the new connoisseur, for whom picture collecting is a high-stakes game of money and ego.

One time I was fooled without knowing it. Michelin [a Parisian art dealer] sold me a beautiful copy of [Jean Baptiste] Forest [a pupil of Pier Francesco Mola] that I took to be by Mola. But it was very understandable and [I] should be pardoned as an apprentice collector who still did not know anything. But I deceived my deceiver in turn. I had Forest copy my little Hagar by Mola for 100 livres and sold it to Michelin, that clothesmender of paintings, for 400 livres as an original by Mola.[59]

High art and cupidity have entered here into a mortal combat, the outcome of which, while still awaited, will probably soon be known.

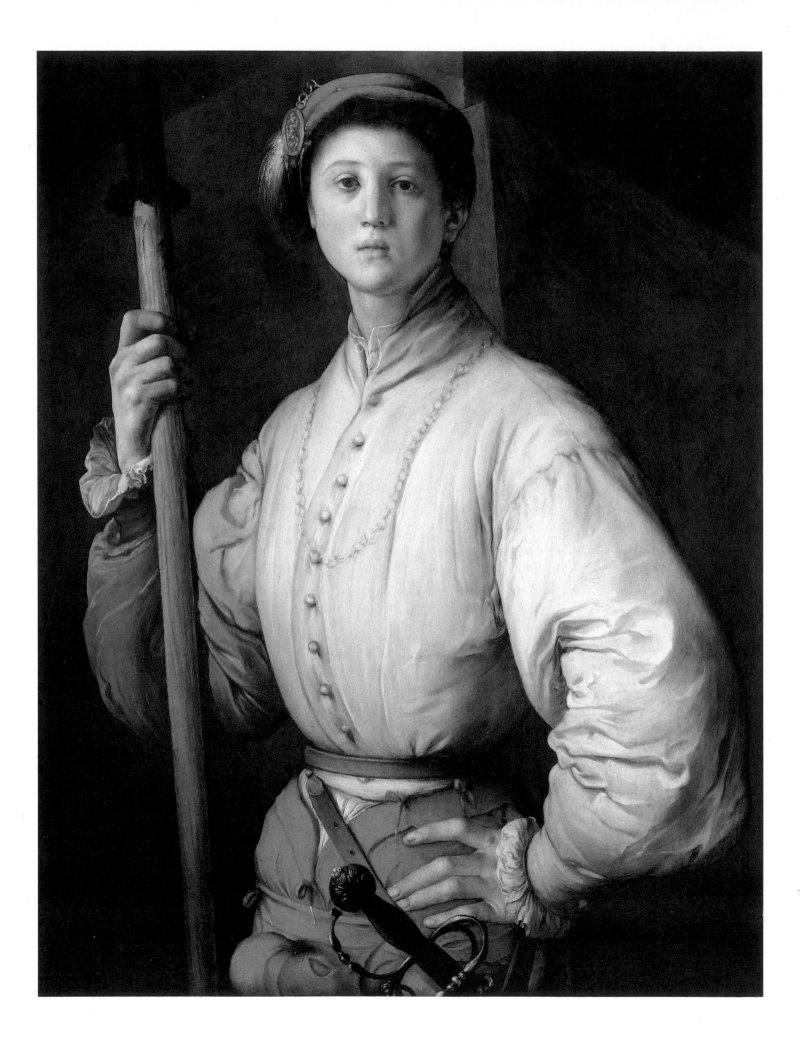

Where Have All the Masterpieces Gone?
An Essay on the Market for Old Pictures, 1700–1995

On 31 May 1989 the J. Paul Getty Museum in California paid $35 million for the *Portrait of Cosimo I de' Medici* (plate 219) by the sixteenth-century Italian painter Jacopo Pontormo. The amount was impressive by any measure, the more so when it is considered that portraits are not usually among the most coveted pieces. And while the quality is indisputable, the picture is not on a par with the great masterpieces of the Italian Renaissance, or even with the most important works of this artist.

The explanation of this lofty price is not hard to find. Available works by acknowledged masters of the Renaissance and Baroque have become exceedingly rare, and prices have risen correspondingly. Or, to put it another way, the art market is now experiencing the ultimate consequences of the triumph of painting which was initiated in the seventeenth century.

As we have seen in the preceding chapters, the quantity of old pictures available to collectors in the 1600s was enormous and included excellent examples by the most renowned artists. The rise in supply was caused by several factors. Most dramatic was the English Civil War, which forced the sale of the best collections in London. In addition, the decline in the Italian economy, which compelled many collectors to sell their pictures, also contributed to the phenomenon. At the same time the rulers of other European courts, who had access to tax revenues, were well provided with the money to make wholesale purchases of what were still relatively inexpensive artistic commodities. Over the next three centuries some of the most momentous developments in picture collecting followed a similar script. Collectors, beset by adverse economic and political circumstances were required to divest their holdings to the benefit of those who possessed wealth and wished to share in the prestige of painting.

A comprehensive account of these events is obviously beyond the scope of this brief essay, but it may be possible, by choosing a few representative moments, to illustrate the dynamics of the redistribution and eventual contraction of the quantity of important old pictures.

The transfer of ownership of paintings reached a high water mark in the late eighteenth and early nineteenth centuries, as a consequence of the French Revolution and the Napoleonic Wars. Emigré French nobles forfeited their collections either through confiscation or forced sale, while the depredations of the French Army brought hundreds of paintings and antique sculptures to the Louvre and the provincial museums of France.

The first notable event was the sale of the collection of Louis-Philippe-Joseph, Duke of Orléans, considered the best in Paris. In the confusing aftermath of the Revolution the duke made a bid for the throne which he financed by the sale in 1792 of some four hundred choice pictures to a consortium of three English noblemen, led by the duke of Bridgwater.[1] Bridgwater, who had made a fortune in coal and canals, is a prototype of the new English collector of the nineteenth century, the captain of industry, with a fortune accumulated in the Industrial Revolution. The consortium kept the best pictures (plates 220–1) and sold the remainder to finance the deal.

219. Jacopo Pontormo,
Portrait of Cosimo I de'Medici
Malibu, J. Paul Getty Museum

220. Raphael, *Madonna del Passeggio*
Edinburgh, National Gallery of Scotland,
on loan from Duke of Sutherland

The systematic looting of foreign collections by the army of France in the years following the Revolution is of a different and entirely nefarious order. The mode of operation was put into practice when the Republican army occupied Belgium in 1794.[2] A commission of French experts was sent north to choose works for the Musée du Louvre, which had been established the year before, and several altarpieces by Rubens, among many other works, were quickly transferred from churches in Antwerp to the right bank of the Seine.

This concept of educated plunder was learned by Napoleon when, as a Republican general, he led an army into Italy in 1796. With a committee of connoisseurs in tow, he removed pictures and ancient sculpture from Parma, Modena, Milan, Bologna and Cento, and sent them to Paris.

During the Empire (1804–14) Bonaparte continued this illegal enrichment of the French national collection, which was masterminded by Domenique-Vivant Denon, director of the Musée Napoléon, as the Louvre was now called. When at last the emperor was defeated, delegations from the plundered cities and states came to Paris to reclaim the booty, but they achieved only partial success. For instance, just about half of the five hundred pictures removed from Italy were finally recovered. Some were too large to be retrieved (plate 222)—they literally needed a corps of army engineers to move them—some were sequestered in provincial museums by directors who ignored the appeals for their return (plate 223) and some were retained by officials who, with guile and evasion, deflected the entreaties of the legitimate owners.

Similar methods of acquisition were employed by other French generals who were less altruistic and simply wanted to make personal collections. One notable example is Nicolas Jean-de-Dieu Soult, who commanded the army in southern Spain. On his orders the churches, monasteries and convents of Seville were systematically stripped of their pictures and brought to a central depot, where they were culled by his experts.[3] Soult forced the ecclesiastics to transfer legal ownership to him in the form of "gifts" and thus, when the army retreated, he kept the booty and took it back to Paris, financing his retirement with the sale of the pictures.

Other collectors were more scrupulous in acquiring massive collections. However, the tide was running in their favor, as hundreds of pictures were dumped on the market during the wars and their aftermath. It is no accident that one of the most aggressive collectors was Napoleon's uncle, Cardinal Joseph Fesch (1763–1839).[4] Benefiting from the favors bestowed by Napoleon on his family, he rapidly ascended the ecclesiastical hierarchy and was appointed archbishop of Lyon and Grand Almoner of the Empire. With enormous sums at his disposal, Fesch bought pictures on an incredible scale; the exact number of his holdings has never been determined, but it easily reached into the thousands. While he acquired works across a broad spectrum of European painting, he is now best known for his holdings of Italian trecento and quattrocento masters (plate 224; considered better than the version in plate 39). Much was sold off after the cardinal's death, although a sizable number of his early Italian pictures was bequeathed to the town of Ajaccio in his native Corsica and can be seen there today in the museum which bears his name.

If further evidence were needed of the abundant supply of pictures available during the period, it can be found in the collecting activities of Edward Solly (1776–c.1845), an English merchant who prospered during the Napoleonic Wars.[5] Solly was posted to Germany to manage his family's lucrative trade in timber and settled in Berlin in 1800, where he remained

221. Raphael, *Madonna and Child* (Bridgwater Madonna). Edinburgh, National Gallery of Scotland, on loan from Duke of Sutherland

for twenty years. The canny merchant deployed his wealth to amass a collection of three thousand paintings, including many great works of the fifteenth century, both Netherlandish and Italian. The jewels of the collection, incredibly, were six panels from the Ghent altar by Jan van Eyck. Then, in 1821, Solly, having suffered serious financial reverses, sold his entire collection to a new European power, the state of Prussia, and it became the nucleus of the first public art museum in Berlin. (The panels of the Ghent altar were returned in 1920, under the terms of the Treaty of Versailles.)

In the blizzard of pictures descending on the market during these decades, it is difficult to discern the outline of a new development which in time would transform the market for old pictures. This is the concession of public access to princely galleries, the first step toward public ownership of the great hereditary collections of Europe. The earliest example is the Uffizi in 1769, and over the next fifty years all the monarchical collections studied in this book were opened to public view—Austria, in 1781 (including the collection of Leopold William); France in 1793 (including the collection of Louis XIV); Spain, in 1819 (including the collection of Philip IV). Eventually each of these would pass into the public domain and become one of the great state museums of Europe.

The establishment of the state museum is a watershed in the history of art collecting. For one thing, it meant the permanent retirement of art works from the open market. Moreover, a modern industrialized state could dedicate large sums to building its collections. However, there was more at stake than acquiring works of art. The French Republic and Empire had introduced a new concept into collecting, the cultural trophy as a means to express the political and economic domination of a powerful nation. The addition of nationalistic pride to the motives for forming a collection has proved to be a great stimulus to large-scale collecting by public institutions, with inevitable repercussions on the supply of cultural artifacts of every kind.

222. Paolo Veronese, *Marriage at Cana*
Paris, Musée du Louvre

223. Andrea Mantgena, *Agony in the Garden*
Tours, Musée des Beaux-Arts

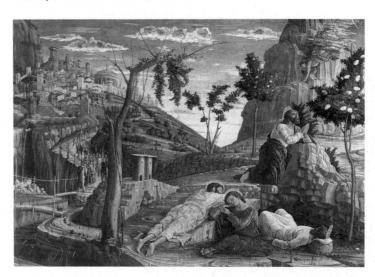

A lucid example of the phenomenon, as far as pictures are concerned, is the National Gallery in London.[6] In England the royal collection remains in theory the property of the sovereign, although surely it is inalienable. Therefore the public collection had to be started from scratch, which was done in 1824, when Parliament voted to acquire thirty-eight pictures from the estate of the financier John Julius Angerstein (d. 1823). These pictures remained in Angerstein's house until the building in Trafalgar Square (only a fraction of the present structure) was opened to the public in 1838. During the rest of the century the National Gallery, with monies principally supplied by the state, was able to build a public collection worthy of a great mercantile and military power.

The last important entrant into the market for old pictures was the United States of America. The importance of the American chapter in the history of picture collecting (indeed, of art collecting of every sort) may not as yet be fully evident, although it is as impressive as earlier episodes. Perhaps because we are so close to the phenomenon, there is still little serious study of how this nation carved out its niche among the major international collectors.

The origins of world-class collecting in the United States date to the closing decades of the nineteenth century, when American financiers and industrialists, who had prospered during the Civil War, began to imitate European collectors.[7] Motivated by a sense of noblesse oblige as well as a desire to create enduring personal memorials, many donated their collections to public institutions which, however, remained independent of the state. Ownership of the collections and control over their administration were vested in trustees where, for the most part, they remain today. This unusual form of quasi-public institution has proved to be an exceptionally successful way to build collections, and the major American museums have grown from nothing to where they are today in little more than a hundred years.

224. Attributed to Giorgione, *Nativity*
Washington, D.C., National Gallery of Art

225. Raphael, *Alba Madonna*
Washington, D.C., National Gallery of Art

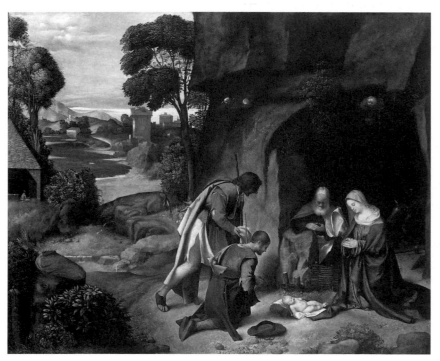

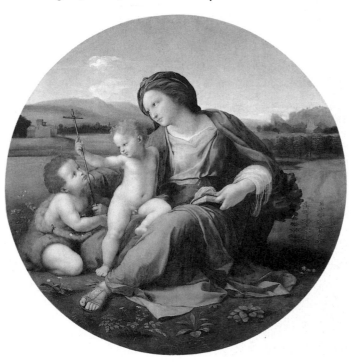

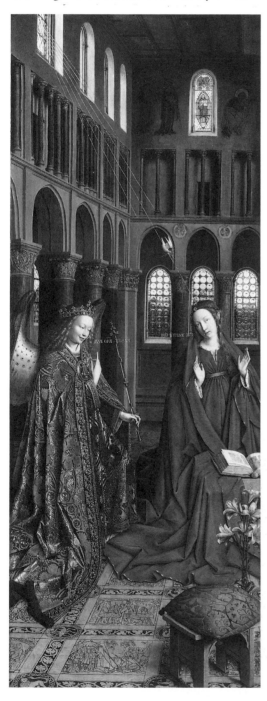

226. Jan van Eyck, *Annunciation*
Washington, D.C., National Gallery of Art

Certainly the most conspicuous example of this unusual partnership between the private and public sectors is the National Gallery of Art in Washington.[8] From its inception the Gallery has relied on private donors for acquisitions and on the federal government for operating funds. The results speak for themselves, although it is worth emphasizing the speed at which the museum has achieved its place among the major art collections of the world. The Gallery was dedicated in March 1941, and is thus just over fifty years old. To place its growth in a purely personal perspective, a man or woman who was twenty years old when the Gallery was inaugurated could have attended the fiftieth birthday celebration (assuming they had the right connections) without defying the actuarial odds.

The secret of the Gallery's success is really no secret at all. Once again, wealth has profited from adversity. The great fortunes made from the industrialization of the United States in the late nineteenth and early twentieth centuries were available to buy works from European collectors, particularly aristocratic collectors, who had been reduced by adverse political circumstances and an inability to manage their assets in a productive way. English collectors have proved to be especially vulnerable, and important pictures began to drain out of the country into the hands of such men as Samuel H. Kress and Joseph Widener, both important benefactors of the National Gallery of Art.

The most dramatic example of a distress sale involves the founder of the Gallery, the banker Andrew W. Mellon. In 1931 the Soviet Union, in desperate need of hard currency, sold twenty-one important pictures from the former imperial collections of the Hermitage for the enormous sum of $6,654,000.[9] Even if all the attributions have not survived the scrutiny of experts, Raphael's *Alba Madonna* and Jan van Eyck's *Annunciation* (plates 225–6) are regarded as among the best old pictures in American collections.

The implications of these developments, here reduced to the barest bones, hardly require emphasis. The proliferation of public museums and the expansion of public collections that began in the early nineteenth century have removed most of the great and near-great old pictures from circulation. Could a collector of 1995 acquire 1500 paintings in fifteen years' time, as did Charles I in the 1620s and 1630s, or the 224 paintings bought by the duke of Hamilton in 1638? As for a Solly-sized collection, with all its quality pictures, this is obviously impossible. Even the large-scale collections formed recently by Norton Simon and Baron Heinrich Thyssen now appear to be the last gasp of this type of endeavor, particularly since laws prohibiting the export of important pictures are now in force all over Europe.

It is true that not all veins of the old-picture market have been exhausted to the same degree and that dealers and collectors tend to inflate the importance of what remains. For example, Flemish and Dutch pictures of the seventeenth century, which were mass-produced at a certain level of quality, are still abundant. Italian Baroque paintings by creditable masters can also be found. However, anyone who goes to the salerooms of Sotheby's and Christie's in London, after a visit to the nearby National Gallery, will draw the inevitable conclusion about the evolution of the market for old pictures in the waning moments of the twentieth century. Perhaps $35 million for Pontormo's *Portrait of a Cosimo I de Medici* is not such an astronomical price after all.

Notes

I. CHARLES AND THE WHITEHALL GROUP

1. Millar 1970–2, xi–xvi.
2. For a readable biography, see Gregg 1981.
3. Stone 1992, 47–52.
4. Strong 1980.
5. Millar 1982.
6. Magurn 1955, 101.
7. Stone 1959, 92–4.
8. For Prince Henry, see Strong 1986 and Wilks 1987; for Carr, see Wilks 1989 and Braunmiller 1991; for Salisbury, see Auerbach & Adams 1971, 16–27.
9. Hervey 1921; Howarth 1985.
10. Sainsbury 1859 publishes many documents concerning Carleton's activities in the art market. For a biography, see Lee 1972, 5–23.
11. Wilks 1989.
12. Hervey 1921, 161–2.
13. Sainsbury 1859, 27–44.
14. Howarth 1985, 127–148.
15. For his biography, see Lockyer 1981; for his art collection, see Davies 1906–7, Betcherman 1970, McEvansoneya 1986 and 1987, Garas 1987 and McEvansoneya 1992.
16. Cited by Gregg 1981, 49.
17. For a short biography, see Williamson 1949, 26–60.
18. Brown 1990, 231–9, and Klauner 1991, 107–19.
19. Philip 1957 and Betcherman 1970.
20. For this trip, see Betcherman 1961 and 1970, 252–4, and McEvansoneya 1987.
21. Cited by Betcherman 1970, 250.
22. For Titian's painting, see Jaffé 1966.
23. Cited by Howarth 1985, 198.
24. Barcroft 1979, 130–2.
25. Muller, *Rubens*, 1989, 82–7.
26. Cited by Betcherman 1970, 250.
27. For Charles' collection, see Millar 1960 and 1977 and Haskell 1989. A wider perspective is provided by Smuts 1987.
28. Cited by Millar 1977, 29.
29. Sainsbury 1859, 355.
30. Brejon de Lavergnée 1987, 258–9.
31. Huxley 1959.
32. Sainsbury 1859, 14–21; Stoye 1952, 53, 119, 352, 369.
33. Sarah Schroth, "The Prince of Wales' Trip to Spain: A Context for the Arrival of Veronese's *Mars and Venus* in the British Isles," forthcoming.
34. Shearman 1972, 145–9.
35. Luzio 1913; Howarth 1982.
36. Magurn 1955, 321–2.
37. Reade 1947; Ogden 1947.
38. Bruyn & Millar 1962.
39. Wittkower 1948, from which the following quotations are taken.
40. Hamilton to Feilding, 8 December 1637; cited by Shakeshaft 1986, 130, no. 52.
41. Springell 1963, 200, note 34.
42. For Hamilton's biography, see Rubenstein 1975. I am grateful to Sabrina Alcorn Baron for sharing the results of her investigation on Hamilton and the Privy Council.
43. McEvansoneya 1992 points out that, at his death in 1625, some of his pictures passed to Buckingham.
44. Shakeshaft 1986.
45. Waterhouse 1952.
46. Shakeshaft 1986, 125, no. 31.
47. Shakeshaft 1986, 126, no. 37.
48. Shakeshaft 1986, 129, no. 50.
49. Shakeshaft 1986, 129, no. 50.
50. Waterhouse 1952, 14–21.
51. Waterhouse 1952, 21–2.
52. Shakeshaft 1986, 131, no. 159.
53. Garas, "Die Entstehung," 1967, 69–75.

II. THE SALE OF THE CENTURY

1. Millar 1960.
2. Millar 1970–2.
3. Nuttall 1965; Millar 1970–2; MacGregor 1989.
4. Garas 1987.
5. Jaffé 1966; Wood 1994.
6. Stoye 1952, 297–321.
7. See below, Chapter 4.
8. Garas, "Die Entstehung," 1967.
9. Springell 1963.
10. Howarth 1985, 143.
11. Cosnac 1884, 187.
12. Cosnac 1884, 193.
13. Cosnac 1884, 197.
14. Cust & Cox 1911; Weijtens 1971; Dudok van Heel 1975.
15. Cárdenas to Haro, 1 June 1654; Archivo de la Casa de Alba (ACA) Caja 182, no. 181. Many of the documents from ACA cited here were discovered and partially transcribed in English by Burke 1984.
16. "Cuentas de los últimos gastos que Don Alonso de Cárdenas ha hecho de orden del excmo. Sr. Dn. Luis Méndez de Haro," 1 June 1654; ACA Caja 182, no. 185.
17. Grossmann 1951; Fourcart-Walter 1985.
18. Kurz 1943; Grossmann 1944.
19. Millar 1970–2 is fundamental.
20. Elliott 1981.
21. Loomie 1989, 259, note 9.
22. "Memoria de las pinturas originales del Rey más notables y de mayor estimación . . ."; ACA Caja 182, no. 180.
23. "Quenta que dio Dn. Alonso de Cárdenas embajador de Inglaterra al excmo. Sr. D. Luis Méndez de Haro de varias pinturas y tapizerias que tomó de la almoneda del, Sr. Rey Dn. Carlos," 8 August 1651; ACA Caja 182, no. 173.
24. Williamson 1949, 36–56.
25. Cited by Williamson 1949, 55.
26. Loomie 1989, 263–4. As demonstrated by Cárdenas' accounts of 8 August 1651 and 1 June 1654, the sale prices quoted in the documents published by Loomie are not always accurate. Cárdenas' accounts do not include all the transactions listed in the Loomie documents. However, they do record the sale of twenty pictures which are not mentioned by Loomie. Prices are quoted by Cárdenas in *escudos de Inglaterra* which, according to the accounts, equaled four to the pound sterling.
27. Cárdenas to Haro, 10 July 1651; ACA Caja 182, no. 172.
28. Nuttall 1965.
29. The following prices are recorded in "Cuenta de los últimos gastos . . . ," 1 June 1654; ACA Caja 182, no. 185.
30. Vergara 1989.
31. Prices in the documents are quoted in escudos.
32. Cosnac 1884, 147–240. For Bordeaux' instructions and the history of his embassy, see Jusserand 1929, 149–232.
33. Léonardon 1900, 25–34.
34. Cosnac 1884, 188–9.
35. Cosnac 1884, 190.
36. Cosnac 1884, 195.
37. Cosnac 1884, 200–1. Bordeaux usually quotes prices in *livres de France* or *livres tournois* which, as he noted on 11 October 1653 (p. 185), were worth about seventy per cent of the pound sterling. However, the value of the French currency fluctuated during the period of Bordeaux' embassy.
38. For Jabach, see Chapter V.
39. Without citing a source, Reiset n.d., xviii, lists the prices for seven paintings acquired by Jabach. The total is 52,275 *livres de France*.
40. According to Gleissner 1994, about a thousand pictures from the royal collection, mostly of lesser value, were recovered by the crown after the Restoration.
41. "Lo que ha de observar por instrucción la persona que ha de asistir en Inglaterra," 3 June 1662; Archivo General de Simancas Estado 2532; courtesy of A. J. Loomie.
42. Cited by Millar 1970–2, xxii.

III. "THE GREATEST AMATEUR OF PAINTINGS"

1. For Haro's correspondence, see Berwick y de Alba 1891. Cárdenas' letters are preserved in the Archivo de la Casa de Alba.
2. Berwick y de Alba 1891, 488.
3. Berwick y de Alba 1891, 491.
4. Berwick y de Alba 1891, 491.
5. Berwick y de Alba 1891, 493, and Harris 1982.
6. Berwick y de Alba 1891, 494.
7. Brown 1987.
8. Magurn 1955, 292. For a comparison of Charles I and Philip IV as collectors, see Brown 1990.
9. Von Einem 1960.
10. Van den Boogert & Kerkhoff 1993.
11. Checa 1992.
12. Schroth 1990.
13. Trapier 1967.
14. Magurn 1955, 33.

15. Elliott 1986.
16. Andrés 1974 is a useful addition to the copious but scattered literature on this event.
17. Saltillo 1934; Estella 1993, 141–5.
18. Simón Díaz, "La estancia," 1980.
19. Simón Díaz, "El arte en las mansiones nobiliarias," 1980.
20. Brown 1986, 65–6, and Vergara 1994.
21. Magurn 1955, 291.
22. Magurn 1955, 292.
23. Brown & Elliott 1980.
24. Brown & Elliott 1987.
25. For these transactions, see Brown & Elliott 1980, 119–20.
26. Alpers 1971.
27. Rooses & Ruelens 1909, 6, 296.
28. Rooses & Ruelens 1909, 6, 298.
29. Rooses & Ruelens 1909, 6, 304.
30. Muller, *Rubens*, 1989.
31. Orso 1986; Checa 1994.
32. Magurn 1955, 145.
33. See Volk 1980 for the Léganes collection.
34. López Navío 1962.
35. Garas, "The Ludovisi Collection," 1967; Wood 1992.
36. Hervey 1921, 383.
37. Cited by Brown & Elliott 1980, 115.
38. Pérez Sánchez 1977.
39. Burke 1989.
40. Saltillo 1953, 233–4. For a comprehensive survey of Haro's collection, see Burke 1984.
41. See Goldberg 1992 for the following incident.
42. Berwick y de Alba 1891, 492.
43. For Gaspar de Haro and his collection, see Andrés 1975; Burke 1984; López Torrijos 1991.
44. Burke 1984.
45. *Christina of Sweden* 1966, 479.
46. Garas, "The Ludovisi Collection," 1967, 288.
47. Cited by Hume 1907, 449.
48. Zarco del Valle 1870, 544–55.
49. Vannugli 1989.
50. Bottineau 1956 and 1958.
51. Fernández Baytón ed. 1975.
52. Beroqui 1933, 34.
53. For a survey of collecting in Madrid during the reign of Philip IV, see Morán & Checa 1984, 282–306.
54. Cited by Brown & Elliott 1980, 114.

IV. "*AMATOR ARTIS PICTORIAE*"

1. There is no adequate biography of Leopold William.
2. Springell 1963, 68.
3. Scheicher 1979 provides a convenient summary of Habsburg collecting in the sixteenth and seventeenth centuries.
4. Kenseth 1991, 81–101.
5. Kaufmann 1978.
6. Ewing 1990, 558, where the history of the Pand is told. Floerke 1905 remains the only survey of the art market in the Netherlands. See also De Marchi & Van Miegroet 1994.
7. Ewing 1990, 579.
8. Zaremba Filipczak 1987, 58–72; Mai 1992.
9. Held 1982, 35–64; Zaremba Filipczak 1987, 47–50, 71–2; Díaz Padrón & Royo-Villanova 1992, 204–17.
10. Zaremba Filipczak 1992, 51–3.
11. Denucé 1932, 229–32 (Cachiopin); Briels 1980 (Stevens).
12. Denucé 1932, 85–90; Baudouin 1977.
13. Muller, *Rubens*, 1989.
14. Zaremba Filipczak 1987, 130.
15. Duverger 1984–93.
16. Denucé 1930 (Forchondt); Denucé 1949 and Duverger 1968 (Musson).
17. The essential literature on the collection is as follows: Berger 1882; Marés 1887; Garas, "Die Entstehung," 1967 and 1968 (the inventory of 1659).
18. Denucé 1949, 67–8
19. Stoye 1952, 300–19.
20. Cited by Stoye 1952, 308.
21. Duverger 1991, vol. 5, 445–6, 460–1, 479–84; 1993, vol. 6, 68–78, 113–16, 127–8, 131–2, 137–47.
22. Bredius 1886; van der Waals 1988, 204–5.
23. Garas, "Die Entstehung," 1967, 75–80.
24. Garas 1968, 232–79.
25. Klinge 1991.
26. Vlieghe 1961–6.
27. Klinge 1991, 220–3.
28. Zaremba Filipczak 1987, 130–1.
29. Díaz Padrón & Royo-Villanova 1992, 54–77.
30. Von Perger 1864, 117; Neumann 1967, 26–8.
31. *Christina of Sweden* 1966; Allendesalazar 1991.
32. Dreher 1978.
33. Klinge 278–9.
34. Dreher 1977.
35. However, Vlieghe 1961–6, 135–6, cites an entry in Teniers' personal inventory (24 December 1657), which mentions that he had received 2,400 guilders from the archduke for the "book of Italian prints." The relevance of this payment to *Theatrum Pictorium* is possible but not certain. In the foreword to *Theatrum Pictorium*, Teniers claims that the book was published at his expense.

V. REASONS OF STATE

1. Dethan 1981; Goubert 1990.
2. Cited by Dethan 1977, 11–12.
3. Laurain-Portemer 1981, 177–399.
4. Michel 1993 and Le Pas de Sécheval 1993. For French collecting in general, see the pioneering work by Bonnaffé 1884.
5. Aumale 1861.
6. Cosnac 1884, 277–411.
7. Cosnac 1884, 413–18.
8. Cosnac 1884, 218.
9. Cosnac 1884, 217.
10. Brienne, *Mémoires*, ed. Bonnefon 1916–19, vol. 3, 88–90.
11. Burke 1992.
12. Marrow 1982; Mamone 1987; Baudouin-Matuzek 1991.
13. The queen's representative in the dealings with Rubens, Claude Maugis, abbot of St Ambroise (d. 1658), owned a small, choice collection of paintings, including the oil sketches for the Marie de' Medici cycle, which were given to him by the artist.
14. See above, p. 29. For other evidence of the nascent art market in Paris, see the letters from Peiresc to Rubens, 8 April 1622 and 14–15 April 1622, in Rooses & Ruelens 1909, vol. 2, 375–6 and 379–82.
15. Knecht 1991; Mousnier 1992.
16. Bergin 1985.
17. *Richelieu et le monde de l'esprit* 1985 and Caldicott 1992.
18. *Le Palais Royal*, 1988.
19. Levi 1985.
20. Boubli 1985; Levi 1987.
21. *Le Studiolo* 1975; Schloder 1985.
22. Boyer 1985; Boyer & Volf 1988.
23. Cotté 1985; Cotté 1988–89; Haffner 1988–89.
24. Cited by Haffner 1988–89, 38.
25. "Inventaire après décès de Michel Particelli," *Bull. de la Société de l'Histoire de l'Art Français* 1930, 97–8; Madocks 1984.
26. *Colbert 1619–1683*, 1983.
27. Schnapper, *Le géant*, 1988, 187–94.
28. Merlo 1861; Reiset 1866; Grouchy 1894; Vey 1967.
29. Cited by Grossman 1951, 18.
30. Schnapper 1984, 1991, "Trésors" 1993.
31. Brejon de Lavergnée 1987, suggests that nos. 79–116 came from Jabach. Nos. 18–78 are indisputably from the first sale.
32. Brienne, *Mémoires*, ed. Bonnefon, 1916–19; Hourticq 1905.
33. Ranum 1963, 68–9.
34. Cited by Hourticq 1905, 327. For the dealer Perruchot, see Le Brant 1984.
35. Bonnaffé 1873.
36. Cited by Hourticq 1905, 245–6.
37. For this transaction, see Reiset 1868, vii–xv; for the pictures, see Brejon de Lavergnée 1987, nos. 193–293; for the drawings, see Bacou 1978.
38. Schnapper 1983; "Quelques notes," 1993.
39. Monbeig Goguel 1988.
40. Grouchy 1884.
41. For these paintings, see Brejon de Lavergnée 1987, nos. 119–151. For the date of the sale by Mazarin's heirs, see Schnapper, "Trésors," 1993, 54.
42. Michaud 1969; Le Pas de Sécheval 1991.
43. Denucé 1949, 180.
44. Ferraton 1949.
45. Chantelou, *Diary*, ed. 1985.
46. Chantelou, *Diary*, ed. 1985, 171.
47. Chantelou, *Diary*, ed. 1985, 296.
48. Chantelou, *Diary*, ed. 1985, 297.
49. For Liancourt (1599–1674) and his collection, see *Seicento* 1988–9, 226–8.
50. Teyssèdre 1965.
51. Thuillier 1968.
52. Brejon de Lavergnée 1987.
53. Schnapper 1991.
54. Guiffrey 1911.
55. Engerand 1899.
56. Schnapper, "The King of France," 1988.
57. Schnapper, "Trésors," 1993.
58. Constans 1976; Schnapper, "The King of France," 1988, 196–8.
59. Barker 1989.
60. *Le Palais Royal* 1988, 53–115.
61. Félibien, *Conférences*, ed. 1967.

VI. THE PRESTIGE OF PAINTING

1. Cited by Panofsky 1954, 18–19.
2. Pontano 1965, 272.
3. Lightbown 1989.
4. Haskell & Penny 1981.
5. Levi 1987, 180. For a comparable valuation of paintings versus luxury goods at the courts of James I and Charles I, see Smuts, "Art and the Economics of Majesty."
6. Dessert 1976, 169.
7. Dessert 1976, 169.
8. Laurain-Portemer 1981, 261, note 2.
9. Cosnac 1884, 195.
10. Hervey 1921, 383.
11. Garas 1967, "The Ludovisi Collection," 288, 339–48.
12. Sella 1967.
13. Boschini 1660, 4.
14. For this development in England, see Pears 1988, 51–106.
15. However, by the late seventeenth century public auctions, advertised in advance, were regularly being held in Amsterdam. See Dudok van Heel 1977.
16. Wildenstein 1957; Schnapper 1992.
17. Floerke 1905 is out of date. For a recent study of aspects of the market in the Netherlands, see De Marchi & Van Miegroet 1994.
18. Slavicek 1993.
19. Van Eeghen 1968; de la Fontaine Vervey 1969.
20. Sainsbury 1859, 325.
21. Sainsbury 1859, 327–40.
22. Hourticq 1905, 332.
23. Cited by Lightbown 1969, 420.
24. This discussion follows Gibson-Wood 1988.
25. Muller, "Measures of Authenticity," 1989.
26. Mancini, ed. Marucchi, 1956–7.
27. For the French texts on connoisseurship, see Olivier 1976 and Posner 1993.
28. Cited by Gibson-Wood 1988, 53.
29. For this development in England, see Pace 1987, 170–7.
30. Gibson-Wood 1987.
31. Shakeshaft 1986, 126.
32. Chantelou ed. 1985, 298.
33. Chantelou ed. 1985, 251.
34. Hourticq 1905, 238–42.
35. Béguin 1983–4, 105–7.
36. Logan 1979, 91–6.
37. Pennington 1982, xvii–xxviii.
38. Logan 1979.
39. Montias 1993–4, 98–105, notes the small number of collections of early Italian painting in Holland.
40. Grivel 1985.
41. Hervey 1923, 402.
42. For France, see Schnapper 1987.
43. Bedini n.d. (c. 1986).
44. *Christina of Sweden* 1966, 419.
45. Perger 1864, 126.
46. Prinz 1988.
47. Schnapper, "The King of France," 1988, 200–2.
48. Goldthwaite 1993, 249.
49. Summers 1981. This line of argument is developed by Smuts, "Arts and the Economics of Majesty." I am grateful to Prof. Smuts for help in discussing this problem.
50. The classic study is Lee 1967.
51. Warnke 1992, 109–74.
52. This notion is articulated in Castiglione's *Courtier* (1528) and is echoed, for example, in Henry Peacham's *The Compleat Gentleman* (London, 1622 and 1634).
53. Shakeshaft 1986, 123.
54. Shakeshaft 1986, 125.
55. Kristeller 1951–2.
56. Cadogan 1991, 184–91.
57. Lloyd, 1991, 170–2.
58. Félibien 1987, 133.
59. Hourticq 1905, 333.

POSTSCRIPT

1. Haskell 1976, 24–6.
2. Gould 1965.
3. Lipschutz 1972, 31–9.
4. Carrington 1967.
5. Herrmann 1967–8.
6. Hendy 1971.
7. Boime n.d. (c. 1979).
8. Kopper 1991.
9. Kopper 1991, 86–9.

Bibliography

Allendesalazar, Ursula de. "Queen Christina and Philip IV: Unfulfilled Expectations." *Nouvelles de la République des Lettres* 1 (1991), 83–102.

Alpers, Svetlana. *The Decoration of the Torre de la Parada*. London and New York, 1971.

Andrés, Gregorio de. "La despedida de Carlos Estuardo, Príncipe de Gales, en El Escorial (1623) y la columna-trofeo que se levantó para perpetua memoria." *Anales del Instituto de Estudios Madrileños* 10 (1974), 113–32.

— *El marqués de Liche, bibliófilo y coleccionista*. Madrid, 1975.

Auerbach, Erna, & C. Kingsley Adams. *Paintings and Sculpture at Hatfield House*. London, 1971.

Aumale, Duc de. *Inventaire de tous les meubles du Cardinal Mazarin dressé en 1653 et publié d'après l'original conservé dans les Archives de Condé*. London, 1861.

Bacou, Roseline. "Everhard Jabach: Dessins de la seconde collection." *Revue de l'art* 40–1 (1978), 141–50.

Barcroft, J. H. "Carleton and Buckingham: The Quest for Office." In *Essays in Honor of D. H. Willson: Early Stuart Studies*, ed. H. S. Reinmuth. Minneapolis, 1979, 130–2.

Barker, Nancy Nichols. *Brother to the Sun King: Philippe, Duke of Orléans*. Baltimore and London, 1989.

Baudouin, Frans. *Nicolaas Rockrox, Friend and Patron of Peter Paul Rubens*. Brussels, 1977.

Baudouin-Matuszek, Marie-Noelle, ed. *Marie de Médicis et le Palais du Luxembourg*. Paris, 1991.

Bedini, Silvio A. "Citadels of Learning: The Museo Kircheriano and Other Seventeenth-Century Italian Science Collections." In *Enciclopedismo in Roma Barocca. Athanasius Kircher e il Museo del Collegio Romano tra Wunderkammer e Museo Scientifico*, eds Maristella Casciato, Maria Grazia Ianniello & Maria Vitale. Venice, c. 1986.

Béguin, Sylvie. *Raphael dans les collections françaises*. Paris, 1983–4.

Berger, Adolf. "Studien zu den Beziehungen des Erzherzogs Leopold Wilhelm von Österreich zu dem Grafen Johann Adolf zu Schwarzenberg." *Berichte und Mitteilungen des Altertumsverein zu Wien* 21 (1882), 52–72.

Bergin, Joseph. *Cardinal Richelieu. Power and the Pursuit of Wealth*. New Haven and London, 1985.

Beroqui, Pedro. *El Museo del Prado (Notas para su historia). El Museo Real (1819–1833)*. Madrid, 1933.

Berwick y de Alba, Duquesa de. *Documentos escogidos de la Casa de Alba*. Madrid, 1891.

Betcherman, Lita-Rose. "Balthazar Gerbier in Seventeenth-Century Italy." *History Today* 11 (1961), 325–31.

— "The York House and Its Keeper." *Apollo* 92 (Oct. 1970), 250–9.

Boime, Albert. "America's Purchasing Power and the Evolution of European Art in the Late Nineteenth Century." In *Saloni, Gallerie, Musei e loro influenza sullo sviluppo dell'arte dei secoli XIX e XX*, ed. Francis Haskell. Bologna, n.d. (c. 1979).

Bonnaffé, Edmond. *Dictionnaire des amateurs français au XVII^e siècle*. Paris, 1884.

— *Le Catalogue de Brienne (1662) annoté par E. B.* Paris, 1873.

Boschini, Marco. *La carta del navegar pitoresco*, ed. Anna Palluchini. Venice, 1966.

Bottineau, Yves. "L'Alcázar de Madrid et l'inventaire de 1686." *Bulletin Hispanique* 58 (1956), 421–52; 69 (1958), 30–61, 145–79, 289–326, 450–83.

Boubli, Lizzie. "Les collections parisiennes de peintures de Richelieu." In *Richelieu et le monde de l'esprit*. Paris, 1985, 103–13.

Boyer, Jean-Claude. "Le mécénat officiel et l'Italie." In *L'Age d'or du mécénat (1598–1661)*, eds Roland Mousnier & Jean Mesnard. Paris, 1985, 129–37.

Boyer, Jean-Claude, & Isabelle Volf. "Rome à Paris: les tableaux du maréchal de Crequy (1638)." *Revue de l'art* 79 (1988), 22–41.

Braunmuller, A. R. "Robert Carr, Earl of Somerset, as Collector and Patron." In *The Mental World of the Jacobean Court*, ed. Linda Levy Peck. Cambridge, 1991, 230–50.

Bredius, Abraham. "Zur Geschichte der Sammlungen des Erzherzogs Leopold." *Kunstchronik* 21 (1886), 216–18.

Brejon de Lavergnée, Arnauld. *L'Inventaire Le Brun de 1683. La collection des tableaux de Louis XIV*. Paris, 1987.

Briels, J. "Amator Pictoriae Artis. Peeter Stevens (1590–1668) en zijn Constcamer." *Jaarboek Koninklijk Museum voor Schone Kunsten-Antwerpen*, 1980, 137–226.

Brienne, Louis-Henri de Loménie, Comte de. *Mémoires de Louis-Henri de Loménie, comte de Brienne, dit le jeune Brienne*, ed. Paul Bonnefon. Paris, 1916–19.

Brown, Beverly Louise. "The So-Called Duke of Buckingham Series." In *Nuovi studi su Paolo Veronese*, ed. Massimo Gemin. Venice, 1990, 231–9.

Brown, Jonathan. *Velázquez, Painter and Courtier*. New Haven and London, 1986.

— "Felipe IV, Carlos I y la cultura del coleccionismo en dos cortes del siglo XVII." In *La España del Conde Duque de Olivares*, eds John Elliott & Angel García Sanz. Valladolid, 1990, 83–97.

— "Felipe IV, el rey de coleccionistas." *Fragmentos. Revista de Arte*, no. 11 (1987), 4–20.

Brown, Jonathan, & J. H. Elliott. *A Palace for a King: The Buen Retiro and the Court of Philip IV*. New Haven and London, 1980.

— "The Marquis of Castel Rodrigo and the Landscape Paintings in the Buen Retiro." *Burlington Magazine* 129 (1987), 104–7.

Bruyn, J. & Oliver Millar. "Notes on the Royal Collection III: The 'Dutch Gift' to Charles I." *Burlington Magazine* 104 (1962), 291–4.

Burke, Marcus B. "Private Collections of Italian Art in Seventeenth-Century Spain." Ph.D. dissertation, Institute of Fine Arts, New York University, 1984.

— "Paintings by Ribera in the Collection of the Duque de Medina de las Torres." *Burlington Magazine* 131 (1989), 132–5.

Burke, Peter. *The Fabrication of Louis XIV*. New Haven and London, 1992.

Cadogan, Jean K. *Wadsworth Atheneum, Paintings II: Italy and Spain, Fourteenth through Nineteenth Centuries*. Hartford, 1991.

Caldicott, Edric. "Richelieu and the Arts." In *Richelieu and His Age*, eds Joseph Bergin & Laurence Brockliss. Oxford, 1992, 203–35.

Carrington, Dorothy. "Cardinal Fesch, a Grand Collector." *Apollo* 86 (1967), 346–57.

Chantelou, Paul Fréart de. *Diary of the Cavaliere Bernini's Visit to France*, ed. Anthony Blunt, with notes by George C. Bauer; trans. Margery Corbett. Princeton, 1985.

Checa, Fernando. *Felipe II, mecenas de las artes*. Madrid, 1992.

Checa, Fernando, ed. *El Real Alcázar de Madrid: Dos siglos de arquitectura y coleccionismo en la corte de los reyes de España*. Madrid, 1994.

Christina, Queen of Sweden: A Personality of European Civilization. Stockholm, 1966.

Colbert 1619–1683. Paris, 1983.

Constans, Claire. "Les tableaux du Grand Appartement du Roi." *Revue du Louvre* 3 (1976), 157–73.

Cosnac, Gabriel-Jules, Comte de. *Les Richesses du Palais Mazarin*. Paris, 1884.

Cotté, Sabine. "Inventaire après décès de Louis Phelypeaux de La Vrillière." *Archives de L'Art Français* 27 (1985), 89–100.

— "Un exemple du 'gout italien': la galerie de l'hôtel de la Vrillière à Paris." In *Seicento, le siècle de Caravage dans les collections françaises*. Paris, 1988–9, 39–46.

Cust, Lionel, & Mary L. Cox. "Notes on the Collections Formed by Thomas Howard, Earl of Arundel and Surrey, K.G." *Burlington Magazine* 19 (1911), 278–86, 323–5.

Davies, Randall. "An Inventory of the Duke of Buckingham's Pictures in 1635." *Burlington Magazine* 10 (1906–7), 376–82.

De Marchi, Neil, & Hans J. Van Miegroet. "Art, Value and Market Practices in the Netherlands in the Seventeenth Century." *The Art Bulletin* 76 (1994), 451–64.

Denucé, Jan. *Exportation d'oeuvres d'art au 17^e siècle à Anvers: la firme Forchondt*. Antwerp, 1930.

— *Les Galeries d'art a Anvers aux 16^e et 17^e siècles. Inventaires*. s'Gravenhage, 1932.

— *Na Peter Pauwel Rubens. Documenten uit den Kunsthandel te Antwerpen in de XVII^e eeuw van Matthijs Musson*. s'Gravenhage, 1949.

Dessert, Daniel. "Pouvoir et finance au XVII^e siècle: la fortune de Cardinal Mazarin." *Revue d'Histoire Moderne et Contemporaine* 23 (1976), 161–81.

Dethan, Georges. *The Young Mazarin*. London, 1977.
Mazarin, un homme de paix à l'âge baroque, 1602–1661. Paris, 1981.

Díaz Padrón, Matías, & Mercedes Royo-Villanova. *David Teniers, Jan Brueghel y los gabinetes de pinturas.* Madrid, 1992.

Dreher, Faith Paulette. "David Teniers II Again." *The Art Bulletin* 59 (1977), 108–10.
"The Artist as Seigneur: Chateaux and Their Proprietors in the Work of David Teniers II." *The Art Bulletin* 60 (1978), 682–703.

Dudok van Heel, S.A.C. "De Kunstvezameligen Van Lennep met de Arundel-Tekeningen." *Amstelodamum* 67 (1975), 137–48.
"Jan Pietersz Zomer (1641–1724), Makelaar in Schilderijen (1690–1724)." *Amstelodamum* 69 (1977), 89–106.

Duverger, Erik. "Nieuwe gegevens betreffende de Kunsthandel van Matthijs Musson en Maria Fourmenois te Antwerpen tussen 1633 en 1681." *Gentse Bijdragen tot Kunstgeschiedenis en de Oudheid Kunde* 21 (1968), 5–250.
Antwerpse Kunstinventarissen uit de Zaventiende Eeuw. 6 vols. Brussels, 1984–93 (in progress).

Elliott, John H. "The Year of the Three Ambassadors." In *History and Imagination: Essays in Honour of H. R. Trevor-Roper,* ed. Hugh Lloyd-Jones, Valerie Pearl and Blair Worden. London, 1981, 165–181.
The Count-Duke of Olivares. The Statesman in an Age of Decline. New Haven and London, 1986.

Engerand, Fernand. *Inventaire des collections de la Couronne: inventaire des tableaux du roy rédigé en 1709 et 1710 par Nicolas Bailly publié pour la première fois avec des additions et des notes par F. Engerand.* Paris, 1899.

Estella, Margarita. "Algo más sobre Pompeyo Leoni." *Archivo Español de Arte* 66 (1993), 133–49.

Ewing, Dan. "Marketing Art in Antwerp, 1460–1560: Our Lady's Pand." *The Art Bulletin* 72 (1990), 558–84.

Félibien, André. "Conférences de l'Académie Royale de Peinture et de Sculpture." In *Entretiens sur les vies et sur les ouvrages des plus excellents peintres,* ed. Anthony F. Blunt. Farnborough, 1967.

Fernández Baytón, Gloria. *Inventarios reales. Testamentaría del Rey Carlos II, 1701–1703.* Vol. 1. Madrid, 1975.

Ferraton, Claude. "La collection du duc de Richelieu au Musée du Louvre." *Gazette des Beaux-Arts* 35 (1949), 437–48.

Floerke, Hans. *Studien zur Niederländischen Kunst- und Kunturgeschichte. Die Formen des Kunsthandels, das Atelier und die Sammler in den Niederlanden von 15.-18. Jahrhundert.* Munich and Leipzig, 1905.

Foucart-Walter, Elisabeth. *Les peintures de Hans Holbein le Jeune au Louvre.* Paris, 1985.

Garas, Klara. "Die Entstehung der Galerie des Erzherzogs Leopold Wilhelm." *Jahrbuch der Kunsthistorisches Sammlungen in Wien* 27 (1967), 39–80.
"The Ludovisi Collection of Pictures in 1633, I and II." *Burlington Magazine* 109 (1967), 287–9, 339–48.

"Das Schicksal der Sammlungen des Erzherzogs Leopold Wilhelm." *Jahrbuch der Kunsthistorischen Sammlungen in Wien* 64 (1968), 181–278.
"Das Sammlung Buckingham und die Kaiserliche Galerie." *Wiener Jahrbuch für Kunstgeschichte* 40 (1987), 111–21.

Gibson-Wood, Carol. "Jonathan Richardson and the Rationalization of Connoisseurship." *Art History* 7 (1984), 38–56.
Studies in the Theory of Connoisseurship from Vasari to Morelli. New York and London, 1988.

Gleissner, Stephen. "Reassembling a Royal Art Collection for the Restored King of Great Britain." *Journal of the History of Collections* 6 (1994), 103–15.

Goldberg, Edward. "Spanish Taste, Medici Politics and a Lost Chapter in the History of Cigoli's 'Ecce Homo.'" *Burlington Magazine* 134 (1992), 102–10.

Goubert, Pierre. *Mazarin.* Paris, 1990.

Gould, Cecil. *Trophy of Conquest: The Musée Napoléon and the Creation of the Louvre.* London, 1965.

Gregg, Pauline. *King Charles I.* London, 1981.

Grivel, Marianne. "Le Cabinet du Roi." *Revue de la Bibliothèque Nationale* 18 (1985), 36–57.

Grossmann, F. "Notes on the Arundel and Imstenraedt Collections." *Burlington Magazine* 84 (1944), 151–5, 173–6.
"Holbein, Flemish Paintings and Everhard Jabach." *Burlington Magazine* 93 (1951), 16–25.

Grouchy, Vicomte de. "Everhard Jabach, collectionneur parisien (1695)." *Mémoires de la Société de l'Histoire de Paris et de l'Ile de France* 21 (1894), 217–92.

Guiffrey, Jules M. J. "Tableaux, bronzes et marbres donnez au Roy par M. Le Nostre en septembre 1693." *Bulletin de la Société de l'Histoire de l'Art Française* 1911, 211–25.

Haffner, Christel. "La Vrillière, collectionneur et mécène." In *Seicento, le siècle de Caravage dans les collections françaises.* Paris, 1988–9, 29–38.

Harris, Enriqueta. "Velázquez as Connoisseur." *Burlington Magazine* 24 (1982), 436–40.

Haskell, Francis. *Rediscoveries in Art. Some Aspects of Taste, Fashion and Collecting in England and France.* Ithaca, 1976.
"Charles I's Collection of Pictures." In *The Late King's Goods. Collections, Possessions and Patronage of Charles I in the Light of the Commonwealth Sale Inventories,* ed. Arthur MacGregor. London and Oxford, 1989.

Haskell, Francis, & Nicholas Penny. *Taste and the Antique. The Lure of Classical Sculpture.* New Haven and London, 1981.

Held, Julius. "Artis Pictoriae Amator: An Antwerp Art Patron and His Collection." In *Rubens and His Circle.* Princeton, 1982.

Hendy, Philip. *The National Gallery.* London, 1971.

Herrmann, Frank. "Who Was Solly?" *Connoisseur* 164 (1967), 229–34, 165 (1967), 12–18, 153–61; 166 (1967), 10–18; 169 (1968), 12–17.

Hervey, Mary S.F. *The Life, Correspondence and Collections of Thomas Howard, Earl of Arundel, "Father of Vertu in England."* Cambridge, 1921.

Hourticq, Louis. "Un amateur de curiosités sous Louis XIV. Louis-Henri de Loménie, comte de Brienne, d'après un manuscrit inédit." *Gazette des Beaux-Arts* 33 (1905), 57–71, 237–51, 326–40.

Howarth, David. "Charles I and the Gonzaga Collections." In *Splendours of the Gonzaga,* ed. David Chambers & Jane Martineau. London, 1981–2.
Lord Arundel and His Circle. New Haven and London, 1985.

Hume, Martin. *The Court of Philip IV. Spain in Decadence.* London, 1907.

Huxley, Gervas. *Endymion Porter. The Life of a Courtier 1587–1649.* London, 1959.

"Inventaire après décès de Michel Particelli." *Bulletin de la Société de l'Histoire de l'Art Française* 1930, 97–8.

Jaffé, Michael. "The Picture of the Secretary of Titian." *Burlington Magazine* 108 (1966), 114–26.

Jusserand, J. J. *Receuil des instructions données aux ambassadeurs et ministres de France depuis les traités de Westphalie jusqu' à la révolution française.* Paris, 1929.

Kaufmann, Thomas DaC. *Variations on the Imperial Theme in the Age of Maximilian II and Rudolf II.* New York, 1978.

Kenseth, Joy. "A World of Wonders in One Closet Shut." In *The Age of the Marvelous,* ed. Joy Kenseth. Hanover, N.H., 1991, 81–101.

Kenseth, Joy, ed. *The Age of the Marvelous.* Hanover, N.H., 1991.

Klauner, Frederike. "Zu Veroneses Buckingham-Serie." *Wiener Jahrbuch für Kunstgeschichte* 44 (1991), 107–19.

Klinge, Margret. *David Teniers the Younger: Paintings, Drawings.* Antwerp, 1991.

Knecht, Robert. *Richelieu.* London and New York, 1991.

Kopper, Philip. *America's National Gallery of Art. A Gift to the Nation.* New York, 1991.

Kristeller, Paul Oskar. "The Modern System of the Arts." *Journal of the History of Ideas* 12 (1951), 496–527; 13 (1952), 17–46.

Kurz, Otto. "Holbein and Others in a Seventeenth-Century Collection." *Burlington Magazine* 82–3 (1943), 279–82.

LaFontaine Vervey, H. de. "De Zaken van Daniel Nys." *Amstelodamum* 56 (1969), 79–82.

Laurain-Portemer, Madeleine. *Etudes mazarines.* Paris, 1981.

Le Blant, R. "Un marchand de tableaux bourguignon au XVIIᵉ siècle, Nicolas Estienne dit Perruchot." *109ᵉ Congrès National des Sociétés Savantes.* Dijon, 1984, I, 217–35.

Lee, Rensselaer W. *Ut Pictura Poesis. The Humanistic Theory of Painting.* New York, 1967.

Léonardon, H. "Une dépêche diplomatique relative à des tableaux acquis en Angleterre pour Philippe IV." *Bulletin Hispanique* 2 (1900), 25–34.

Le Palais Royal. Paris, 1988.

Le Pas de Sécheval, Anne. "Les collections Ludovisi et la politique royale française au XVIIᵉ siècle: une tentative d'achat à la fin du règne de Louis XIII." *Révue de l'Art* 94 (1991), 69–73.

"Aux origines de la collection Mazarin: l'acquisition de la collection romaine du Duc Sannesio (1642–1644)." *Journal of the History of Collections* 5 (1993), 13–21.

Le Studiolo d'Isabelle d'Este. Les dossiers du département des peintures, 10. Musée du Louvre. Paris, 1975.

Levi, Honor. "L'Inventaire après décès du Cardinal de Richelieu." *Archives de L'Art Français* 27 (1985), 9–83.

——. "Richelieu collectionneur." In *Richelieu et la culture*, ed. Roland Mousnier. Paris, 1987, 175–84.

Lightbown, Ronald W. "Van Dyck and the Purchase of Paintings for the English Court." *Burlington Magazine* 111 (1969), 418–21.

——. "Charles I and the Tradition of European Princely Collecting." In *The Late King's Goods. Collections, Possessions and Patronage of Charles I in the Light of the Commonwealth Sale Inventories*, ed. Arthur MacGregor. London and Oxford, 1989, 53–72.

Lipschutz, Ilse Hempel. *Spanish Painting and the French Romantics*. Cambridge, Mass., 1972.

Lloyd, Christopher. *The Queen's Pictures. Royal Collectors Through the Centuries*. London, 1991.

Lockyer, Roger. *Buckingham. The Life and Political Career of George Villiers, Duke of Buckingham, 1592–1618*. Harlow and New York, 1981.

Logan, Anne-Marie S. *The "Cabinet" of the Brothers Gerard and Jan Reynst*. Amsterdam, Oxford, and New York, 1979.

Loomie, Albert J. "New Light on the Spanish Ambassador's Purchases from Charles I's Collection 1649–53." *Journal of the Warburg and Courtauld Institutes* 52 (1989), 257–67.

López Navío, José. "La gran colección de pinturas del Marqués de Leganés." *Analecta Calasanctiana* 8 (1962), 260–330.

López Torrijos, Rosa. "Coleccionismo en la época de Velázquez: El marqués de Heliche." In *Velázquez y el arte de su tiempo*. V Jornadas de Arte, Departamento de Historia del Arte "Diego Velázquez." Madrid, 1991, 27–36.

Lugt, Fritz. *Répertoire des catalogues de ventes, 1600–1925*. Vol. 1. The Hague, 1938.

Luzio, Alessandro. *La Galleria dei Gonzaga venduta all'Inghilterra nel 1627–28. Documenti degli archivi di Mantova e Londra*. Milan, 1913.

McEvansoneya, Philip. "A Note on the Duke of Buckingham's Inventory." *Burlington Magazine* 128 (1986), 607.

——. "Some Documents Concerning the Patronage and Collections of the Duke of Buckingham." *Rutgers Art Review* 8 (1987), 27–38.

——. "An Unpublished Inventory of the Hamilton Collection in the 1620s and the Duke of Buckingham's Pictures." *Burlington Magazine* 134 (1992), 524–5.

MacGregor, Arthur, ed. *The Late King's Goods. Collections, Possessions and Patronage of Charles I in the Light of the Commonwealth Sale Inventories*. London and Oxford, 1989.

Madocks, Susan. "'Trop de beautez decouvertes'— New Light on Guido Reni's late 'Bacchus and Ariadne.'" *Burlington Magazine* 126 (1984), 544–7.

Mai, Ekkehard. "Pictura in der 'Constkamer'— Antwerpens Malerei in Spiegel von Bild und Theorie." In *Von Brueghel bis Rubens. Das goldene Jahrhundert der Flämischer Malerei*, Cologne, 1992, 39–53.

Mamone, Sara. *Firenze e Parigi: due capitali dello spettacolo per una regina, Maria de' Medici*. Milan, 1987.

Mancini, Giulio. *Considerazioni sulla pittura*, ed. Adriana Marucchi. Rome, 1956–7.

Marrow, Deborah. *The Art Patronage of Maria de' Medici*. Ann Arbor, 1982.

Marés, Franz. "Beiträge zur Kenntnis der Kunstbestrebungen des Erzherzogs Leopold Wilhelm." *Jahrbuch der Kunsthistorischen Sammlungen des Allerhöchsten Kaiserhauses* 5 (1887), 344–63.

Merlo, J. J. "Die Famille Jabach zu Köln und ihre Kunstliebe." *Annalen des historischen Vereins für den Niederrhein* 1861, 1–80.

Michaud, Claude. "François Sublet de Noyers, surintendant des bâtiments de France." *Revue Historique*, April–June 1969, 327–64.

Michel, Patrick. "Rome et la formation des collections du Cardinal Mazarin." *Histoire de l'Art* 21–2 (1993), 5–16.

Millar, Oliver. "Abraham van der Doort's Catalogue of the Collection of Charles I." *Walpole Society* 37 (1960).

——. "The Inventories and Valuations of the King's Goods, 1649–1651." *Walpole Society* 43 (1970–2).

——. *The Queen's Pictures*. London, 1977.

——. *Van Dyck in England*. London, 1982.

Monbeig Goguel, Catherine. "Taste and Trade: The Retouched Drawings in the Everhard Jabach Collection in the Louvre." *Burlington Magazine* 130 (1988), 821–35.

Montias, J. Michael. "Review of *De wereld binnen handbereick*." *Simiolus* 22 (1993–4), 98–105.

Morán, J. Miguel, & Fernando Checa. *El coleccionismo en España: de la cámara de maravillas a la galería de pinturas*. Madrid, 1985.

Mousnier, Roland. *L'Homme rouge, ou la vie du Cardinal de Richelieu (1585–1642)*. Paris, 1992.

Muller, Jeffrey M. "Measures of Authenticity: The Detection of Copies in the Early Literature on Connoisseurship." In *Retaining the Original: Multiple Originals, Copies and Reproductions*. Studies in the History of Art, 20. Washington, 1989, 141–59.

——. *Rubens. The Artist as Collector*. Princeton, 1989.

Neumann, Jaromír. *The Picture Gallery of Prague Castle*. Prague, 1967.

Nuttall, W. L. F. "King Charles I's Pictures and the Commonwealth Sale." *Apollo* 82 (Oct. 1965), 302–9.

Ogden, H. & M. Ogden. "Van der Doort's Lists of the Frizell and Nonsuch Pictures." *Burlington Magazine* 89 (1947), 247–50, 323–5.

Olivier, Louis A. "Curieux, Amateurs and Connoisseurs: Laymen and the Fine Arts in the Ancien Régime." Ph.D. dissertation, The Johns Hopkins University, Baltimore, 1976.

Orso, Steven N. *Philip IV and the Decoration of the Alcázar of Madrid*. Princeton, 1986.

Pace, Claire. "Virtuoso to Connoisseur. Some Seventeenth-Century English Responses to the Visual Arts." *The Seventeenth Century* 2 (1987), 166–88.

Panofsky, Erwin. *Galileo as a Critic of the Arts*. The Hague, 1954.

Pears, Iain. *The Discovery of Painting. The Growth of Interest in the Arts in England, 1680–1768*. New Haven and London, 1988.

Pennington, Richard. *A Descriptive Catalogue of the Etched Work of Wenceslaus Hollar, 1607–1677*. Cambridge, 1982.

Pérez Sánchez, Alfonso E. "Las colecciones de pintura del Conde de Monterrey (1653)." *Boletín de la Real Academia de Historia* 174 (1977), 417–59.

Perger, A. Ritter von. "Studien zur Geschichte der K. K. Gemäldegalerie im Belvedere zu Wien." *Bericht und Mitteilungen des Alterthumsverein zu Wien* 7 (1864), 102–68.

Philip, I. G. "Balthazar Gerbier and the Duke of Buckingham's Pictures." *Burlington Magazine* 99 (1957), 155ff.

Pontano, Giovanni. *I trattati delle virtù sociali*, ed. Francesco Tateo. Rome, 1965.

Posner, Donald. "Concerning the 'Mechanical' Parts of Painting and the Artistic Culture of Seventeenth-Century France." *The Art Bulletin* 75 (1993), 583–98.

Prinz, Wolfram. *Galleria. Storia e tipologia di uno spazio architettonico*. Modena, 1988.

Ranum, Orest. *Richelieu and the Councillors of Louis XIII*. Oxford, 1963.

Reade, Brian. "William Frizell and the Royal Collection." *Burlington Magazine* 89 (1947), 70–5.

Reiset, Frédéric. *Notice des dessins, cartons, pastels, miniatures et émaux exposés dans les salles du 1ᵉʳ et 2ᵉ étage au Musée National du Louvre*. Paris, n.d.

Richelieu et le monde de l'esprit. Paris, 1985.

Rooses, Max, & Charles Ruelens. *Correspondance de Rubens et documents épistolaires concernant sa vie et ses oeuvres*. Antwerp, 1909.

Rubenstein, Hilary K. *Captain Luckless. James, First Duke of Hamilton, 1606–1649*. Edinburgh and London, 1975.

Sainsbury, W. Noël. *Original Unpublished Papers Illustrative of the Life of Sir Peter Paul Rubens as an Artist and Diplomatist*. London, 1859.

Saltillo, Marqués del. "La herencia de Pompeyo Leoni." *Boletín de la Sociedad Española de Excursiones* 42 (1934), 95–121.

——. "Artistas madrileños (1592–1850)." *Boletín de la Sociedad Española de Excursiones* 57 (1953), 137–243.

Scheicher, Elisabeth. *Die Kunst- und Wunderkammern der Habsburger*. Vienna, Munich and Zurich, 1979.

Schloder, John. "Richelieu, mécène au château de Richelieu." In *Richelieu et le monde de l'esprit*. Paris, 1985, 115–27.

Schnapper, Antoine. "Jabach, Mazarin, Fouquet, Louis XIV." *Bulletin de la Société de l'Histoire de l'Art Français* 1984, 85–6.

"The King of France as Collector in the Seventeenth Century." In *Art and History. Images and Their Meanings*, ed. Robert I. Rotberg & Theodore K. Rabb. Cambridge, 1988, 185–202.

Le Géant, la licorne et la tulipe. Collections et collectionneurs dans la France du XVIIᵉ siècle. I. Histoire et histoire naturelle. Paris, 1988.

"Observations sur les inventaires des tableaux de Louis XIV, de Le Brun à Bailly." *Bulletin de la Société de l'Histoire de l'Art Français* 1991, 19–26.

"Vignon et Compagnie." In Paola Pacht Bassani, *Claude Vignon, 1593–1670*. Paris, 1992, 61–6.

"Trésors sans toit: sur les débuts de Louis XIV collectionneur." *Révue de l'Art* 99 (1993), 53–9.

"Quelques notes sur les curieux du dessin dans la France du XVIIᵉ siècle." In *Dessins français du XVIIᵉ siècle dans les collections publiques françaises*. Paris, 1993, 17–25.

Schroth, Sarah. "The Private Picture Collection of the Duke of Lerma." Ph.D. dissertation, Institute of Fine Arts, New York University, 1990.

Seicento: le siècle de Caravage dans les collections françaises. Paris, 1988–9.

Sella, Domenico. "The Rise and Fall of the Venetian Woolen Industry." In *Crisis and Change in the Venetian Economy in the Sixteenth and Seventeenth Century*, ed. Brian Pullen. London, 1967.

Shakeshaft, Paul. "'To much bewiched with thoes intysing things.' The Letters of James, Third Marquis of Hamilton, and Basil, Viscount Feilding, Concerning Collecting in Venice, 1635–1639." *Burlington Magazine* 128 (1986), 114–32.

Shearman, John. *Raphael's Cartoons in the Collection of Her Majesty the Queen and the Tapestries for the Sistine Chapel*. London, 1972.

Simón Díaz, José. "El arte en las mansiones nobiliarias madrileñas de 1626." *Goya* 154 (1980), 200–5.

"La estancia del cardenal legado Francesco Barberini en Madrid el año 1626." *Anales del Instituto de Estudios Madrileños* 17 (1980), 159–213.

Slavicek, Lubomir. *Chvála sberatelstivi: ein Lob der Sammlerätigkeit. Holländische Gemälde des 17. und zu Beginn des 18. Jahrhunderts in böhmischen Sammlungen, 1600–1739*. Cheb, 1993.

Smuts, R. Malcolm. *Court Culture and the Origins of a Royalist Tradition in Early Stuart England*. Philadelphia, 1987.

"Art and the Economics of Majesty in Early Stuart England." Forthcoming.

Springell, Francis C. *Connoisseur and Diplomat*. London, 1963.

Stone, Lawrence. "The Market for Italian Art." *Past and Present* (Nov. 1959), 92–4.

"The Revolution over the Revolution." *New York Review of Books*, 11 June 1992, 47–52.

Stoye, John W. *English Travellers Abroad, 1604–1667: Their Influence in English Society and Politics*. Oxford, 1952.

Strong, Roy. *Britannia Triumphans. Inigo Jones, Rubens and Whitehall Palace*. London, 1980.

Henry, Prince of Wales and England's Lost Renaissance. London, 1986.

Summers, David. *Michelangelo and the Language of Art*. Princeton, 1981.

Teyssèdre, Bernard. *Roger de Piles et les débats sur le coloris au siècle de Louis XIV*. Paris, 1965.

Thuillier, Jacques. "Doctrines et querelles artistiques en France au XVIIᵉ siècle: Quelques textes oubliés ou inédits." *Archives de L'Art Français* 23 (1968), 125–217.

Trapier, Elizabeth Du G. "Sir Arthur Hopton and the Interchange of Paintings between Spain and England in the 17th Century." *Connoisseur* 164 (April 1967), 239–43; 165 (May 1967), 60–3.

van Eeghen, I. H. "Het geslacht Nijs (Nederlandse Cosmopolieten in de 17de Eeuw)." *Amstelodamum* 60 (1968), 74–102.

van der Boogert, Bob, & Jacqueline Kerkhoff. *Maria van Hongarije 1505–1558. Koningin tussen keizers en kunstnaars*. Utrecht and 's-Hertogenbosch, 1993.

Vannugli, Antonio. *La collezione Serra di Cassano*. Salerno, 1989.

Vergara, W. Alexander. "The Count of Fuensaldaña and David Teniers: Their Purchases in London after the Civil War." *Burlington Magazine* 131 (1989), 127–32.

"The Presence of Rubens in Spain." Ph.D. dissertation, Institute of Fine Arts, New York University, 1994.

Vey, Horst. "Die Bildnisse Everhard Jabachs." *Wallraf-Richartz Jahrbuch* 29 (1967), 157–87.

Vlieghe, Hans. "David II Teniers (1610–1690) en het hof van Aartshertog Leopold-Wilhelm en Don Juan van Oostenrijk—1647–1659." *Gentse Bijdragen tot de Kunstgeschiedenis en de Oudheidkunde* 19 (1961–6), 123–49.

Volk, Mary Crawford. "New Light on a Seventeenth-Century Collector." *The Art Bulletin* 52 (1980), 256–68.

von Einem, Herbert. "Karl V und Titian." In *Karl V der Kaiser und seine Zeit*. Cologne, 1960, 67–93.

van der Waals, Jan. *Der Prentschat van Michiel Hinloopen*. Amsterdam, 1988.

Warnke, Martin. *The Court Artist. On the Ancestry of the Modern Artist*, Cambridge, 1992.

Waterhouse, Ellis K. "Paintings from Venice for Seventeenth-Century England." *Italian Studies* 7 (1952), 1–23.

Weijtens, F. H. C. *De Arundel-Collectie. Commencement de la Fin, Amersfoort, 1655*. Utrecht, 1971.

Wildenstein, Georges. "Deux inventaires de l'atelier de Claude Vignon." *Gazette des Beaux-Arts* 49 (1957), 183–92.

Wilks, Timothy. "The Court Culture of Prince Henry and His Circle, 1603–1613." D.Phil., University of Oxford, 1987.

"The Picture Collection of Robert Carr, Earl of Somerset." *Journal of the History of Collections* 1 (1989), 167–77.

Williamson, H. R. *Four Stuart Portraits*. London, 1949.

Wittkower, Rudolf. "Inigo Jones—'Puritanissimo Fiero.'" *Burlington Magazine* 90 (1948), 50–1.

Wood, Carolyn H. "The Ludovisi Collection of Paintings in 1623." *Burlington Magazine* 134 (1992), 515–23.

Wood, Jeremy. "Van Dyck and the Earl of Northumberland: Taste and Collecting in Stuart England." In *Van Dyck 350*, ed. Susan J. Barnes & Arthur K. Wheelock, Jr. Studies in the History of Art, 46. National Gallery of Art, Hanover and London, 1994, 281–324.

Zaremba Filipczak, Zirka. *Picturing Art in Antwerp, 1550–1700*. Princeton, 1987.

Zarco del Valle, Manuel R. "Documentos inéditos para la historia de las bellas artes en España." In *Colección de documentos inéditos para la historia de España*, vol. 45. Madrid, 1870.

Photographic Acknowledgments

All pictures are reproduced by kind permission of their owners. Specific acknowledgments are as follows: Alinari/Art Resource: 124; Crown copyright, Historic Royal Palaces: 19; Devonshire Collection, Chatsworth. Reproduced by permission of the Chatsworth Settlement Trustees. Photograph Courtauld Institute of Art: 36; Photo Giraudon: 223; Glasgow Museums: Art Gallery and Museum, Kelvingrove: 163; Courtesy of the Hispanic Society of America: 102; Master and Fellows, Magdalene College, Cambridge: 21; The Metropolitan Museum of Art: The Elisha Whittelsey Collection, The Elisha Whittelsey Fund, 1951. (51.5017502), 140, Rogers Fund, 1962. (62.602.112), 166, Gift of Wildenstein Foundation, Inc., 1951 (51.34), 185, Harris Brisbane Dick Fund, 1930[30.19.(7)], 208; National Gallery of Art, Washington DC: Gift of Arthur and Charlotte Vershbow in honor of the 50th anniversary of the National Gallery of Art, 139, Samuel H. Kress Collection, 224, Andrew W. Mellon Collection, 225, 226; National Trust Photo Library, Derrick Whitty: 154; New York Public Library, Miriam and Ira D. Wallach Division of Art, Prints and Photographs: 210, 212; Photo © RMN: 3, 25, 26, 31, 49, 50, 51, 52, 53, 59, 62, 63, 64, 66, 67, 81, 82, 83, 84, 168, 171, 172, 173, 174, 175, 176, 177, 181, 182, 183, 184, 188, 190, 191, 193, 194, 195, 196, 199, 210, 204, 211, 213; By permission of the Earl of Rosebery and the Trustees of the National Galleries of Scotland: 1; Courtesy the Royal Academy: 38; The Royal Collection © 1995 Her Majesty Queen Elizabeth II: 4, 7, 9, 33, 56, 192, 206, 209, 218; Copyright the Trustees of Sir John Soane's Museum: 54, Duke of Sutherland Collection, on loan to the National Gallery of Scotland: 161, 220, 221; Rheinisches Bildarchiv: 186 (ref. 10722); Courtesy of the Board of Trustees of the Victoria and Albert Museum: 28, 29: Wadsworth Atheneum, Hartford, Conn., The Ella Gallup Sumner and Mary Catlin Sumner Collection Fund: 217.